pity this busy monster,manunkind,

not. Progress is a comfortable disease:
your victim(death and life safely beyond)

plays with the bigness of his littleness
—electrons deify one razorblade
into a mountainrange;lenses extend

unwish through curving wherewhen till unwish
returns on its unself.
 A world of made
is not a world of born—pity poor flesh

and trees,poor stars and stones,but never this
fine specimen of hypermagical

ultraomnipotence. We doctors know

a hopeless case if—listen;there's a hell
of a good universe next door;let's go

<div align="right">E. E. Cummings, 1944</div>

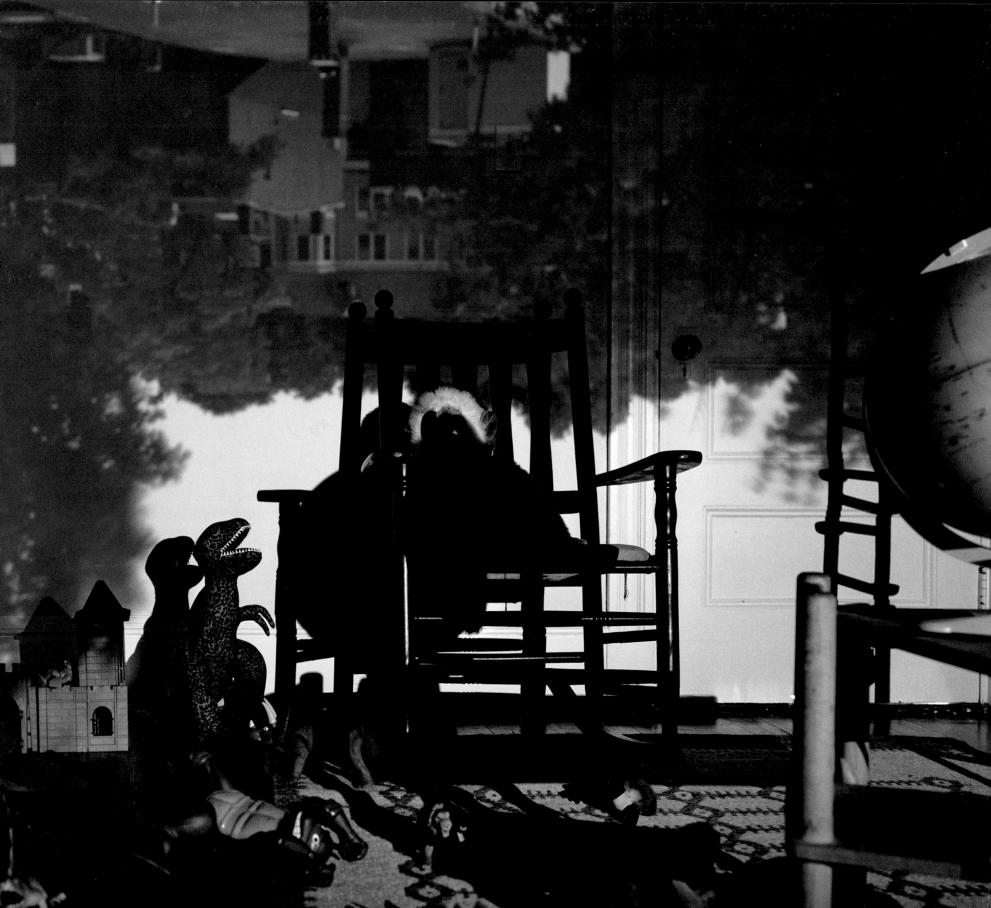

ABELARDO
MORELL

THE
UNIVERSE
NEXT
DOOR

Elizabeth Siegel
With Brett Abbott and Paul Martineau

The Art Institute of Chicago
Distributed by Yale University Press, New Haven and London

Abelardo Morell: The Universe Next Door was published in conjunction with an exhibition of the same title organized by the Art Institute of Chicago in association with the J. Paul Getty Museum, Los Angeles, and the High Museum of Art, Atlanta.

Exhibition Dates

The Art Institute of Chicago
June 1 – September 2, 2013

The J. Paul Getty Museum, Los Angeles
October 1, 2013 – January 5, 2014

High Museum of Art, Atlanta
February 22 – May 18, 2014

Major support for *Abelardo Morell: The Universe Next Door* has been generously provided by Joyce Chelberg.

Funding for the exhibition catalogue has been provided by the Robert Mapplethorpe Foundation.

Generous in-kind support for the exhibition has been provided by Tru Vue, Inc., and Gemini Moulding, Inc.

First edition, second printing
Printed in Italy
ISBN: 978-0-300-18455-6 (hardcover)

Published by
The Art Institute of Chicago
111 South Michigan Avenue
Chicago, Illinois 60603-6404
www.artic.edu

Distributed by
Yale University Press
302 Temple Street
P.O. Box 209040
New Haven, Connecticut 06520-9040
www.yalebooks.com/art

Produced by the Publications Department of the Art Institute of Chicago, Robert V. Sharp, Executive Director

Edited by Amy R. Peltz

Production by Joseph Mohan and Sarah E. Guernsey

Photography research by Lauren Makholm

Proofreading by Christine Schwab

Designed and typeset in Bauer Bodoni, Proforma, and Univers by Roy Brooks, Fold Four, Inc., Milwaukee, Wisconsin

Separations by Robert J. Hennessey Photography, Middletown, Connecticut

Printing and binding by Graphicom, Verona, Italy

This book has been printed on paper certified by the Forest Stewardship Council.

Jacket illustrations: (front) *Camera Obscura: View of Central Park Looking North — Summer* (detail), 2008 (plate 86); (back) *Camera Obscura: View of Central Park Looking North — Winter* (detail), 2013 (plate 88).

Frontispiece: *Camera Obscura: Brookline View in Brady's Room* (detail), 1992 (plate 25).

Library of Congress Cataloging-in-Publication Data

Abelardo Morell : the universe next door / Elizabeth Siegel with Brett Abbott and Paul Martineau.—First edition
 pages cm
 Abelardo Morell: The Universe Next Door was published in conjunction with an exhibition of the same title presented by the Art Institute of Chicago, June 1–September 2, 2013, in association with the J. Paul Getty Museum, October 1, 2013–January 5, 2014, Los Angeles, and the High Museum of Art, Atlanta, Februrary 22–May 18, 2014.
 ISBN 978-0-300-18455-6 (alk. paper)
 1. Photography, Artistic—Exhibitions. 2. Morell, Abelardo—Exhibitions. I. Siegel, Elizabeth, 1969– II. Abbott, Brett, 1978– III. Martineau, Paul, 1967– IV. Morell, Abelardo, photographer. V. Art Institute of Chicago. VI. Title: Universe next door.
TR645.C552A77 2013
770—dc23
 2013005550

CONTENTS

FOREWORD

The Art Institute's photography collection ranges from the earliest experiments of William Henry Fox Talbot in the 1830s to contemporary works that engage the concerns of the present. Not surprisingly, the Department of Photography has long been committed to the work of Abelardo Morell, a practicing artist who has often turned to the history of photography for inspiration. The museum first acquired a small group of his images nearly twenty years ago, and the collection now boasts more than twenty-five works, with strong examples from throughout the artist's career. In 2005 the department had a small showing of Morell's camera obscura images. Now we are pleased to mount *Abelardo Morell: The Universe Next Door*, the first comprehensive retrospective devoted to the artist in fifteen years, which covers over a quarter century of work and demonstrates Morell's profound delight in photography as a source of visual surprise and wonder.

I wish to thank Associate Curator of Photography Elizabeth Siegel for initiating this exciting project and the fruitful collaboration with her curatorial colleagues Brett Abbott, Curator of Photography and Head of Collections at the High Museum of Art in Atlanta, and Paul Martineau, Associate Curator of Photographs at the J. Paul Getty Museum in Los Angeles. I am grateful as well to Timothy Potts, Director, the J. Paul Getty Museum, and Michael Shapiro, Nancy and Holcombe T. Green, Jr., Director of the High Museum of Art, for their partnership on this exhibition. We are delighted that audiences in Los Angeles and Atlanta will also have the opportunity to enjoy this wide-ranging look at Morell's career.

This catalogue, along with the exhibition it accompanies, would not have been possible without the generous support of Joyce Chelberg, who has underwritten the entire year's series of photography exhibitions being held in the Art Institute's Modern Wing. We are also grateful to the Robert Mapplethorpe Foundation for its contribution to the catalogue. An in-kind donation of acrylic glazing from Tru Vue has enabled us literally to see these works as never before, their lush blacks and large-format detail appearing free of reflections. Finally, I wish to thank Daniel Greenberg and Susan Steinhauser, who have generously promised a significant group of Morell's photographs to the permanent collections of all three participating museums, that will serve as a lasting legacy of the exhibition.

In Chicago, the exhibition is being presented simultaneously in the Department of Photography's galleries in the Robert Allerton Building, the Art Institute's oldest surviving structure, and in the new Modern Wing. These two spaces, holding within them the art of the past and the present, respectively, provide an especially illuminating context for the work of an artist who employs photography's earliest techniques to reveal something new about today's world.

Douglas Druick
President and Eloise W. Martin Director
The Art Institute of Chicago

ACKNOWLEDGMENTS

The first photographs by Abelardo Morell that I encountered were his camera obscura works, and I was struck then by how the simple mechanisms of the camera, depicted at the end of the twentieth century, could evoke the wonder of photography's beginnings. In the years since, I have remained fascinated by Morell's pictures across many series, and I am grateful to all the people who have allowed us to bring this work together and share it with a broader public.

This catalogue and the exhibition it accompanies would not have been possible without the outstanding efforts of remarkable staff members at three exceptional institutions. Above all I thank my curatorial collaborators, Brett Abbott, Curator of Photography and Head of Collections at the High Museum of Art in Atlanta, and Paul Martineau, Associate Curator of Photographs at the J. Paul Getty Museum in Los Angeles, for their excellent contributions to the catalogue. Acknowledgment is also due to the Getty and High for their vital loans to the exhibition and for hosting the show in Los Angeles and Atlanta, enabling it to be shared with viewers across the country.

At the Art Institute of Chicago, thanks must begin with Douglas Druick, President and Eloise W. Martin Director, and Matthew S. Witkovsky, Richard and Ellen Sandor Chair and Curator, Department of Photography. As always, the team in the Department of

Photography came together for this exhibition with resourcefulness and humor. Exhibitions Manager Michal Raz-Russo gracefully handled all the logistics of the exhibition, Departmental Specialist Jim Iska beautifully framed the works with the help of Anna Kaspar, and Collection Manager Natasha Derrickson arranged all elements of the process pertaining to the permanent collection. I am also grateful to Conservator Doug Severson, Secretary and Assistant to the Chair Amy Diehl, and Mellon Fellow in Photography Conservation Mirasol Estrada for their assistance, and especially to Associate Curator Kate Bussard for her enthusiasm and support.

The Art Institute's exhibition team, led by Dorothy Schroeder, Vice President for Exhibitions and Museum Administration, and assisted by Brice Kanzer and Megan Rader, skillfully handled matters related to loans and budgets. In the Department of Museum Registration, I am grateful to Executive Director Jennifer Draffen, Senior Registrar for Loans and Exhibitions Darryl Green, and especially Associate Registrar for Loans and Exhibitions Susanna Hedblom, who expertly coordinated all aspects of transporting the works. Vice President Elizabeth Hurley, Directors George Martin and Jennifer Oatess, and Associate Director Jeffrey Arnett in the Development Department helped make this project possible. I also wish to recognize Erin Hogan, Director, and Chai Lee, Associate Director, in the Department of Public Affairs and Communication; Yaumu Huang,

Exhibition Designer, in the Department of Design and Construction; Salvador Cruz in the Department of Graphic Design; and Associate General Counsel Jennifer Sostaric in the Legal Department for their contributions to the exhibition.

This catalogue was produced by the outstanding staff in the Department of Publications, headed by Robert Sharp, Executive Director. Editor Amy Peltz ensured the clarity and consistency of the text with her wise edits, and Production Coordinator Joseph Mohan ably oversaw all aspects of the book's production, with the invaluable assistance of Photography Editor Lauren Makholm and Director Sarah Guernsey. Roy Brooks of Fold Four, Inc., provided a clean, elegant design for the catalogue that perfectly complements Morell's work. Robert J. Hennessey worked closely with the artist to create reproductions faithful to the originals.

At the J. Paul Getty Museum, I express my gratitude to Timothy Potts, Director; Thomas Kren, Associate Director of Collections; Quincy Houghton, Associate Director of Exhibitions; and Judith Keller, Senior Curator, Department of Photographs, for their enthusiastic support of this project. In the Department of Photographs, thanks also go to Arpad Kovacs, Assistant Curator, and Miriam Katz, Cataloguer, whose assistance in preparing the photographs for digital imaging and in cataloguing them was essential. In the Department of Paper Conservation, the expertise of Sarah Freeman and Ernie Mack,

Conservators, and Stephen Heer, Mountmaker, proved invaluable. The exhibition at the Getty also benefited from the contributions of Amber Keller, Principal Project Specialist for Exhibitions; Chris Keledjian, Editor; Tuyet Bach, Educator; and Elie Glyn, Designer.

Many individuals and organizations generously supported the High Museum of Art's participation in the show through early-stage grants as well as gifts and promised gifts of art. I wish to thank Lucinda Bunnen for directing contributions in memory of Dr. Robert Bunnen, Cathy and Bert Clark, Charlotte Dixon, Tede Fleming and Joe Williams, the Friends of Photography, Marian and Ben Hill, Ellen and George Nemhauser, Lindsay W. Marshall, and the Robert Mapplethorpe Foundation. Special appreciation also goes to the High's administrative leaders and their staff, including Michael E. Shapiro, Nancy and Holcombe T. Green, Jr. Director; David Brenneman, Director of Collections and Exhibitions and Frances B. Bunzl Family Curator of European Art; Philip Verre, Chief Operating Officer; Virginia Shearer, Eleanor McDonald Storza Director of Education; Kimberly Watson, Director of Museum Advancement; and Rhonda Matheison, Chief Financial Officer. Other key team members included Maria Kelly and Andrew Huff in the Department of Photography; Jackie Beres, Lauren Pastwik, and Susan Aspinwall in the Department of Development; Frances Francis, Becky Parker, and Paula Haymon in the Department of Registration; Amy Simon, Brian Kelly, Larry Miller, and Jim Waters in the Department of Exhibitions; Julia Forbes in the Department of Education; Jennifer Bahus and Kristen Heflin in the Department of Communications; and Angela Jaeger in the Department of Creative Services.

As I conducted research for my essay, several people generously agreed to share their recollections of Morell in interviews, and I am grateful to them for their time and memories: Kevin Bubriski, Lois Conner, Lisa McElaney, John McKee, Nicholas Nixon, Tod Papageorge, Irina Rozovsky, Stephen Scheer, Melinda Simon, and Mike Smith. I also wish to thank Alissa Schapiro and Ellen Martin, former interns in the Art Institute's Department of Photography, for their help with research. Matt Witkovsky, Kate Bussard, and Greg Jacobs all read the essay at various stages and kindly offered their usual constructive comments, and Josh Chuang served as a sounding board early in the process.

We wish to remember Bonni Benrubi, Morell's gallerist for two decades, whose fierce and enthusiastic support of the artist and this exhibition was invaluable; her recent death was a great loss for the photography community. We are grateful to the gallery, now headed by Rachel Smith, for lending work from its inventory. Morell's dedicated assistants — Aimee Fix, CJ Heyliger, and Robin Myers — have all been enormously helpful in preparing both the exhibition and the catalogue. We also appreciate the efforts of the staff at Edwynn Houk Gallery, New York. Finally, we recognize Marc Elliott at Color Services, Inc., for producing many of the fine prints on view in the exhibition.

Such endeavors also depend, of course, on the support and generosity of numerous sponsors, and thus I express my gratitude to Daniel Greenberg and Susan Steinhauser, who have been collecting Morell's work for many years and have graciously promised gifts of photographs to all three institutions, greatly enriching our holdings. This exhibition was also made possible by Joyce Chelberg, whose generosity extends to all the photography exhibitions taking place this year in the Art Institute's Modern Wing. Additionally, we are grateful to the Robert Mapplethorpe Foundation for their support of this catalogue. Tru Vue kindly provided sheets of Optium acrylic for framing Morell's work, which immeasurably enhanced its presentation, and Gemini Moulding donated its cutting services; for these contributions I particularly thank Patti Dumbaugh, Vice President of Sales at Tru Vue.

Above all, I remain grateful to Abelardo Morell, who has been a true pleasure to work with for many years and whose creativity and curiosity are inspiring.

Elizabeth Siegel
Associate Curator
Department of Photography
The Art Institute of Chicago

WONDERLANDS
Elizabeth Siegel

Who would believe that so small a space could contain the image of all the universe? O mighty process!

—Leonardo da Vinci, *Codex Atlanticus*

L eonardo da Vinci wrote with amazement about the workings of the camera obscura, a device that harnesses the optical principle that light passing through a small aperture into a dark room will project an image of the outside world.[1] Combining art, science, and a sense of magic, the camera obscura was a means of turning the universe into a picture and was a forerunner of photography. Five centuries later, Abelardo Morell returned to the camera obscura to explore his own amazement at photography, making the pictures of camera images projected onto domestic interiors for which he would become most well known. But Leonardo's expression of delight at this natural process could also describe most of Morell's photographs, across a variety of series: twenty-five years of work motivated by the belief that camera images are full of wonder and reveal unseen beauty in the everyday world.

Morell's achievement reveals its full significance when considered against the landscape of contemporary photography. The past several decades have witnessed the rapid expansion of photography as an artistic practice and an enormous increase in the critical attention it receives. Artists have employed appropriative, diaristic, directorial, and numerous other strategies to critique originality, challenge myths of photographic truth, question memory and identity, complicate received notions of race and gender, revisit ideas of photographic narrative, or comment on the stream of media images assaulting us daily. Technological advances have facilitated the common adoption of color, greater manipulation of photographs, and enlargements that allow photography to rival the scale and aesthetic impact of history painting. The boundaries between photography and other media have now been thoroughly muddied.

In the context of this diversity, over the last quarter century Morell has carved a singular path.[2] On one hand, he is firmly entrenched in a modernist approach that understands photographs as self-contained, autonomous images bounded by their four edges, and he mines essential qualities of the medium—light, optics, the workings of the camera—for both subject matter and form. He

refuses to manipulate his prints and has only recently expanded from classical black and white to the color his peers have embraced for decades. In addition, unlike many artists who produce tableau-sized photographs, he continues to make pictures of a more intimate scale and quieter effect. He rejects postmodernist notions that photography is overdetermined, only and always mediated through other images, or exhausted of any possibility for originality, instead viewing picture-making as an intuitive more than a critical act. And yet the photographs Morell makes are not pure or disinterested records. Like many of his contemporaries, he demonstrates—but with the most basic and elemental of means—that photography is a construction, a subjective interpretation. In Morell's camera obscura, the raw image of the outside scene is altered and distorted as it meets the furniture of the interior, which, in many cases, he has actually arranged; the camera is never merely receptive, but transformative. Underscoring this point, Morell turns his camera on conveyors of cultural meaning and knowledge such as books, maps, money, and museums that, like photographs, are not the transparent vehicles they may appear to be, but are in fact highly constructed. Similarly, Morell produces tabletop compositions, designed to be photographed, whose obvious fabrication highlights the ways some pictures make particular claims to truthfulness. Works of art of all sorts—not just photographs—populate his images, from paintings in museums to art reproductions in books, from cut-up and reassembled prints to theatrical flats on stage sets. In a practice of invention as much as observation, Morell continues to find rich possibilities in the essential strangeness and complexity of images.

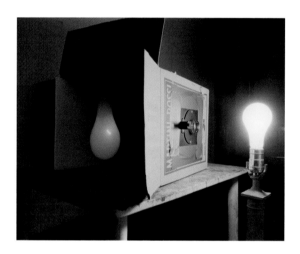

Fig. 1. *Lightbulb*, 1991

This book begins with the photographs Morell made when, after the birth of his son, he started to examine common household objects with childlike curiosity. It ends with his most recent photographs, including pictures made with his latest pictorial innovation, the tent camera (a kind of portable camera obscura). In between, Morell explored domestic optics, the sensory properties of books, the display and reproduction of works of art, and the American landscape, experimenting with photograms, stop-motion studies, the camera obscura, and the painterly possibilities of color.

Across his work, Morell has been keenly attentive to the material qualities of tangible things in an increasingly virtual world, particularly the kinds of things that seem now on the verge of obsolescence, like books and maps—objects that once existed, like photographs, only as pieces of paper. His attentiveness renders them unfamiliar, often strange, and the resulting pictures arrest our habitual perceptions.[3] He brings that same investigative rigor to the materiality of his medium, probing and pushing photography not out of nostalgia for its vanishing forms but as a way to exploit its potential and make something new. This intense inward look at the properties of photography has allowed Morell to look back out at the world with fresh eyes, and his transformation of the universe into pictures remains a project full of possibility.

When he received an honorary Doctor of Fine Arts degree from Bowdoin College in 1997, Morell credited his perspective as an artist in part to his loss of a childhood homeland: "This break with the place where I grew up is probably still stirring at the bottom of much of what I do in art now," he told the graduating

class. "Somehow the conflicts of cultures, languages, and places that I felt didn't just scare me, these things also gave me a sense of exhilaration, a feeling that things out there were wild and surreal."[4] Now nearing sixty-five, Morell (who is warm and engaging, prone to loud laughter in conversation—as well as visual jokes in his photographs) reflects often on exile and how the early dislocation from home continues to shape his view of the world.[5] He was born in Havana, Cuba, in 1948. When he was young, his family moved to Guanabo, a small seaside town, where his father secured a position as a sergeant at the naval base. There he was part of a large, close-knit extended family, regularly enjoying communal meals and gatherings. His parents were working class and had only attended school through the eighth grade, but an uncle, Juan, was training as an architect and had amassed a collection of "exotic-looking volumes" with pictures of buildings in faraway places, which the young Morell was allowed to peruse.[6] Some of his most vivid memories are of going to the movies, often three or four times a week (his father, as a small-town official, had a free pass). There American cowboy and gangster films offered an enticing albeit distorted glimpse of the foreign country to the north. The sea—which would later figure dramatically in certain camera obscura photographs—looms large in his recollections, offering a sense of expansive possibility, an early understanding of being connected to something larger than himself. It also became a symbol of escape.

"The revolution," Morell says, "changed everything."[7] After Fidel Castro seized power in 1959, danger alternated with absurdity against the idyllic beach town backdrop. Soldiers with guns paced the streets, neighbors spied on one another, and executions by firing squad were regularly televised. Morell recalls citizens having to turn in all their cash and exchange it for new currency, which featured revolutionaries in tanks and felt bizarrely like play money. His father, gregarious and well liked, survived in this atmosphere for a few years, but soon he was falsely accused of carrying explosives and was arrested several times, including once in front of his son. It became clear to the whole family that he was in real danger

and that they would need to leave Cuba. In the end, they escaped by plane, pretending, like so many others, that their trip out of the country was merely a vacation. They surrendered their house and belongings to the authorities, to be kept until their return. In a frightening moment Morell describes as straight out of Hitchcock, his father was detained for questioning as they walked across the tarmac to their PanAm flight, while Morell, his mother, and his sister were allowed to proceed. His father finally rejoined the family on the plane, and when the wheels left the ground, they knew they were safe. Many of the adults on the flight began to cry and burst out spontaneously into the Cuban national anthem. Vowing not to visit as long as Castro remained in power, his parents never returned to the country. The plane left on March 8, 1962; Morell was thirteen years old.[8]

After some time in Miami and New Orleans, where Morell studied English words on flashcards, the family moved to New York City, and his father began working as a building superintendent. They lived in a basement apartment in one of the buildings he maintained on West Sixty-Ninth Street, and the contrast between a dark, subterranean existence shoveling coal and the open, fresh-air pleasures of nearby Central Park remains clear in Morell's mind. New York landmarks and skyscrapers, which would later show up tamed in interiors in photographs, were foreign but fascinating. A gangly teenager, Morell went to school, worked a few after-school jobs (often making deliveries to fancier apartment buildings), and helped his father; he did not speak English well and did not have many friends. A high school English teacher, however, nurtured him and introduced him to Ernest Hemingway—*A Farewell to Arms* was an especially beloved volume—and the books became a lifeline, a way to learn both a language and a culture. With his use of concrete, tangible words to express complex emotions and ideas, Hemingway was an inspired choice for a new speaker, and he taught Morell about starting from solid ground before becoming more abstract.[9] During these years, Morell also made his first photographs, black-and-white snapshots taken with a Brownie camera

(see fig. 2 in the chronology), as well as home movies showing the family at play.

In 1967, Morell was awarded a scholarship to attend Bowdoin College in Maine, a small liberal arts school in a place so utterly alien to Cuban immigrants living in New York that his parents had to look it up in an atlas. He initially intended to become an engineer but found the math and physics too challenging and ended up majoring in comparative religion, attracted to the field's philosophical underpinnings. But it was when he entered John McKee's photography class in the spring of 1969 that a world truly opened to him. McKee, who had come to Bowdoin as a French professor, was himself new to photography. He possessed an expansive intellect and wide interests that encompassed Japanese culture, music from around the globe, modern poetry, and Zen Buddhism. The old barn he owned some miles outside campus served as an informal gathering place for students. Uninterested in the zone system or camera club pedagogy, McKee instead urged his class to read Wallace Stevens, look at Mark Rothko, listen to Bach and Bartók. A typical assignment might be to make pictures that related to the Stevens poem "Thirteen Ways of Looking at a Blackbird," or to photograph with all the possibilities of a particular word — *palimpsest*, for example — in mind. Technical issues were relegated to handouts, and class time was taken up with the serious business of looking. This fluid way of understanding the medium — whereby photography connected to painting, to music, to language, to life — would exert a lifelong influence on Morell's own work.

Morell had found his métier and threw himself into photography. "I could finally put into images bottled-up feelings of absurdity and alienation, and also joy and delight," he later said of this discovery.[10] If an assignment called for shooting one roll of film, he would shoot ten, selecting the smart but unexpected picture for review. McKee recalls that Morell quickly grasped the logical extension of ideas and took on an unofficial leadership role in the class. He spent hours in the darkroom and tried everything he could to make the work a little wild — he blasted the contrast, sandwiched

negatives, solarized prints, even stepped on them during development. "I didn't know what surrealism was at the time, but my pictures were probably about things not making sense."[11] A breakthrough came with a picture of a young girl wearing a white Communion dress in a garden in Galicia, Spain (taken while visiting relatives), which he had always printed dramatically solarized. When he produced it without his usual darkroom interventions, he was pleasantly surprised by the innate strangeness of the image (fig. 7 in the chronology) and resolved from then on to avoid manipulation in favor of the straight print.

Morell started regularly visiting the Museum of Modern Art to see the shows organized by John Szarkowski, then the director of the Photography Department. He also began to devour photography books, finding models in the work of Diane Arbus, Henri Cartier-Bresson, and fellow exiles Robert Frank and Josef Koudelka, and started working in a surrealist street photography vein (see fig. 5 in the chronology). "I was obsessed with this newfound language," he recalls.[12] Always interested in music — his tastes today remain eclectic and all-encompassing — Morell also began playing both piano and percussion while at Bowdoin. He spent an entire summer at the library at Lincoln Center listening to jazz records (John Coltrane was a particular favorite), but also gravitated toward more experimental composers such as Steve Reich, John Cage, and Philip Glass. In his class, McKee had explained the idea of counterpoint — different musical lines that move independently but sound harmonious when played or sung together — and this concept resonated deeply with Morell, who came to see that photography was more about the relationships among the elements of the picture than about any single subject.

Frustrated with his other classes and influenced by the early 1970s counterculture, Morell dropped out of college his senior year. He held a number of menial jobs, continuing to set up darkrooms and make pictures wherever he went. He eventually committed to a career in photography, returning to Bowdoin to finish his degree in 1976, and later applied to Yale's Master of Fine Arts program, which

he entered in the fall of 1979. There Morell was one of a class of five that also included Lois Conner, Robert Lisak, Mike Smith, and Mary Tortorici. The program was newly headed by Tod Papageorge, the brilliant but irascible photographer with connections to the Museum of Modern Art and the New York street photography scene.[13] He in turn hired Richard Benson, a generous photographer and printmaker with endless curiosity and unparalleled technical skills that would serve the students well. Yale had long been the teaching home of Walker Evans, who retained a cultlike status there long after his death in 1975. When Papageorge took the reins, the roster of models expanded to include Frank, Szarkowksi, Lee Friedlander, Helen Levitt, and Garry Winogrand—who all visited the school and showed work—as well as Eugène Atget, Brassaï, and August Sander. Educated in English literature, Papageorge was eloquent and prone to literary metaphors in his criticism, but also sharp, even harsh, at times. The atmosphere was not unsupportive— students recall both Papageorge and Benson as ardent defenders of the medium, tough but fair—yet for Morell it proved much more rigid and challenging than his comparatively open-ended experience at Bowdoin. Yale stripped students of their comfortable skins so that they could find a more meaningful core, and they emerged, as Lois Conner has put it, "wounded but wiser."[14] Morell absorbed the school's modernist dictate that photography was a unique medium with its own specific sets of practices and expressive possibilities, and that a photograph was above all a picture with an internal logic, not a literal depiction of the world represented.

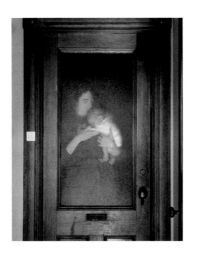

Fig. 2. *Lisa and Brady behind Glass,* 1986

Morell had met Lisa McElaney, a fellow student, upon his return to Bowdoin; they married in 1982. When Morell obtained a position at Massachusetts College of Art and Design in 1983, they moved to Boston, and he settled into his roles as husband and professor. He turned out to be a gifted teacher, beloved by his students, who recall him creating a warm environment, a multisensory experience that opened them to discovery. Like McKee, he played experimental compositions and music from around the world in class, and he urged students to attend every visiting artist lecture and gallery show. He also admonished them that "A photograph is *about*, it's not just *of*."[15] Morell had assimilated Papageorge's commitment to capturing the world within a single frame, but he enlarged that philosophy to include allusion and emotion, assigning, for example, the task of photographing a childhood memory so that students would attempt to tap into their visceral, almost unconscious perceptions. Morell would remain at MassArt for the rest of his teaching career, drawing inspiration from his students, finding in the classroom a fertile testing ground for new ideas, and pursuing deep personal and artistic relationships with fellow teachers Laura McPhee, Nick Nixon, and Barbara Bosworth.

Morell became a father in 1986, and the birth of his son, Brady, marked a turning point in his life and his photography. Unable to prowl the streets for his pictures and struggling with the simultaneous depression and exhilaration of caring for a newborn, he found novel subject matter in the domestic interior. "I started making photographs as if I were a child myself," he later wrote. "This strategy got me to look at things around me more closely, more

slowly and from vantage points I hadn't considered before. This way of seeing changed me and my photography."[16] He switched from a lightweight, portable 35 mm camera to a large-format view camera, which necessitated a more deliberate approach and elicited a wealth of tactile detail from his subjects. For Morell, fatherhood was not a distraction from the more pressing business of art-making; rather, the two became intimately intertwined—they remain almost inseparable in his mind—and he embraced the reality happening at home. His pictures became more overtly emotional, testing the limits of sentiment, as in an early photograph of Lisa holding Brady behind the pebbled glass of a door (fig. 2, plate 1). Temperamentally neither detached nor cynical, he was nonetheless aware that he was entering territory that might be considered anathema to other artists: "People in New York or at Yale will hate [the picture]," he thought.[17] He tried to see objects from the literal vantage point of his son, placing the camera on the floor at the foot of a skyscraper-like stack of blocks, or atop a slide looking down at the perilous view (plates 2 and 6). He attempted to harness a prelingual visuality, a way of depicting and understanding the visible world before it is domesticated by naming. More than simply imitating a child's point of view, however, Morell's photographs became an exercise in noticing the wonders of the everyday, with their long exposure times allowing ample time for the contemplation of the object in front of him. The poet Charles Simic, a friend of Morell, commented on his appreciation of "the inexhaustible power of common objects," arguing, "This may turn out to be the most original undertaking of our century: the quest for the magic substance to be found in the ordinary."[18]

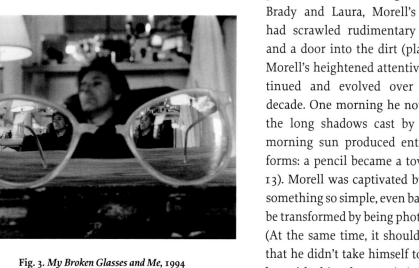

Fig. 3. *My Broken Glasses and Me,* 1994

Morell had been introduced to Minor White's photographs and writings at Bowdoin, and he was attracted to his mysticism and the way White saw "things for what else they are."[19] Now more bound to his home, Morell too saw objects with fresh eyes. A paper bag, seen from above, possesses a gaping maw that opens ominously, its dark interior seemingly without bottom (plate 15). The shape of the typical American house—a square topped by a triangle, in the child's shorthand for "home"—began populating his pictures, from a playhouse to a dollhouse to the shadow cast by his own pitched roof onto the ground where Brady and Laura, Morell's daughter, had scrawled rudimentary windows and a door into the dirt (plates 9–12). Morell's heightened attentiveness continued and evolved over the next decade. One morning he noticed how the long shadows cast by the early morning sun produced entirely new forms: a pencil became a tower (plate 13). Morell was captivated by the way something so simple, even banal, could be transformed by being photographed. (At the same time, it should be noted that he didn't take himself too seriously: with his characteristic sense of humor, he depicted a group of pencils jostling one another in group protest in a picture he titled *Pencil Demonstration,* plate 14.) He photographed things with a literary descriptiveness that might be fruitfully compared with the concrete clarity of Hemingway, who had been so formative in Morell's learning English; like the author, he now focused on depicting visible facts that could possess broader meanings.

The optical effects of everyday objects began to fascinate him, and he found humble forms of lenses around his home. Water was a potent medium, distorting and enlarging the forms of forks

clutching each other in a glass, or proving simultaneously reflective and transparent as it poured over the top of a pot in the accumulated motion of a lengthy exposure (plates 17 and 18). A wineglass filled with water became a camera lens, flipping a window upside down (plate 16). Morell's photograph depicts the object (the window, slightly out of focus beyond the glass) and the image (upside down and distorted) simultaneously, calling attention to the more intentional act of image-making by which he produced the picture with his camera. In a self-portrait with his own broken eyeglasses, Morell lies with his eyes closed, the photographer doubly deprived of his vision (fig. 3, plate 21). He plays with the distorting effects of both the camera and the glasses: most of the scene is blurred due to the camera's proximity to the subject, but the view through the corrective lenses is clear, and thus the viewer begins to image the world as the artist himself sees it.

The more calculated optical mechanisms of photography, too, could be gratifyingly simple and yet still wondrous. In 1991, Morell wanted to demonstrate both the optical principles and the delight to his students, and so he constructed a homemade camera from a cardboard box open at one end, a lens, and some duct tape. He placed it on a wooden tabletop, positioned a lamp with a bare lightbulb alongside it, and revealed an image projected on the opposite wall of the box: an inverted, slightly dimmer bulb. *Lightbulb* (fig. 1, plate 23) was a revelation, clumsy and obvious and yet elemental, stripping the camera to its essence. "This picture gave me the feeling that photography is in many ways still raw and unexplored," Morell explained a few years later. "Making this picture was for me a way to rediscover the mystery of the medium and maybe to share

it with others."[20] Although the image merely demonstrates a basic principle of light, the process ends up seeming more remarkable than ever; the picture is, as critic Richard B. Woodward has put it, "a taunting reminder that photography really is a kind of magic trick."[21] The photograph also advanced Morell's career in two key ways: it got him noticed, at the relatively advanced age of forty-three (it graced the poster and cover of the brochure for the Museum of Modern Art's 1992 group show, *More Than One Photography*), and it led him in the direction of photographing the effects of the camera obscura.

Like *Lightbulb*, Morell's camera obscura photographs originated in an attempt to share his knowledge and enthusiasm with his students. The principle is straightforward enough and has been known since antiquity: if a small aperture is cut in the wall of a dark room (in Latin, a *camera obscura*), the light that passes through will project an image of the outside world, upside down and laterally reversed, upon the opposite wall. This is the principle on which our eyes work (our brains flip the image to accord with reality), as well as all cameras. The camera obscura was a remarkably effective teaching tool for Morell. In a cavernous MassArt classroom, he would cover all the windows with black plastic and assemble his class in a semicircle. He would then poke a three-eighths-inch hole in the plastic, and the jaded students would emit a collective gasp as they saw Huntington Avenue projected upside down, the buses running along the ceiling. The scenes we see every day, it turns out, are much more entrancing when formed as a picture. It was several years, however, before Morell thought to photograph the projection, recording the way the interior and exterior met to

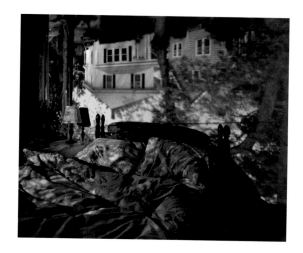

Fig. 4. *Camera Obscura: Houses across the Street in Our Bedroom, Quincy, Massachusetts, 1991*

form a new image. Suitably enough, given his earlier investigations of childhood and home, the initial camera obscura works originated in his house in Quincy, while he was on sabbatical in the summer of 1991, and involved his young family. The first successful picture took place in their living room (fig. 14 in the chronology), the next in their bedroom (fig. 4, plate 24). "Every time I got a room ready for a camera obscura picture, my wife and son would witness it," Morell recounted. "I remember lying in bed with them watching neighbors going to work and squirrels walking on telephone poles."[22] He eventually figured out that an exposure of six to eight hours was required, which eliminated all moving things (people, cars) from a scene and rendered objects that moved slightly (the leaves on a tree, for example) as a blur. In the photograph in their bedroom, the pale wall and sheets made ideal screens for the projection, as the roof of the house across the street pressed against their bed frame in a gesture both intimate and invasive. "That summer," he said, "I felt that I had touched on something very important: that the very basics of photography could be potent and strange."[23]

Morell moved steadily outward from the familiarity of home, progressing to such in-between spaces as hotel rooms and strangers' houses and then to more institutional sites such as offices and museums. He first tackled New York City, whose skyscrapers and landmarks had seemed overwhelming to him as an immigrant teenager in the 1960s. In a camera obscura picture of the Empire State Building, he now domesticated the tower, depicting it sprawling languidly in a bed as its shorter neighbors hover along the ceiling (plate 26). The chaos, lights, and signage of Times Square splash over the surfaces of a standard-issue hotel room as if trying to extend the reach of advertising and entertainment into every corner (plate 28).[24] In later years, Morell traveled to well-known American sites and European cities for the specific purpose of making camera obscura pictures, often transforming an iconic, even over-represented attraction into an image new and unfamiliar. For example, the pointed peaks of London's Tower Bridge insistently jab the pillow in a hotel room, and St. Louis's famous Arch hangs in

a loop from a ceiling (plates 29 and 30). Fascinated by the experimental and messy history of early photography, he made a pilgrimage to Lacock Abbey, the country house of William Henry Fox Talbot, one of photography's inventors, and produced a camera obscura homage depicting the site of Talbot's early experiments (plate 33). For Morell, the polymath Talbot—whose innovations in photography were born from frustration with both the camera obscura and camera lucida as drawing aids—was an ideal model: "I want my photographs to reflect a time when science, art, philosophy and religion were closer brothers and sisters, as they were during Fox Talbot's time."[25]

Photography also brought Morell back to Cuba. Invited by Terry McCoy to participate in a book of photographs of Cuba, in 2002 he returned for the first time in forty years, obtaining his American citizenship in order to travel there safely. He made several camera obscura photographs in Havana and reflected in the publication, "This way of making pictures allowed me to contemplate new realities under the half-light of things remembered, so to speak. . . . A long time ago I left Cuba as a boy in circumstances that felt like a strange dream. It's interesting to me that in my ongoing artistic work I struggle with picturing the real within the aura of imaginary and seemingly irrational worlds."[26] He projected La Giraldilla, the sculpture of a female figure atop Havana's old fortress that has become the symbol of the city, against crumbling walls and the remnants of a tiled shower, revealing the literal and metaphorical decay of his homeland under Castro (plate 31). In another camera obscura image, a glamorous head shot from an earlier era—of the apartment's owner, now a middle-aged woman—anchors a room filled with humble furniture and domestic trinkets, while the downtown Havana neighborhood of El Vedado presses in from all sides (plate 32). It seems most fitting that in these Cuba photographs the world is turned upside down, the outside invades the inside so dramatically, and the present collides with the past.[27]

Throughout the camera obscura series, Morell found new truths in the dialogue between the domestic interior and the world

outside. It is as if the rooms themselves enjoy a secret life, whispering conversations with the view they face every day, forming relationships laced with longing, pathos, and humor.[28] Although the pictures are emptied of people (both inside and out), a lingering human presence is invariably discernible in crumpled sheets and pillows, the personal effects on a nightstand, or a piece of furniture that breaks the plane on which the outside image is projected. As an eight-hour exposure compressed onto a single piece of film, the picture is part record, part invention. The combination of presence and absence, the normal and the strange, lends the photographs an air of the uncanny—what Freud defined as the simultaneously familiar and foreign. This disorienting effect, which is both uncomfortable and pleasurable, appeals to the artist, who likes the thought that an empty room may not be truly empty, that the world enters and infuses even the most isolated spaces. The scene so commonly viewed every day out the window is now jarringly upside down, and objects, though familiar, are not where they are supposed to be: as if in a movie dream sequence, trees take a shower in the bathroom, mountains crowd a corner,

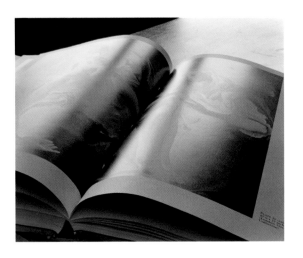

Fig. 5. *Pietà by El Greco*, 1993

and an ocean fills an attic (plate 34). Perhaps it is no accident that beds feature so prominently and so often as screens for the projections.[29] As Luc Sante writes, in the introduction to Morell's book on the series, "It is a bit as if he had taken his camera into the dream state and emerged with proof of what he saw there."[30]

These rooms lend themselves easily to metaphor. The darkened interiors, with a pinhole functioning like a single Cyclopean eye, evoke the inner life of the mind, always absorbing and transforming the sensory input of the outside world. "The eye takes in everything of the world," Sante continues, "but subjectivity ensures that the world arrives in the mind changed by the experience of being seen."[31] Morell's rooms are never empty, blank, or flat; their architectural forms and furnishings alter, frame, and distort the view beyond the windows. The optics by which the camera obscura works are the same as those of the human eye, but they are, of course, also the operating principle of photography. Although the adage that the camera does not lie has been disproven time and time again, the laying bare of this basic principle in such a de-skilled fashion—employing just black plastic and a small hole—seems to lend the pictures a truthful inevitability. And yet Morell not only makes a number of choices, selecting the room, the view, and the position of the pinhole, but he also often intervenes in the scene, rearranging furniture or moving smaller objects. These seemingly pure photographs are, in fact, highly constructed. They thus explicitly mediate—as all photographs do, if perhaps less obviously—the objective and the subjective, the natural and the cultural. And they perform this stage play using photography's most basic and primal means, inspiring in the viewer a remarkable return to a kind of visual innocence despite our media-saturated, technologically sophisticated culture.

If the camera obscura revealed ephemeral glimpses of the world contained in a room, then books can be seen to concretize that experience, holding within their collective cover the sum of all our knowledge. Indeed, shortly after Morell began the camera obscura series, he also started exploring books, hoping to depict them simultaneously as conveyors of information and as tangible objects appealing to all the senses. The book series was sparked, as

was the pencil photograph, by his visual openness and propensity to notice what others overlook. One day in 1993, as Morell was leafing through a book of El Greco paintings, the light from a nearby window happened to reflect off the inky expanses of one of the reproductions, creating an intriguingly odd negative effect (fig. 5, plate 44). He began taking books home from the library and photographing them on his table, and in 1995 accepted a position as artist in residence at the Boston Athenæum. "One of the big pleasures of this project has come from spending a good amount of time looking at, holding, smelling, and reading a terrific number of skinny, fat, tall, pompous, modest, funny, sad, proud, injured, and radiant books," he later wrote in the publication that compiled this series.[32] In his pictures, two stacks of bound newspapers form a human spine in the negative space between them (plate 39); four books with gilded pages appear as so many gold bars piled on top of one another (plate 35); the section thumbholes of three dictionaries catch the light and take on architectural proportions (plate 37). By recognizing that books are first and foremost objects whose physical features affect how they convey their contents, Morell transformed these humble, familiar things into new worlds whose possibilities continue to occupy him (see plates 106 and 107).

As Diana Gaston has observed, Morell possessed a material conception of language even before he began photographing books. He depicted early language acquisition in Brady's magnetic letters on the refrigerator (plate 3) and constructed a new alphabet using the surface tension of water (plate 19).[33] In books, he grasped that words were things as much as symbols; in his picture of the Book of Proverbs for the blind, the raised letters cast shadows in raking light (plate 36). On the opening page of *A Tale of Two Cities*, the paper, translucent in the light, allows words from either side to blend and confuse meaning (plate 40). Phrases running forward and backward—"Light" and "dirty procession," "epoch of belief" and "because he had not kneeled"—contradict and visually oppose each other as if to literalize Charles Dickens's first sentence: "It was the best of times, it was the worst of times, it was the age of wisdom, it was the age of foolishness, it was the epoch of belief, it was the epoch of incredulity, it was the season of Light, it was the season of Darkness. . . ." Morell approaches books, whether valuable rare volumes or inexpensive, mass-produced titles, with a mixture of reverence and his trademark sly humor. He seems to enjoy an inner laugh at the proposition that all of mankind's ideas could be summed up in a single volume called *Thought*, and he takes pleasure in spinning a book of stars during a lengthy exposure to create a revolving universe (plates 41 and 49). In a visual mash-up, two astronomy books opened up against each other form a new image of a Renaissance scientist peering at the cosmos through his telescope (plate 50).

Since paintings, prints, and sculpture were first photographically reproduced in the nineteenth century, the history of art has been mediated through these representations. Morell calls our attention to this translation by showing how art books in particular alter the perception of works of art. Glimpsed through Morell's camera, Goya's *Naked Maja* peers at her own inky reflection in the opposing page, and a new landscape of rolling hills is formed by the undulating pages of a book of landscape paintings, as the actual sun creates new clouds with dappled shadows (plates 46 and 45). As Nicholson Baker points out, when we read, we imagine the page as neutrally flat, an ideal conveyor of code, but of course it has thickness and weight, bending like a wave toward the binding.[34] At the basic material level, a reproduction in a book is splotches of ink on a piece of paper, at a dramatically different size than the original, with reflections, distortions, gutters, creases, and variations in texture: pictures are therefore also things. Yet a page is primarily meant to be a vehicle of meaning, so we normally overlook such distractions, just as we often ignore the constructedness of photographs to focus simply on what is being depicted; Morell's accomplishment is revealing, in both books and photographs, the material underpinnings of what we see.

This fascination with how images work is also at play in Morell's illustrations for a new edition of *Alice's Adventures in*

Wonderland. Lewis Carroll's story is filled with puns and linguistic confusion, dreams, changes in size, and bizarre transformations; throughout, commonplace things become strange in wonderful ways. At the beginning of her adventures, Alice famously muses to herself, "What is the use of a book without pictures or conversations?" and for Morell, the pictures themselves formed the conversation. Morell decided to merge the real and the imagined by cutting out copies of the original John Tenniel drawings and photographing the two-dimensional figures as if alive and at play in an architecture or landscape of three-dimensional books. In one such image, Alice, now oversized, crouches cramped against the "roof" of the structure formed by two books, her hand reaching out from between the pages to grasp at the cutout of the White Rabbit (plate 53). In another picture, the White Rabbit peers at light beckoning from a hole Morell has drilled sacrilegiously through an old tome, literalizing the seductive power of a good story (plate 51). Rather than merely calling our attention to the artificiality of reproductions (as in his book photographs), here he intervened to blur the boundaries of represented and real objects. The notion of a "wonderland" is itself a fitting description for Morell's approach, as he marvels in the new world created by looking at the old one askance, making invented landscapes of the everyday wonderful with his camera.

From his examination of books, Morell moved on to investigate different kinds of symbolic paper: maps and money. Like photographs, maps employ agreed-upon conventions to represent space and information in regularized and organized ways.[35] Morell reunited maps with the objects they represent, for example imagining a massive freshwater lake smack in the middle of the United States, as both coasts rise up to form the edges of a continent-wide valley (plate 54). "It's important to me to have what I photograph undergo a certain transformation—to become a thing different from what we are used to, to be another version of itself," Morell has said.[36] He later began to look closely at currency in an attempt to separate its physical manifestations from its emotional connotations. If in Morell's photographs maps begin to more literally resemble the landscapes they signified, his photographs of money have precisely the opposite effect. His deadpan picture of seven million dollars, for example, looks as much like stacks of worthless paper destined for recycling as it does wealth beyond most people's imagining (plate 57). Money is ephemeral, useful only in exchange, and oddly empty when at rest. Whereas paper money once stood for a certain amount of gold, it has long been an act of faith, a promise to pay; indeed, personal credit cards and the new financial tools of the global economy have rendered money increasingly abstract. Moreover, most of the time we tend to understand money in terms of what it can buy, or through the lens of not having enough. Morell calls our attention instead to the tangible and aesthetic qualities of these transactional objects. Masterpieces of modern printing and compact design, paper bills are advertisements, populated by portraits of historic figures and heads of state, renderings of national monuments, and arcane symbols of country. Morell began intervening more explicitly in his photographs of maps and money, manipulating objects to reveal something telling or often absurd in the conventions we accept—an allusion to his experiences in Cuba, in which the money changed form overnight and the old currency was instantly worthless. In a puzzle of representation, his photograph of sixty dollars—eight bills folded in such a way as to produce an imagined skyscraper of classical columns—demonstrates imperialistic hubris, as a tall but wobbly tower lays claim to an oversized ancient heritage (plate 56).

In 1998 Morell was invited to be an artist in residence at Boston's Isabella Stewart Gardner Museum, the venerable collection of Old Master paintings, sculptures, and tapestries set in a mansion designed to resemble a fifteenth-century Venetian palace. He became deeply attuned to the exhibition spaces in which the works of art were shown, as well as the artworks' relationship with the people responsible for their care. Morell found, as he later wrote, "a dynamic collection made up of sculptures, guards, gardeners, sunlight, conservators, maintenance people, rooms, and paintings

that, from a certain angle, may be seen talking to one another."[37] He imagined these new dialogues visually, combining, for example, two different paintings with similar arches to create a new shared architectural space, or juxtaposing a Rembrandt self-portrait with a maintenance worker who looks eerily similar to the seventeenth-century painter (plates 72 and 74).[38] Museums had started to become a natural home for Morell, whose work was entering more institutional collections and being featured in exhibitions, including a mid-career retrospective mounted in 1998 that traveled widely. He was not alone in taking a self-reflexive approach to the spaces of exhibition; other artists then photographing in museums included Sophie Calle, Hiroshi Sugimoto, and, perhaps most notably, Thomas Struth. Struth's painting-sized photographs portray museumgoers in the act of looking, hinting at the subjective experience of the viewer of the photograph as he documents the visitors interacting with works of art. Morell, by contrast, takes a more intimate view, and includes no such audience surrogates; he invents rather than records a space of artistic reception.

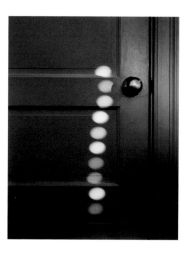

Fig. 6. *Ten Sunspots on My Door*, 2004

Shortly after making these museum pictures, Morell again looked to the material properties of photography as productive subject matter. In an earlier photograph he had demonstrated that the shadows cast by tree leaves during a solar eclipse are really miniature pictures of the crescented sun—the result of the hundreds of pinhole apertures formed by the small spaces between the leaves of a tree (plate 58). Now, in the first years of the new millennium, he returned to these light effects, showing dappled sunspots on a table (the same camera obscura process occurring in nature; plate 59), or ten separate exposures of the sun forming a dotted line across his door (fig. 6, plate 61). In a departure from his previous photographs of domestic objects, Morell began intervening more into the scene, constructing tableaux specifically to be photographed. He made pseudo-scientific arrangements, engaging photography's history as both a subject and a (presumably disinterested) interpreter of scientific experiments. In one such composition, light glints off the various shapes of a stunning—and entirely nonfunctional—sculpture of laboratory glassware (plate 64). Drawing inspiration from the nineteenth-century motion studies of Eadweard Muybridge and Etienne-Jules Marey, Morell simulated photographic stop-motion in a series of sculptures made for the camera. His picture of pounded lead forming the shape of a hammer hitting a nail in three "moments" is not intended to fool the viewer into thinking it is a scientific document (plate 66). Rather, it plays artfully on the conventions of early stop-motion imagery, rendering each successive impression of the hammer slightly less crisp as if to simulate shorter exposure time or blur. Moreover, he seems to equate the imprint in lead with the action of light on photographic film, alluding to theories of photography that posit an "indexical," or physical, connection between photographic images and reality.[39] Photography, Morell suggests in these pictures, makes even the most blatant falsehoods seem plausible. During this period, and again in 2012, he also returned to a process practiced by Talbot in his earliest years of photography: photograms, or pictures made without a camera (see plates 67–70). In his darkroom, Morell splashed and puddled water on top of sheets of 20 × 24 inch film and exposed them to light, or cast shadows of constructed still lifes

directly onto the film. The resulting images are filled with transparency and distortion, yet conjure up matter and volume in a seemingly real space. In this most elemental, unmediated form of photography—in which objects effectively draw themselves with light on film—Morell nevertheless employs photographic tools to invent rather than record.

In 2005, Morell transformed his work yet again: after decades of photographing exclusively in the classical black and white that had come to define his output, he began to incorporate color. While making a camera obscura photograph at the Philadelphia Museum of Art, on a whim he loaded one of his cameras with a sheet of 8 × 10 inch color film. He had moved a De Chirico painting into a gallery that faced the Greek columns of the museum's east entrance, and was delighted to find their golden hues and the blue of the sky echoing the colors as well as the forms of the painting (fig. 7, plate 78). Morell's move to color prompted technical refinements that made his pictures less raw and immediate, and more intentional: instead of just a pinhole, he inserted a diopter lens that minimized the length of exposure and increased the sharpness of focus, and instead of allowing the projected image to remain upside down, he began employing a prism to correct its orientation. A few years later, he also switched from film to digital, further shortening the time required to make the picture. Whereas before he could only show the cumulative effect of an eight-hour exposure, with its softened shadows and blurred motion, Morell was now able to portray a particular time of day or feeling of light; in a series of the Manhattan Bridge, he depicted morning, afternoon, and evening on the same day (plates 89–91).

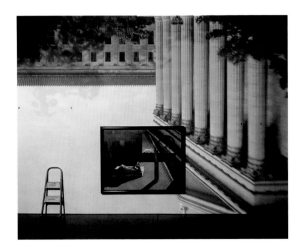

Fig. 7. *Camera Obscura: The Philadelphia Museum of Art East Entrance in Gallery #171 with a De Chirico Painting*, 2005

"Color feels more like Impressionism," he explained.[40] Indeed, the pictures he made in 2006–07 in Venice—a city painters have flocked to for centuries to observe its color and light—are particularly attentive to the effects of the morning sun. In these images, he also began to more overtly reference a prephotographic history of image-making, with a seventeenth-century engraving of Santa Maria della Salute engulfed by the upside-down camera projection of the cathedral, or framed prints of the columns surrounding the Piazzetta San Marco echoing the superimposed arches (plates 79 and 80). Linking painting, print-making, and photography through the camera obscura, of course, makes sense historically: the camera obscura was employed as an aid for painters and draftsmen from the sixteenth century on, and its design incorporated the rules of one-point perspective established by Renaissance painters, thereby shaping what would come to be the norms of photography.[41]

Morell also wanted to bring the camera obscura to the outdoors. Indeed, the portable camera obscura had been used for drawing outside long before the advent of photography. Following the model of nineteenth-century photographers of the American West such as Carleton Watkins and William Henry Jackson (who traveled with mammoth wet-plate cameras and portable darkroom tents to record largely uncharted territory), he set out to photograph America's open vistas, the clichéd American West he had seen in movies as a child in Cuba. Morell had been grappling with how to portray the grand emptiness of the West, a space with no architecture or furniture to lend it a human scale and none of the urban markers among which he had always lived. At first he literally framed the landscape like

an oil painting within the boundaries of a gilded frame (see fig. 18 in the chronology) and shined a circle of light onto the rocks and brush at night to delineate new pictures (see plate 92). In 2010, in Big Bend National Park in Texas, he began experimenting with a portable tent camera with a periscope lens on its top that projected the outside landscape onto the ground below (fig. 21 in the chronology). As with his original camera obscura photographs, Morell employed a camera inside the structure to photograph the image that landed on the ground. He found it appealing that what was overlooked because it was underfoot—something so common and shared—formed the backdrop of these photographs. Energized by the possibilities the tent camera presented, he began to bring it with him to such places as New York, San Francisco, Maine, and Italy, to investigate national parks and sandy beaches, city rooftops and urban sidewalks. He has continued to explore new sites to make these pictures.

The tent camera images function much like the classic optical illusion in which the viewer oscillates between seeing, for example, a duck and a rabbit in the same drawing. The three-dimensional landscape and the two-dimensional surface vie for primacy, with the viewer's attention being drawn alternately to (in one early image) the rocks, dirt, and stray branches of the ground and the larger shapes of the hills and brush of the Chisos Mountains (fig. 8, plate 93). The differences in scale are especially disorienting because the small objects that make up the surface texture appear at the same size as bushes or distant rock formations. Like a chemical suspension in which the elements combine, but not fully, the tent camera pictures seem to operate simultaneously in two

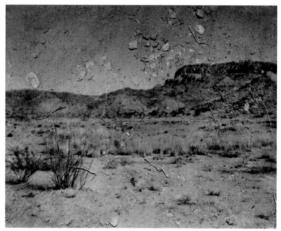

Fig. 8. *Tent Camera Image on Ground: View Looking Southeast toward the Chisos Mountains, Big Bend National Park, Texas,* 2010

separate modes of representation, offering at once an image of receding planes and of insistent flatness. Morell feels he is becoming more painterly with these pictures, echoing pointillism in the rooftop's tar and gravel that compose the ground for a view of downtown Manhattan, and mimicking impasto flourishes in the cakey cracked earth near the Rio Grande (plates 95 and 103). He makes this connection explicit in a view from Winslow Homer's Prouts Neck, Maine, backyard looking out at the sea that evokes the painter's calmer watercolors (plate 105). Through the tangled mesh of sandy grass, clouds can be seen floating above the serene horizon, giving the sense of a moment caught in a painterly sketch. But Morell also tips his hat to photographic history, following Carleton Watkins into Yosemite and locating many of the same views that the nineteenth-century photographer so memorably captured in mammoth-plate albumen prints (see plates 96–98). In Morell's interpretation, however, the landscape is no longer fresh and pristine, but viewed through bike tracks in dirt and sidewalk geometry, evidence of the human presence at the site.

Several other contemporary artists have attempted to reinvigorate the medium by revisiting artisanal techniques and practices from the nineteenth century, partly aiming, like Morell, to return photography to some elemental state, and partly in a backlash against digital anonymity.[42] Morell, however, is less interested in re-creating the past than in isolating what about photography can still be thrilling in today's terms. As with many of his other series, the tent camera pictures refer back to photographs, which, until the most recent years in the medium's history, have existed primarily as images on pieces of paper. They

serve as potent reminders that when we look at a photograph, we are looking at a flat picture plane that provides an illusion of three dimensions; even more than the books, maps, and money that Morell had documented earlier, photographs—it could be argued—are the most symbolic of papers, conjuring up believable worlds that shape our experiences on all levels.

Over the past several decades, Morell has watched developments in contemporary photography with interest and has at times, he says, felt like a defender of photography to those who proclaim its demise.[43] He maintains his belief, even in the present age of digital convenience, that the photograph must be worked for and earned; he continues to delight in conceiving pictures and laboring toward their execution. Returning to an attitude of childlike surprise through the eyes of his son, he has been able to access a moment when photography itself was young and nothing short of miraculous, a "wonderful wonder of wonders!" as a journalist said, describing the first photographs made on America's shores.[44] Morell's work offers one path, among many, for embracing photography's unique qualities without falling into the modernist trap of essentialism or blindly adhering to outdated rules. He is willing to look for beauty and emotion in a time that values cool detachment and irony. His photographs attempt to return to the originary wonder of photography without nostalgia, to convey the excitement of this nineteenth-century invention in a twenty-first-century world inundated with photographic images.

Throughout his wide-ranging body of work, Morell's photographs call attention to the material, physical, and tangible. He renders everyday, overlooked objects unfamiliar by bestowing on them a heightened sense of both their tangible existence and what else they could be. When he turns his focus to images in general—whether paper money folded into an architectural form, maps crumpled into new landscapes, or art reproductions reflected and distorted in books—he reminds us of the very real ways in which the physical manifestations of images in our culture affect how we see. And when he applies those insights toward the material underpinnings of photography, he lays bare the conventions of representation that most often appear transparent and natural. Morell shows, by embracing elemental mechanisms such as the camera obscura, tent camera, and photogram, that photographic images—the kinds of images that possess a seemingly privileged relationship with reality—are actually highly constructed. And yet, this understanding of the nature of representation has not prevented him from attempting to make photographs that are themselves compelling. On the contrary, Morell has found that it is still possible to make interesting pictures, and, moreover, he continues to find the project of making pictures interesting. It is for these reasons that we want to accompany Morell and his camera when he grabs our sleeve and says, in the words of E. E. Cummings, "listen;there's a hell / of a good universe next door;let's go."

NOTES

1. Edward MacCurdy, ed. *The Notebooks of Leonardo da Vinci* (Reynal and Hitchcock, 1938), p. 117.
2. The two most helpful critical writings on Morell's place in recent photographic history are Richard B. Woodward's introduction to *Abelardo Morell* (Phaidon, 2005), which locates Morell as operating between modernist and postmodernist practice; and Andy Grundberg's "Innocence and Photographic Experience in the Work of Abelardo Morell," in *Abelardo Morell: Vision Revealed* (The Patricia and Phillip Frost Art Museum, Miami, 2004), which situates Morell in the context of other contemporary artists who are returning to photography's origins.
3. Carlo Ginzburg discusses this kind of defamiliarizing effect in "Making Things Strange: The Prehistory of a Literary Device," in "The New Erudition," special issue, *Representations* 56 (Autumn 1996), pp. 8–28.
4. Morell, address to Bowdoin College, upon receiving an honorary Doctor of Fine Arts degree at Bowdoin's 192nd Commencement, May 24, 1997.
5. My understanding of Morell's biography is shaped by conversations with the artist conducted over the past several years, including a taped interview conducted in May 2012; Paul Martineau's interview in this catalogue; statements Morell has published in books of his work; *Shadow of the House*, a 2007 documentary film on Morell's work by Allie Humenuk;

and interviews I conducted with Kevin Bubriski, Lois Conner, Lisa McElaney, John McKee, Nick Nixon, Tod Papageorge, Irina Rozovsky, Stephen Scheer, Melinda Simon, and Mike Smith in 2012. Readers can access a comprehensive list of articles and interviews from across his career at www.abelardomorell.net.

6. As told to Christine Temin, in "You Can Judge Morell's Books by Their Covers," *Boston Globe*, Dec. 20, 1995, p. 33.

7. Abelardo Morell, interview with the author, May 8, 2012.

8. In most published essays and interviews, his age at the time of leaving Cuba is given as fourteen, but he actually celebrated that birthday in the United States.

9. Morell, interview (note 7).

10. Morell, address to Bowdoin College (note 4).

11. Abelardo Morell, in *A Camera in a Room: Photographs by Abelardo Morell* (Smithsonian Institution Press, 1995), p. 5.

12. Morell, interview (note 7).

13. For an excellent overview of Papageorge's thinking then and now, see his compilation of lectures and essays, *Core Curriculum: Writings on Photography by Tod Papageorge* (Aperture, 2011).

14. Lois Conner, interview with the author, Aug. 1, 2012.

15. Melinda Simon, interview with the author, July 26, 2012.

16. Abelardo Morell, "Artist's Statement," in Diana Gaston, ed., *Abelardo Morell and the Camera Eye* (Museum of Photographic Arts, San Diego, 1998), p. 7.

17. Morell, in *A Camera in a Room*

(note 11), p. 6. Interestingly enough, it was a photograph of Brady that was first included in a museum exhibition, the Museum of Modern Art's *Pleasures and Terrors of Domestic Comfort* in 1991.

18. Charles Simic, "Abelardo Morell's Poetry of Appearances," in *Abelardo Morell, Face to Face: Photographs at the Gardner Museum* (Isabella Stewart Gardner Museum, 1998), p. 16.

19. Minor White, *Mirrors, Messages, Manifestations* (Aperture, 1969), p. 106; see Diana Gaston's discussion of Minor White's influence on Morell in *Abelardo Morell and the Camera Eye* (note 16).

20. Morell, in *A Camera in a Room* (note 11), p. 8.

21. Woodward, "Introduction," in *Abelardo Morell* (note 2), p. 11.

22. Morell, in *A Camera in a Room* (note 11), p. 7.

23. Ibid.

24. Morell was commissioned by photography editor Kathy Ryan to make this image as part of a *New York Times Magazine* feature on Times Square, May 18, 1997.

25. Morell, quoted in Diana Gaston, "Abelardo Morell and the Camera Eye," in Gaston (note 16), p. 11. The camera lucida was an optical device employed by artists as a drawing aid; unlike the camera obscura, it did not project an image but rather used a mirror or prism to superimpose virtually the outside scene on the drawing surface.

26. Abelardo Morell, "Cuba from a Dark Room," in *Cuba on the Verge: An Island in Transition*, ed. Terry McCoy (Bulfinch Press, 2003), p. 85.

27. For an analysis of dislocation in the Cuba photographs, see Beth A. Zinsli, "Havana through the Lens: Memory

and Exile in Abelardo Morell's Camera Obscura Photographs," *Hemisphere* 2 (2009), pp. 68–83. Zinsli sees the camera obscura images "not just as visual representations of Morell's individual dislocation and memory, but also as a metaphor for the exilic condition of modernity more generally" (p. 70).

28. Luc Sante writes eloquently about this idea in his introduction to Abelardo Morell, *Camera Obscura* (Bulfinch Press, 2004).

29. See Bonnie Costello, "Outside In and Upside Down: The Art of Abelardo Morell," *Yale Review* 96, 3 (July 2008), pp. 56–71, for an iconographical analysis not only of beds, but also of clocks, doors, ladders, prints, towers, walls, and windows in the camera obscura photographs.

30. Sante, "Introduction" (note 28), p. 8.

31. Ibid., pp. 8–9.

32. Abelardo Morell, "Afterword," in *A Book of Books* (Bulfinch Press, 2002), p. 103.

33. Diana Gaston, "Abelardo Morell and the Camera Eye," in Gaston (note 16), p. 13.

34. Nicholson Baker, "Preface," in *A Book of Books* (note 32), p. 8.

35. Richard B. Woodward calls them both "a necessary distortion," in "Introduction," in *Abelardo Morell* (note 2), p. 12.

36. Morell, interview with Joshua Meyer, "Abelardo Morell," *Art New England* 20, 2 (Feb./Mar. 1999), p. 21.

37. Abelardo Morell, "Foreword," in *Abelardo Morell, Face to Face* (note 18), p. 7.

38. A decade later, in 2008, Morell returned to New Haven with a residency at the Yale University Art

Gallery and worked in a similar but more literal fashion, actually moving paintings and sculptures to create a new work of art (plates 75 and 77), what he has called "an impossible conversation." Morell, interview with Paul Martineau in this catalogue, p. 158.

39. See, for example, Rosalind Krauss, "Notes on the Index: Part 1" and "Notes on the Index: Part 2," in *The Originality of the Avant-Garde and Other Modernist Myths* (MIT Press, 1993), pp. 196–219.

40. Morell, quoted in Vince Aletti, "Upside Down and Inside Out," Culture Watch, *Departures*, Mar./Apr. 2007, p. 146.

41. Joel Snyder has argued that post-Renaissance painters were not making works in imitation of the camera image, but rather that the machine itself was designed in accordance with the appearance of their painting. See Joel Snyder, "Picturing Vision," *Critical Inquiry* 6, 3 (Spring 1980), p. 512.

42. See Lyle Rexer, *Photography's Antiquarian Avant-Garde: The New Wave in Old Processes* (Harry N. Abrams, 2002); Morell is not listed among the artists. Andy Grundberg links Morell with Ellen Carey, Susan Derges, Adam Fuss, David Goldes, and Mike and Doug Starn, among others, who have sought to rediscover the amazement of photography's early history; Grundberg (note 2).

43. Morell, interview (note 7).

44. "New Discovery in the Fine Arts," *New Yorker*, Apr. 13, 1839.

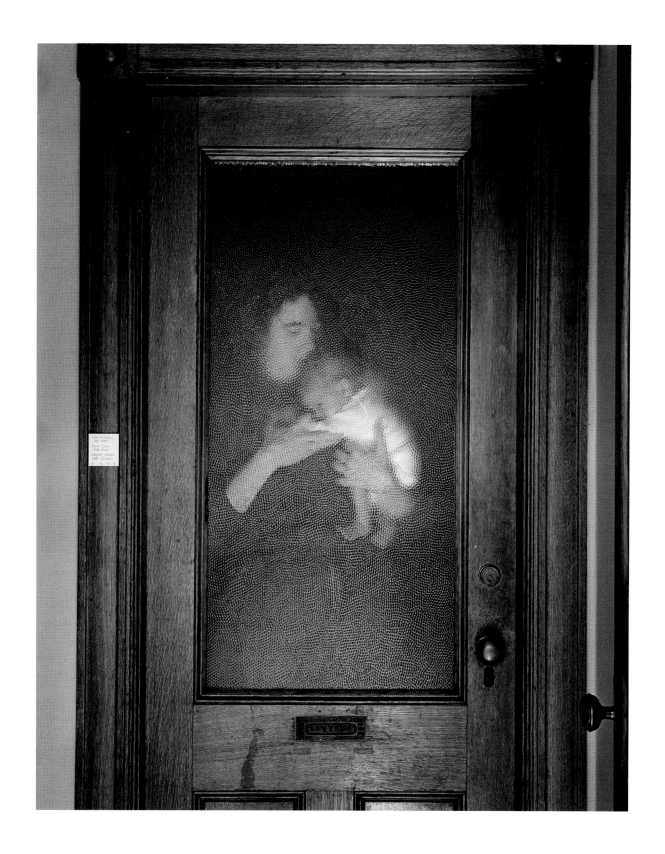

1. *Lisa and Brady behind Glass*, 1986

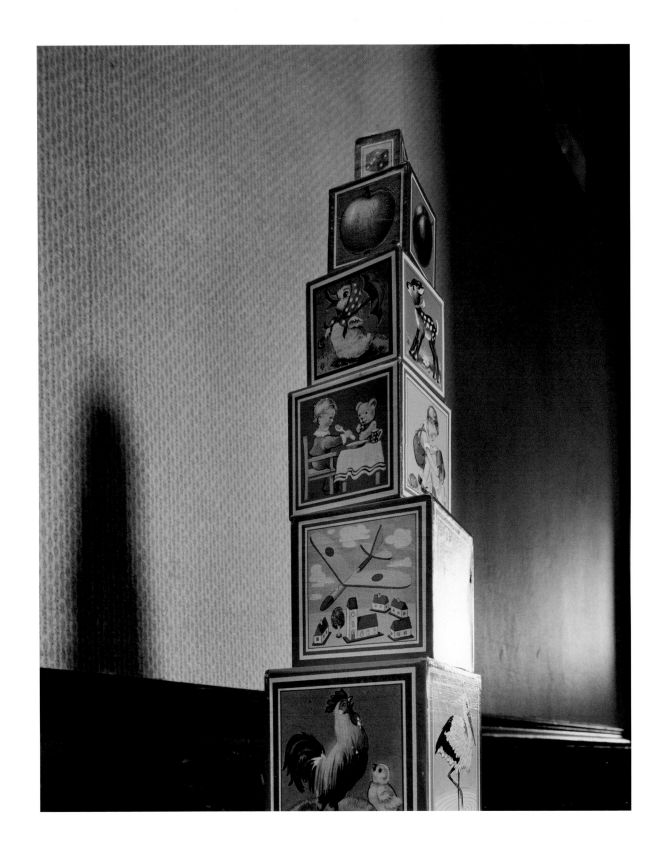

2. *Toy Blocks*, 1987

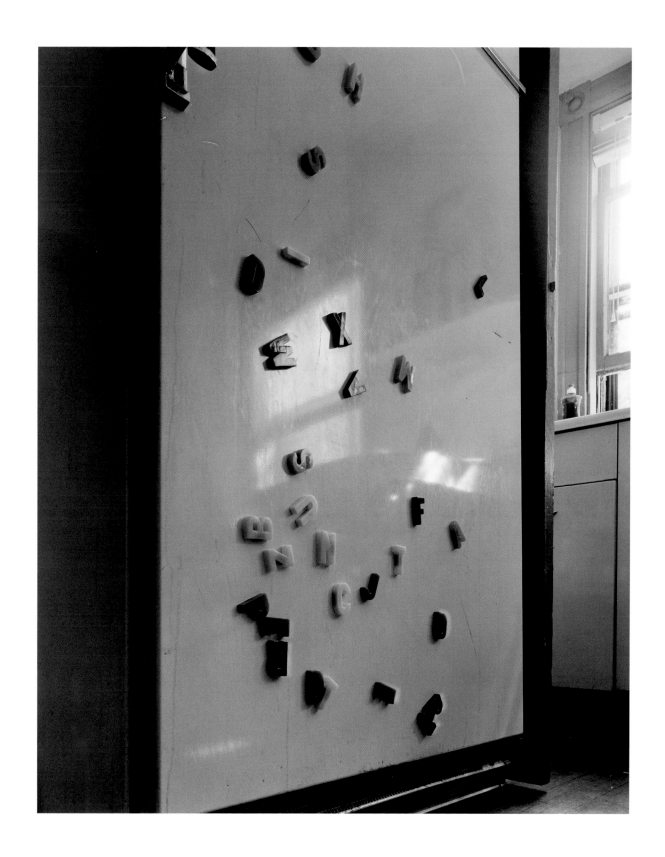

3. *Refrigerator*, 1987

4. *Crayons*, 1987

5. *Ball*, 1987

6. *Slide,* 1988

7. Footprints, 1987

8. Brady Looking at His Shadow, 1991

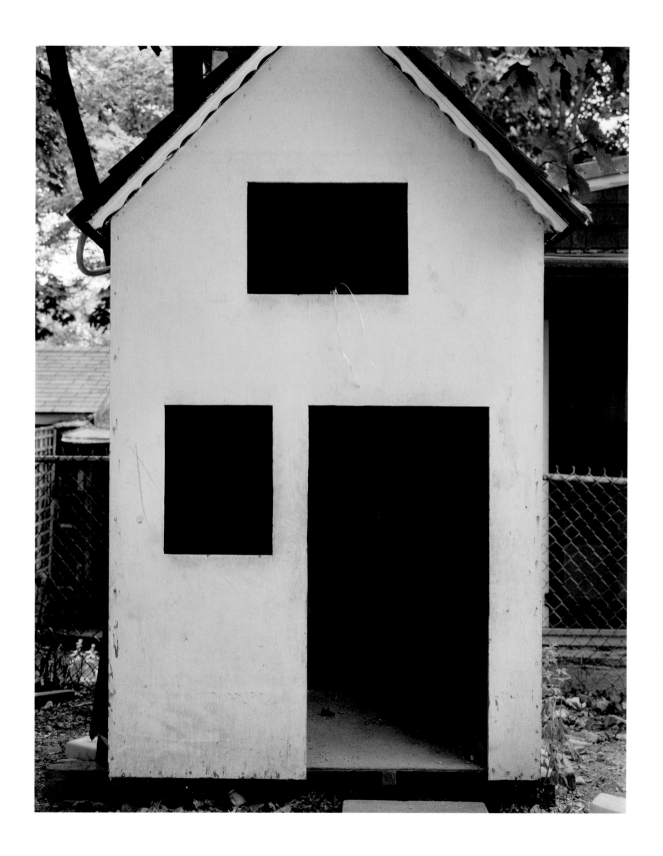

9. Empty Playhouse, 1987

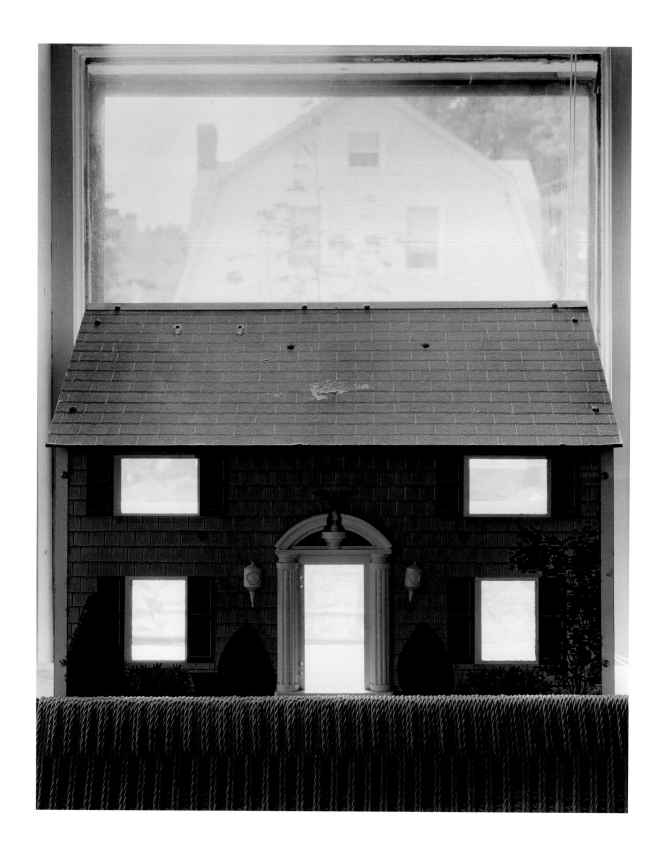

10. *Dollhouse*, 1987

11. *New Year's Eve*, 1989–90

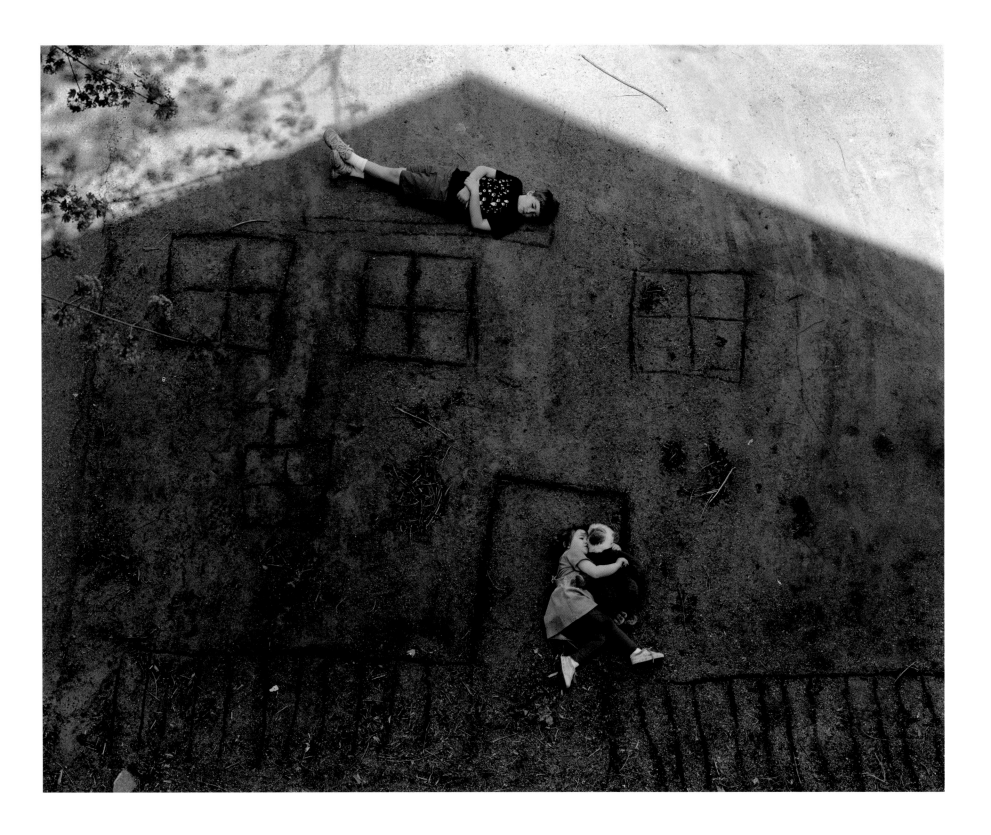

12. *Laura and Brady in the Shadow of Our House*, 1994

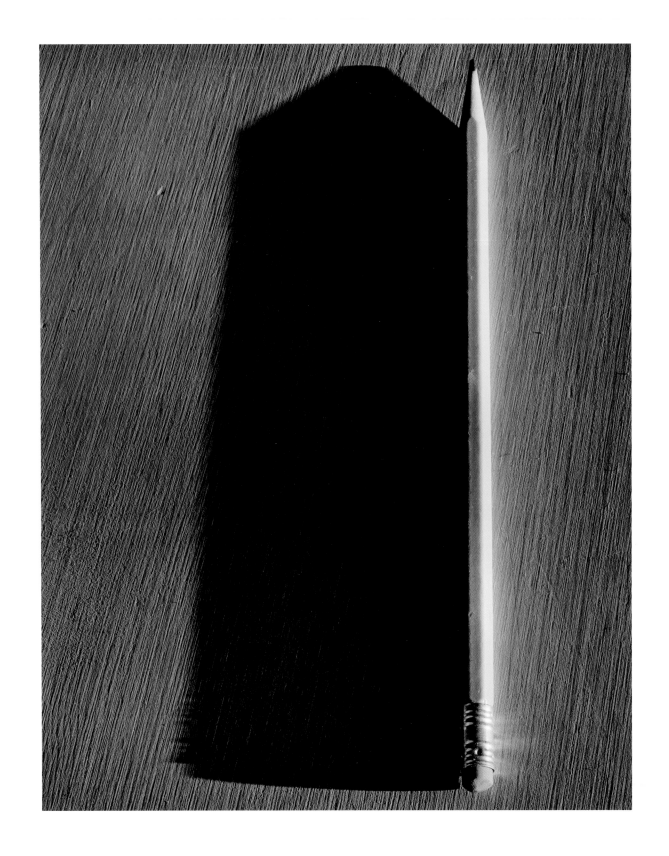

13. *Pencil*, 2000

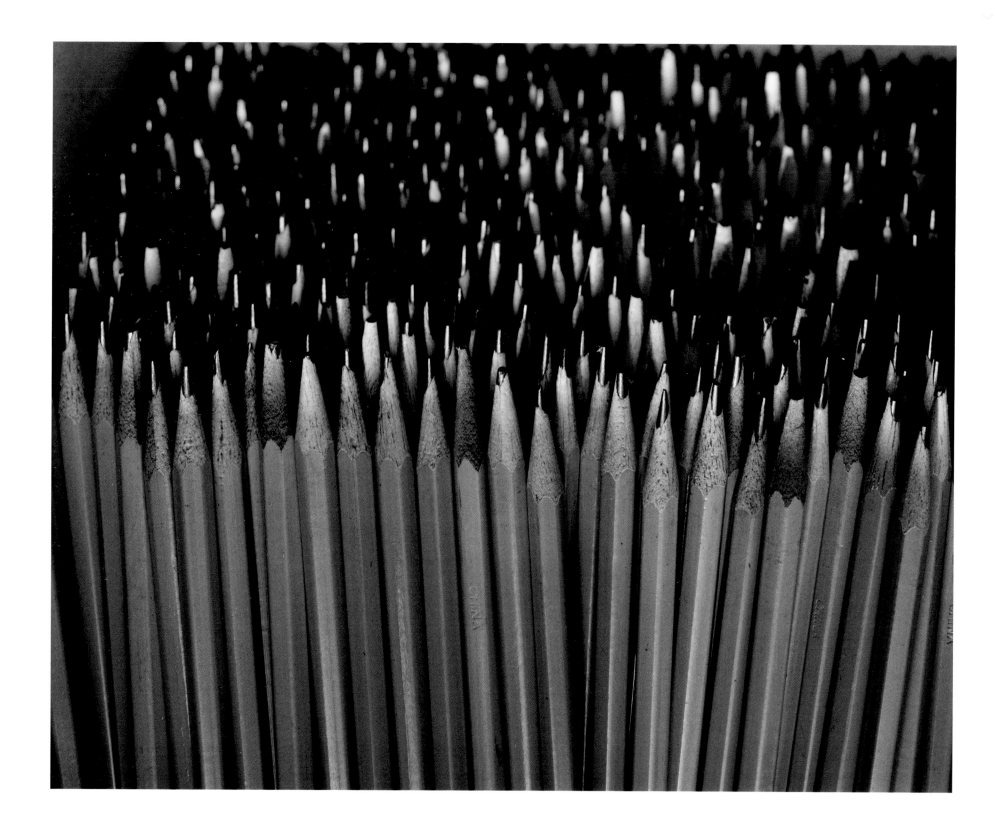

14. *Pencil Demonstration,* 2002

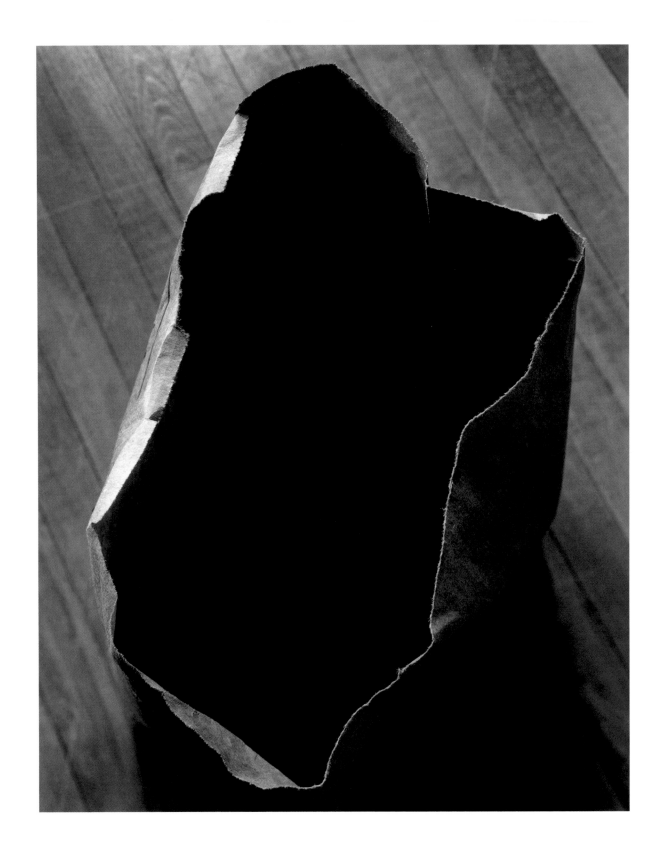

15. *Paper Bag*, 1992

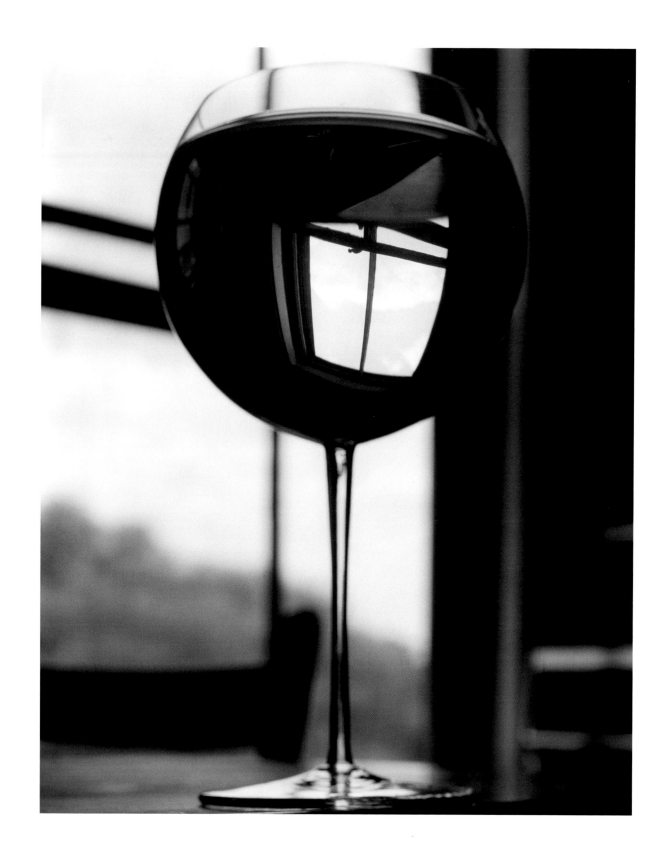

16. *Wine Glass*, 1993

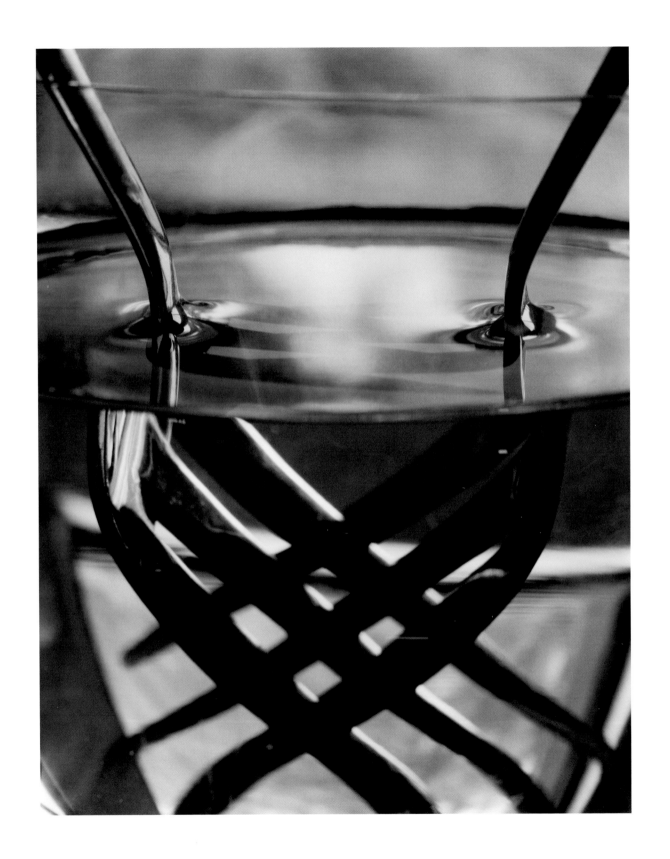

17. *Two Forks under Water*, 1993

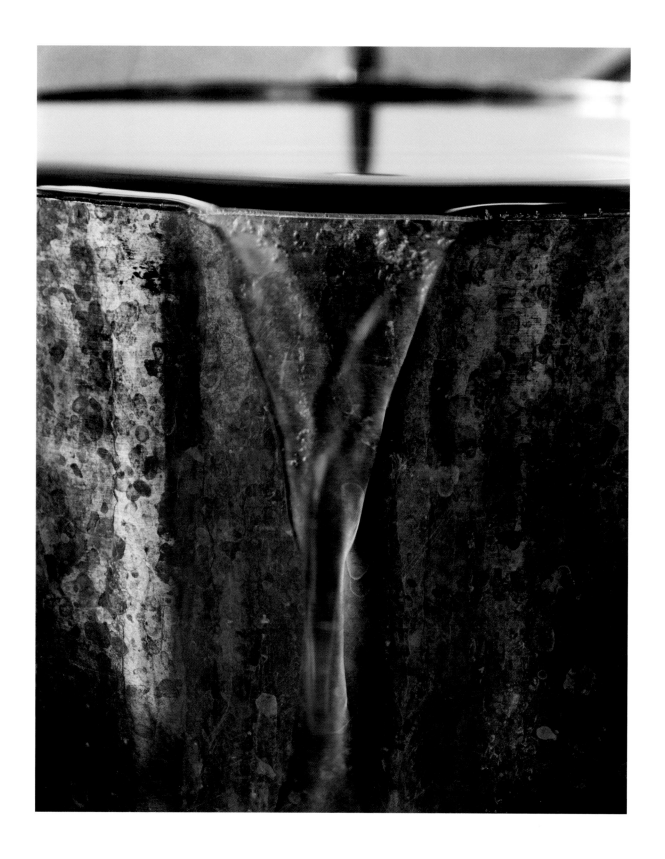

18. *Water Pouring out of a Pot*, 1993

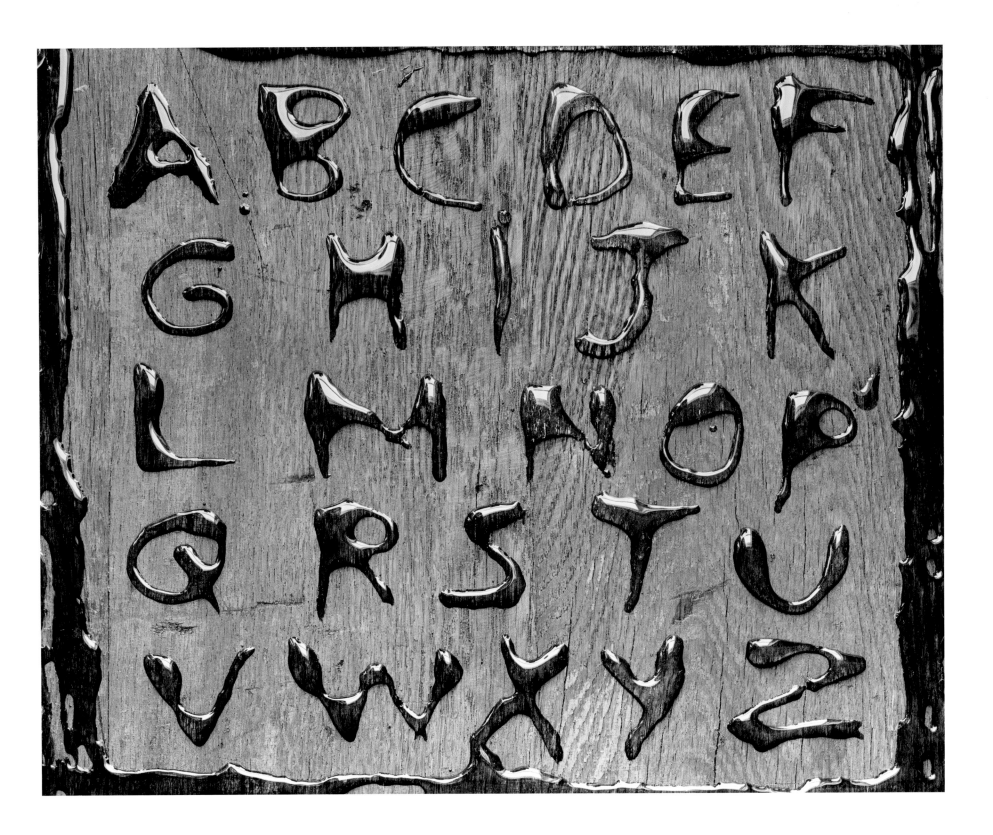

19. *Water Alphabet*, 1998

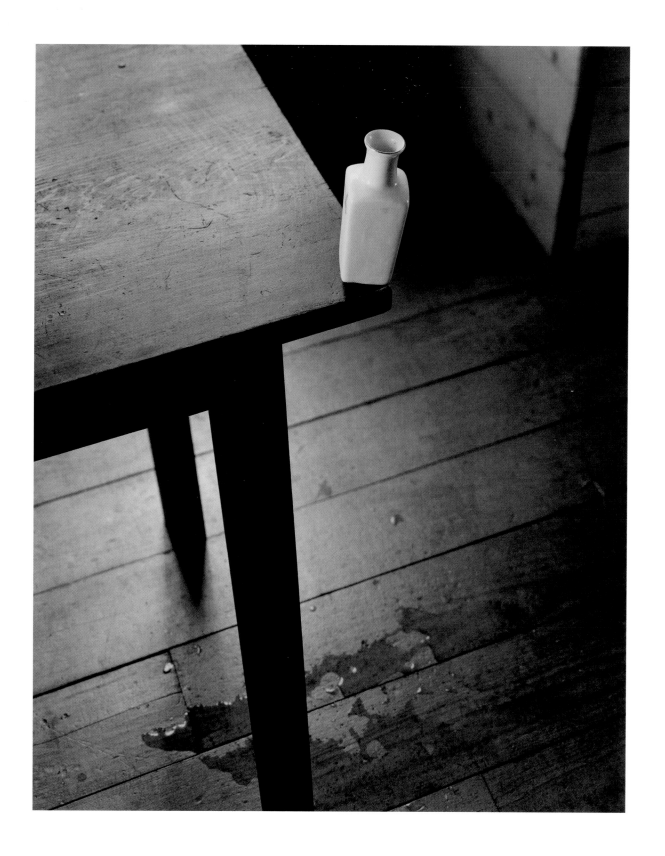

20. *Small Vase at the Edge of a Table*, 2002

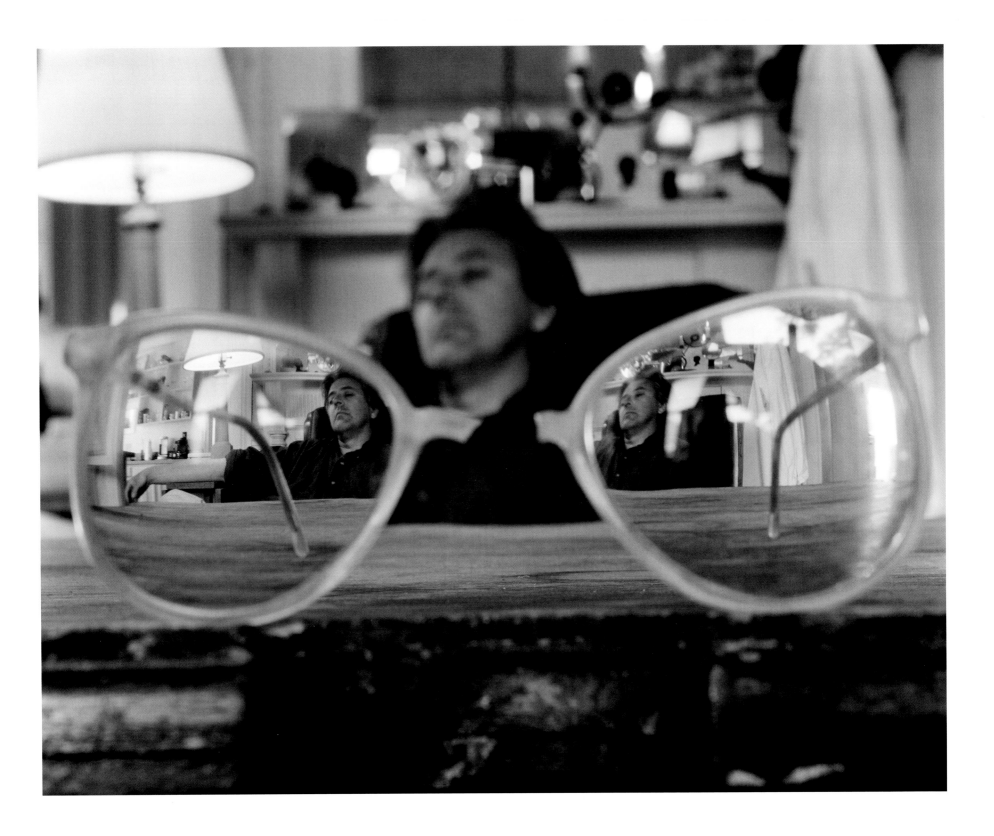

21. *My Broken Glasses and Me*, 1994

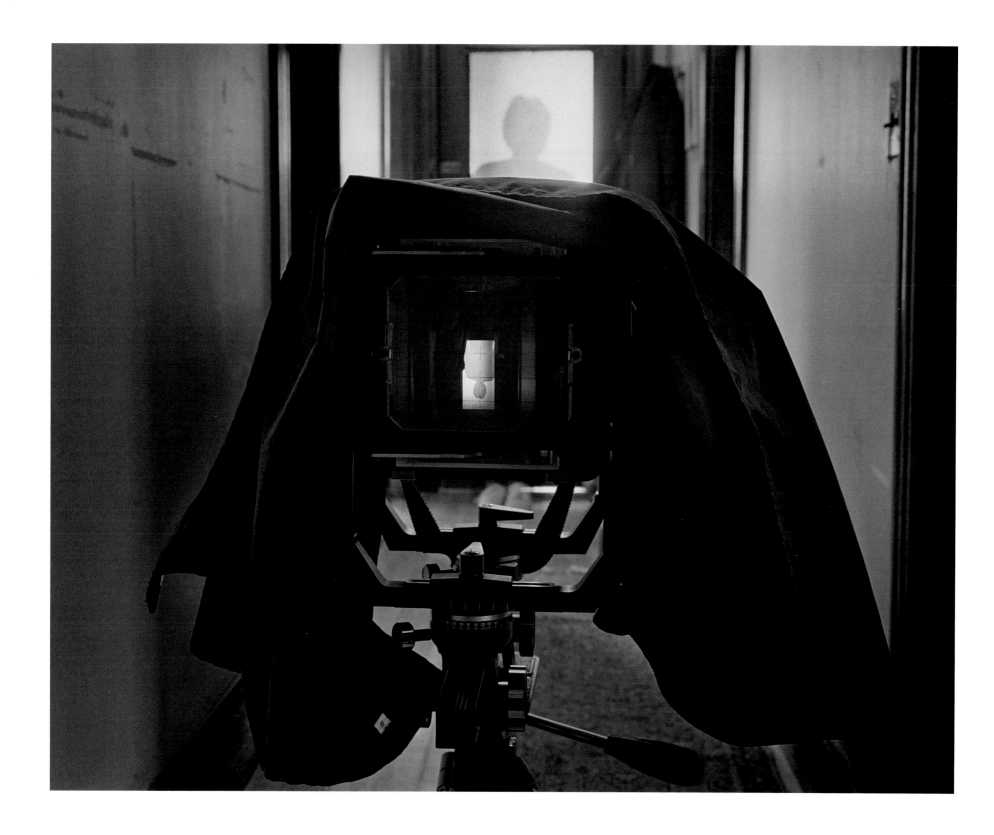

22. *My Camera and Me*, 1990

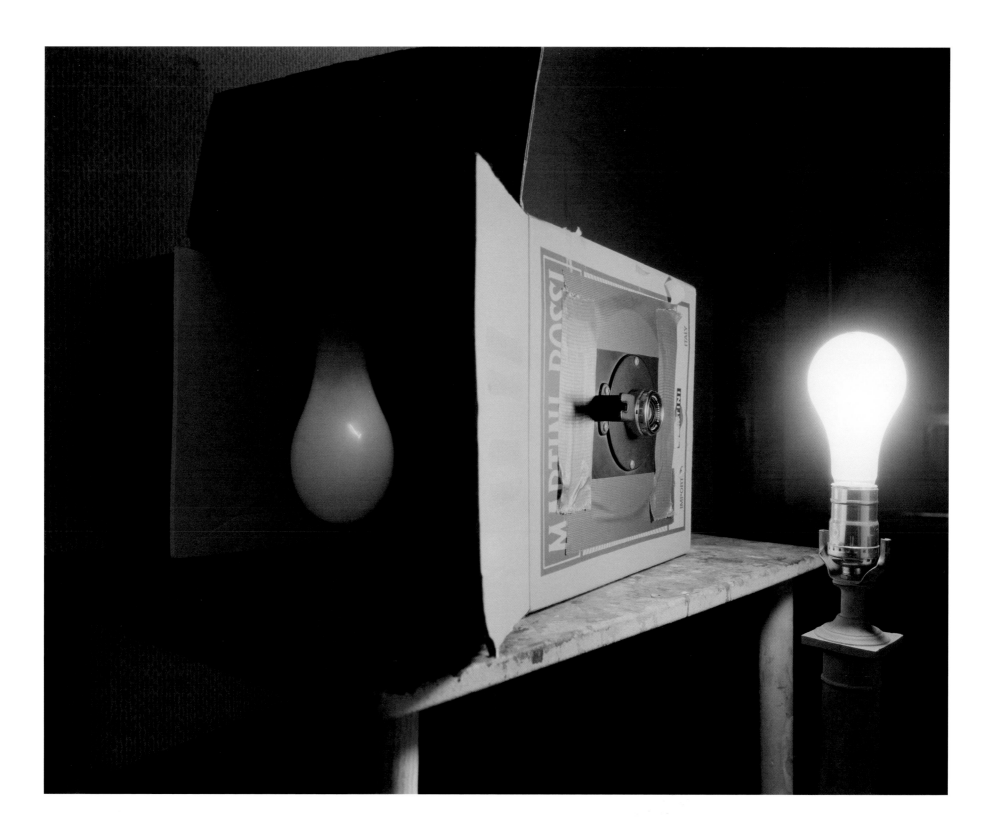

23. Lightbulb, 1991

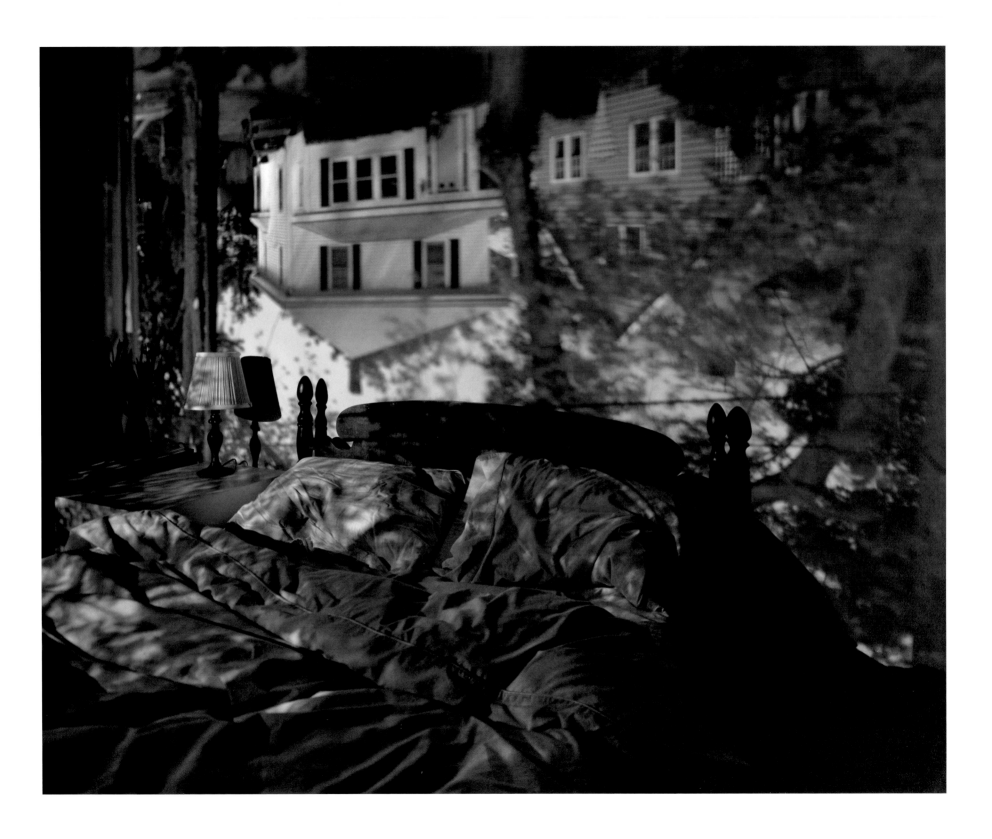

24. Camera Obscura: Houses across the Street in Our Bedroom, Quincy, Massachusetts, 1991

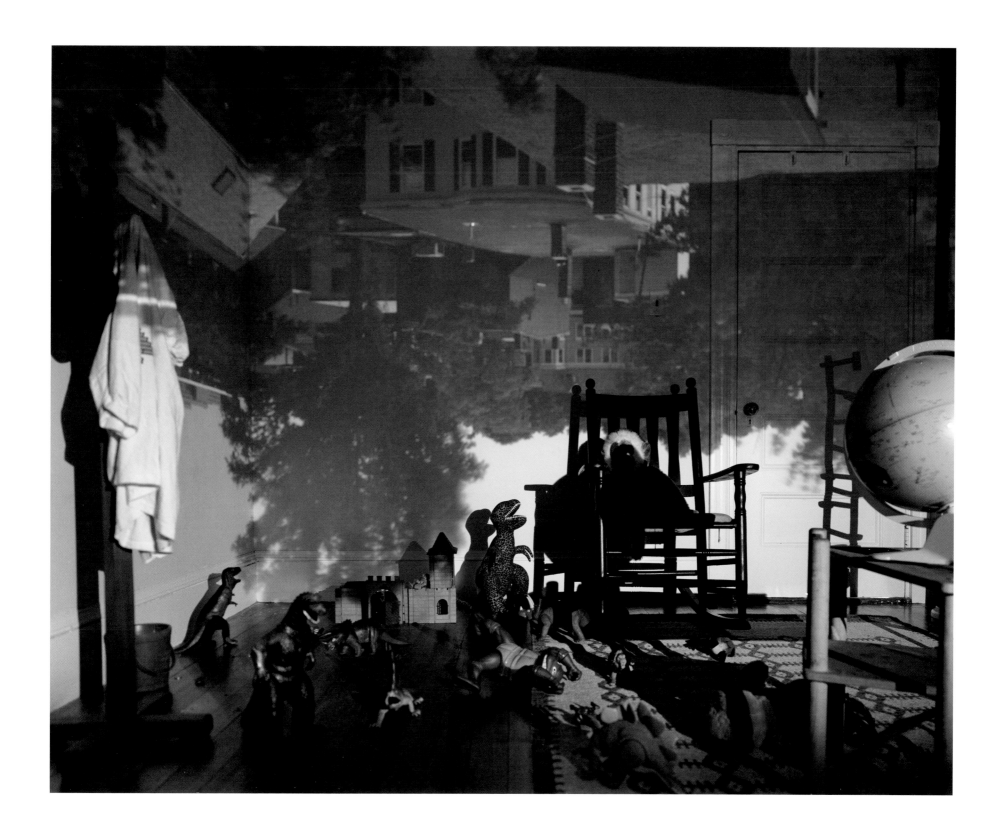

25. *Camera Obscura: Brookline View in Brady's Room,* 1992

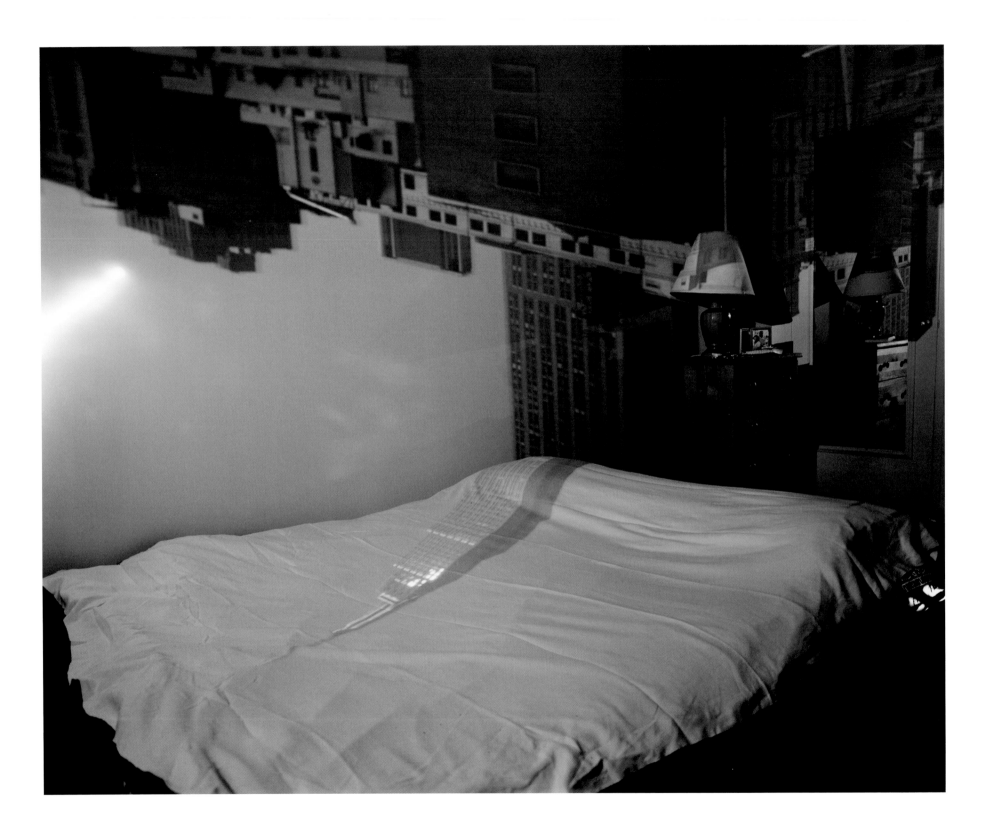

26. *Camera Obscura: The Empire State Building in Bedroom*, 1994

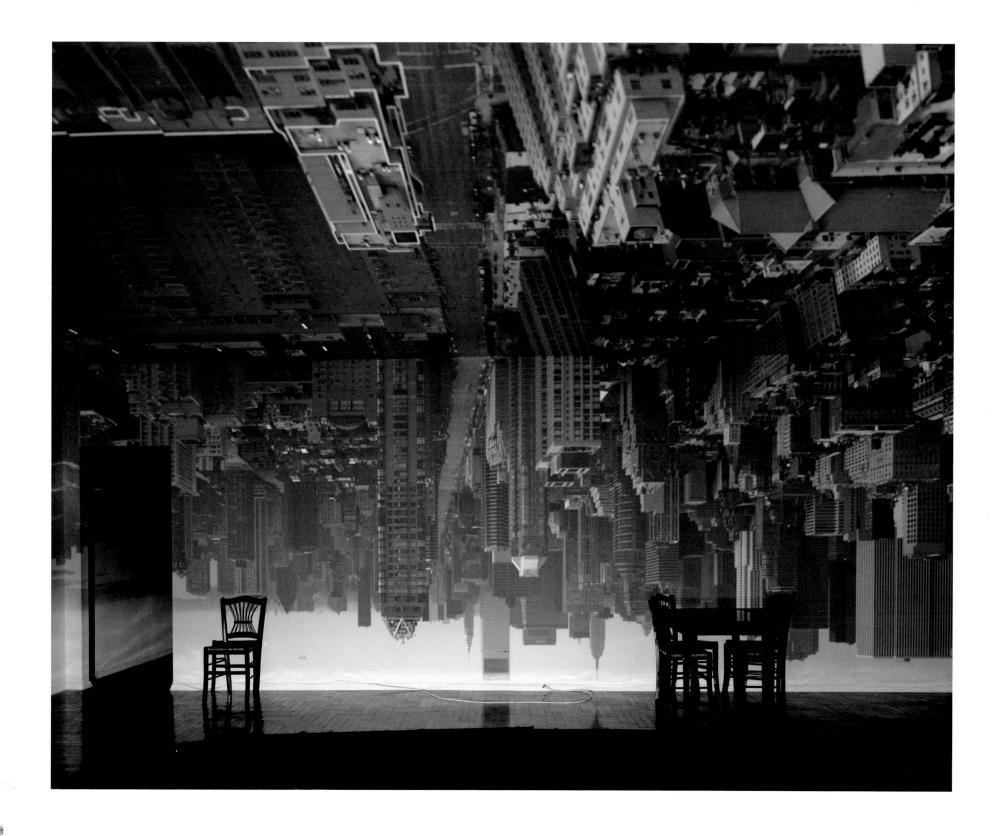

27. Camera Obscura: Manhattan View Looking South in Large Room, 1996

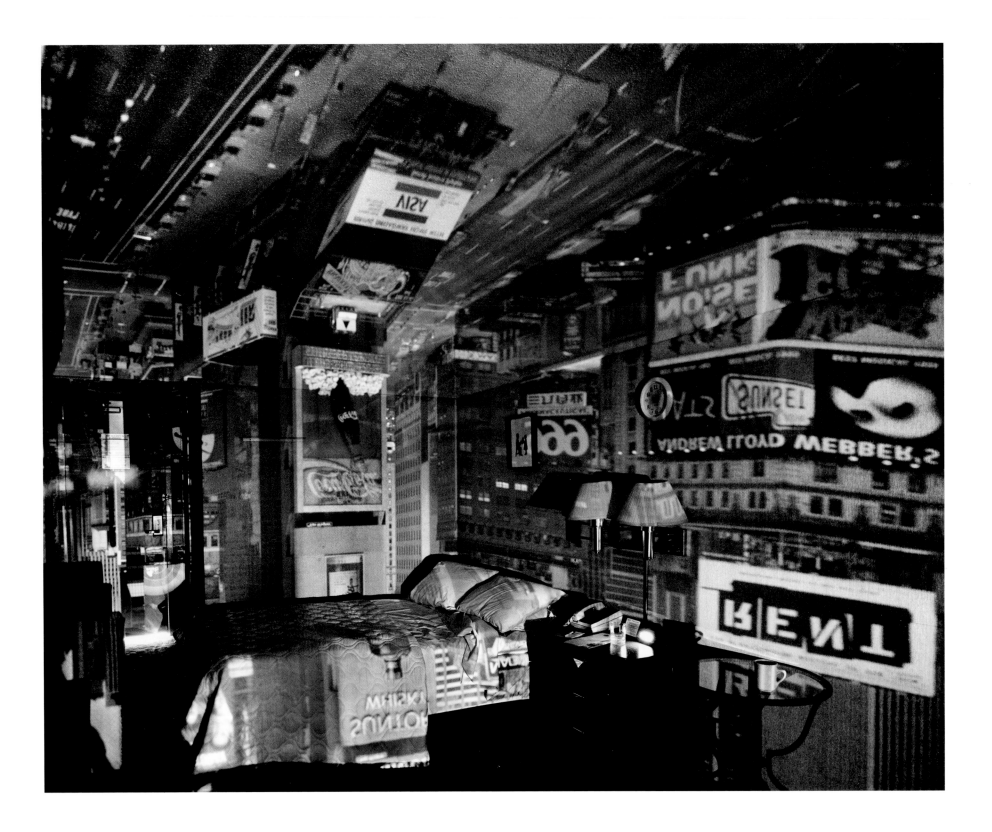

28. Camera Obscura: Times Square in Hotel Room, 1997

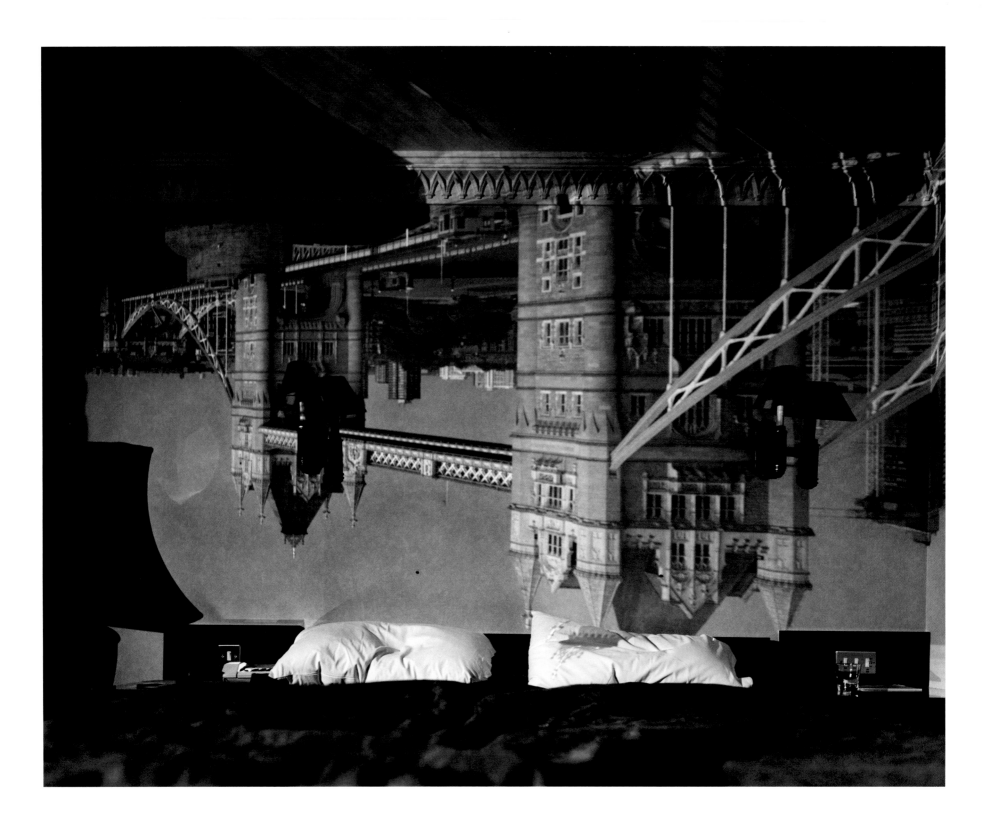

29. *Camera Obscura: The Tower Bridge in the Tower Hotel, London, England, 2001*

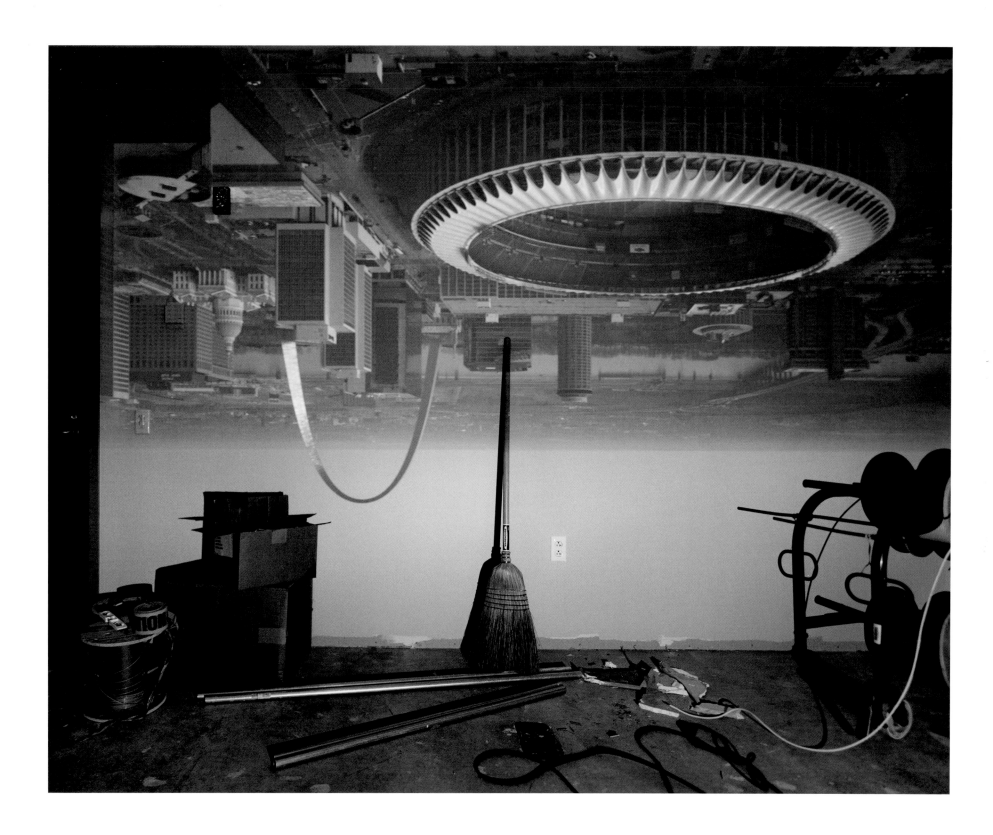

30. *Camera Obscura: View of St. Louis Looking East in Building under Construction*, 2000

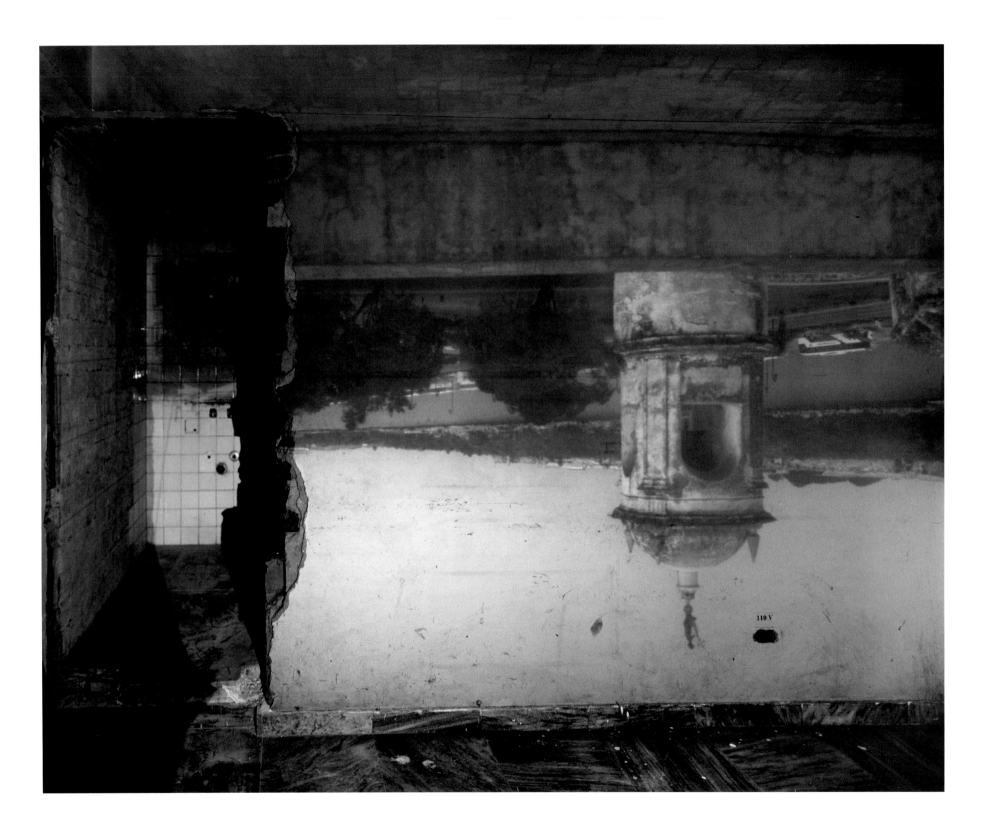

31. *Camera Obscura: La Giraldilla de la Habana in Room with Broken Wall, Havana, Cuba*, 2002

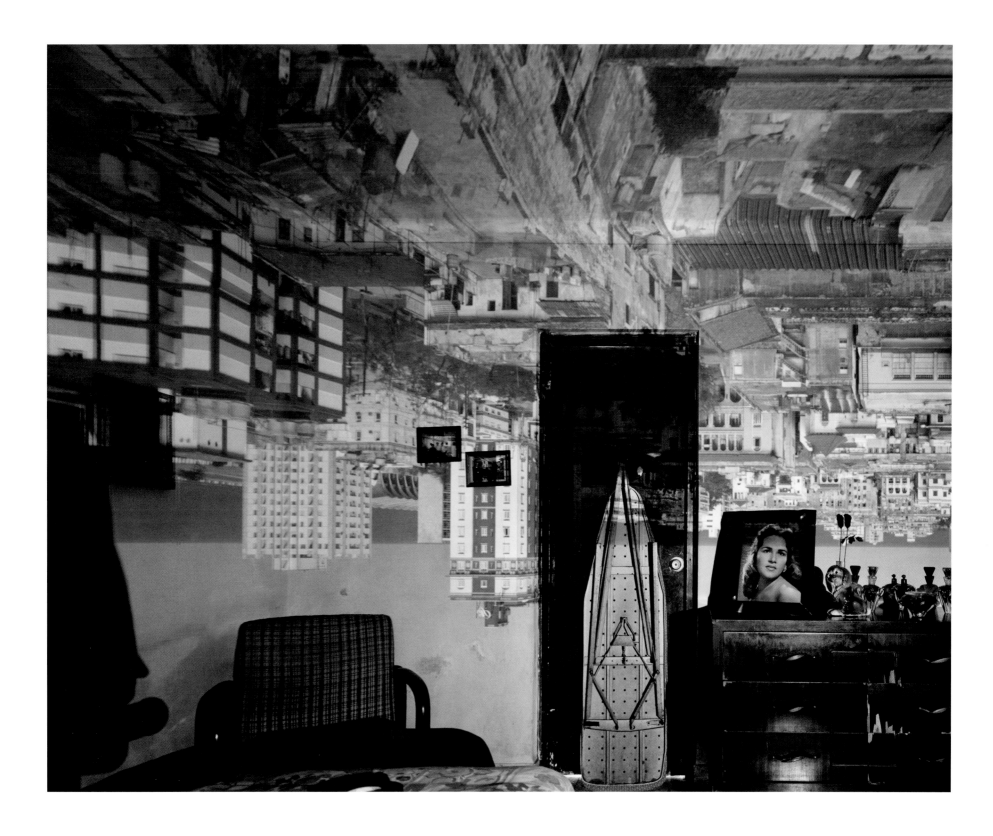

32. *Camera Obscura: El Vedado Looking Northwest, Havana, Cuba,* 2002

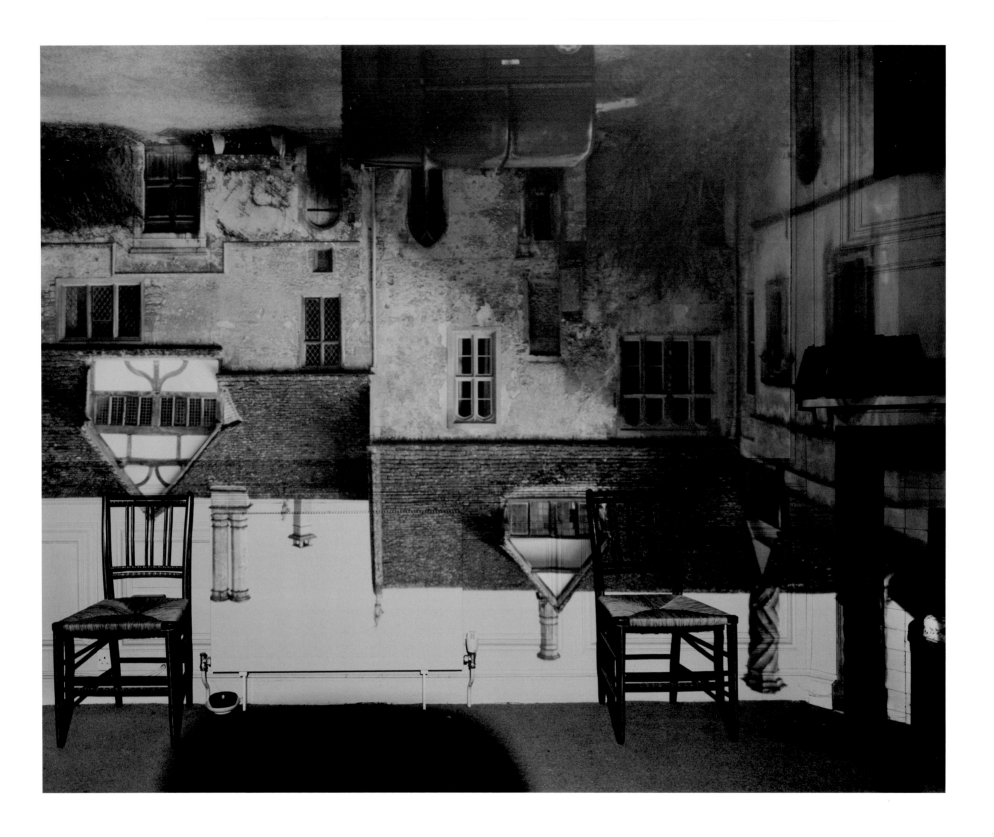

33. *Camera Obscura: Courtyard Building, Lacock Abbey, England, March 16, 2003*

34. *Camera Obscura: The Sea in Attic*, 1994

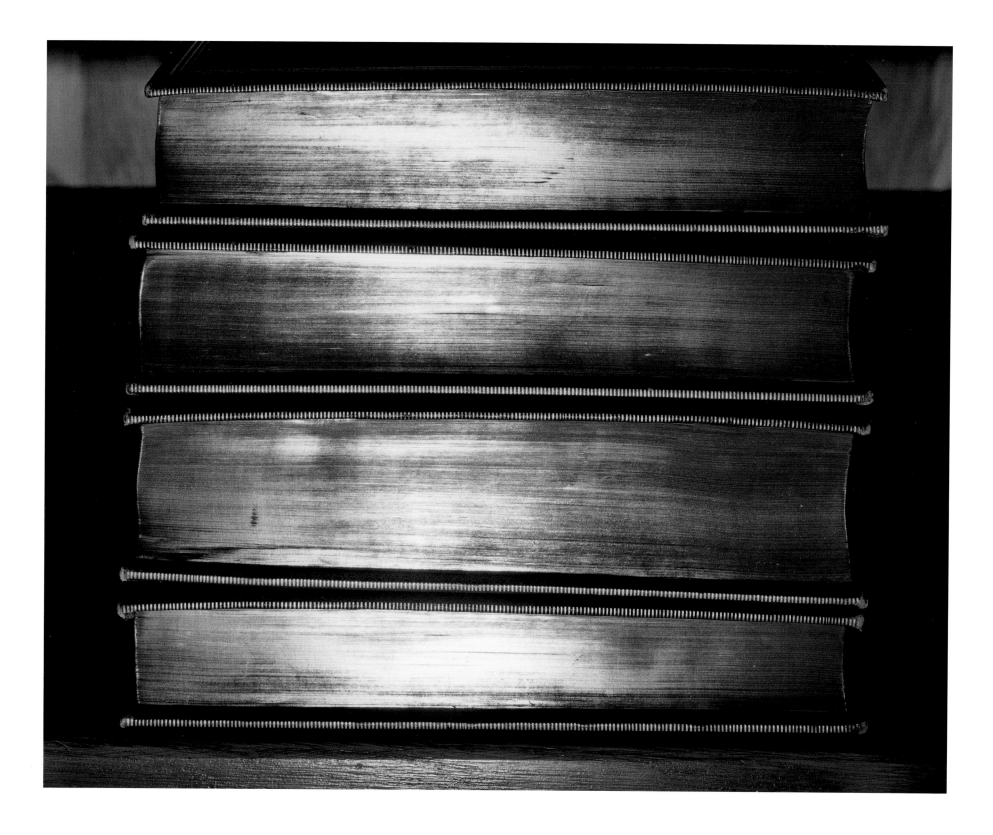

35. *Shiny Books*, 2000

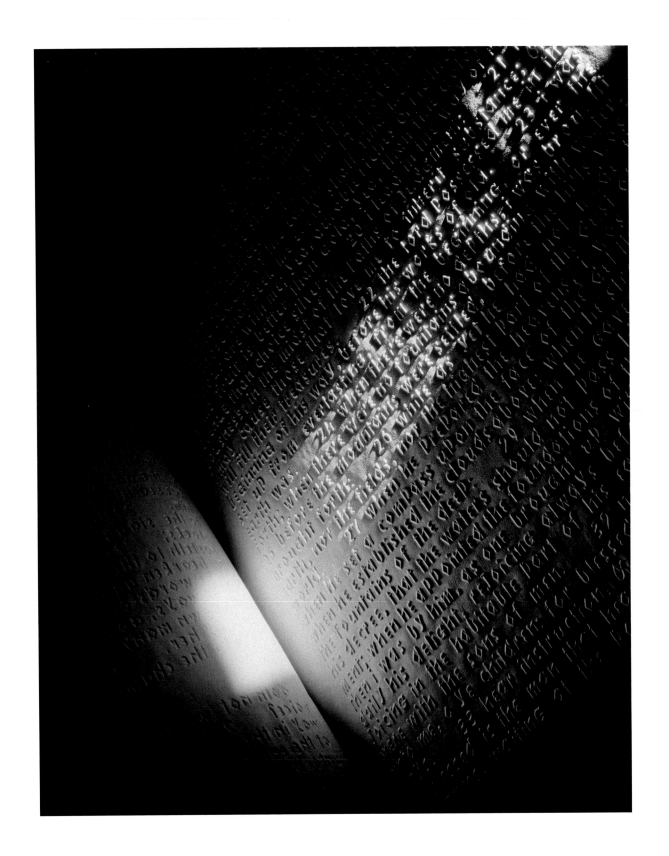

36. *1841 Book of Proverbs for the Blind*, 1995

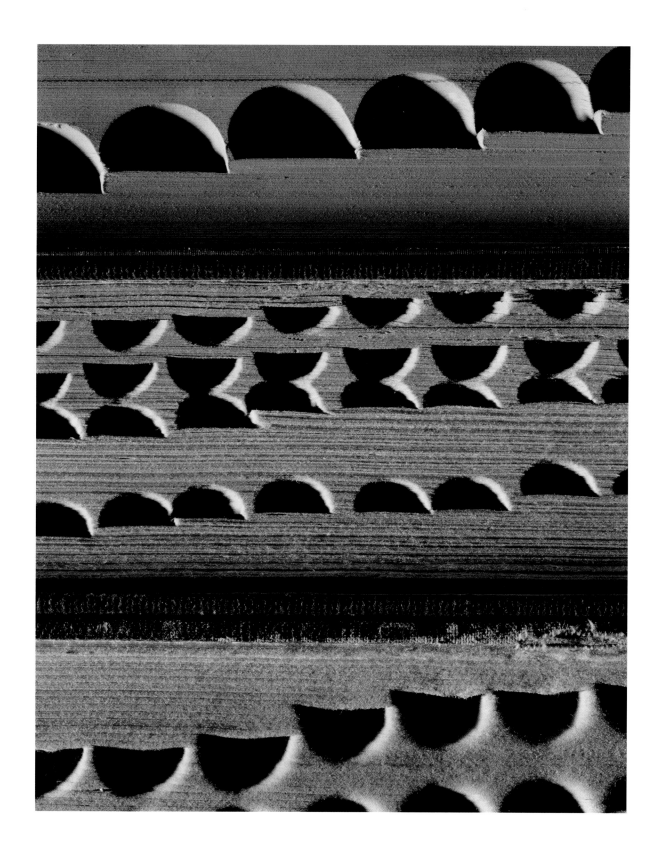

37. *Three Dictionaries,* 2000

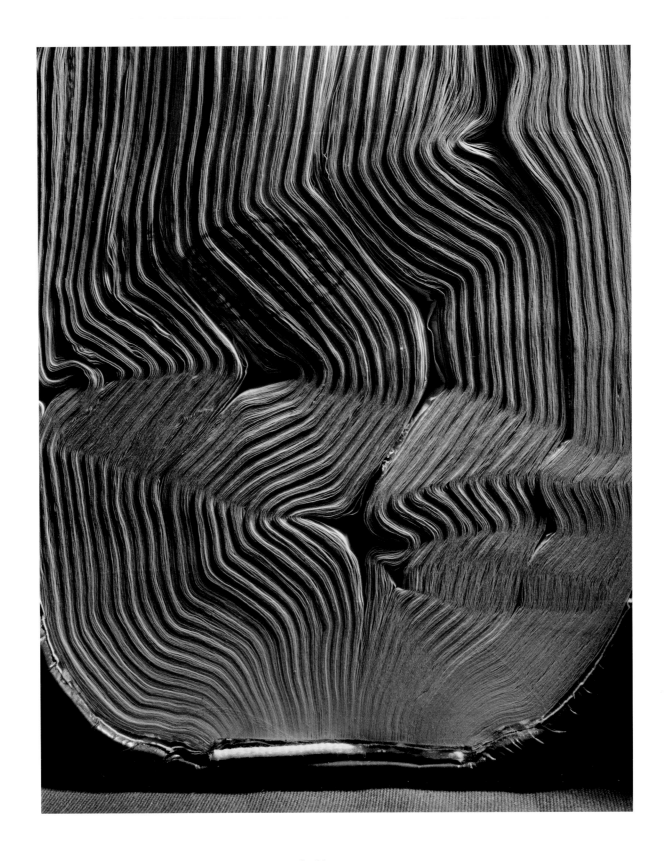

38. *Book with Wavy Pages*, 2001

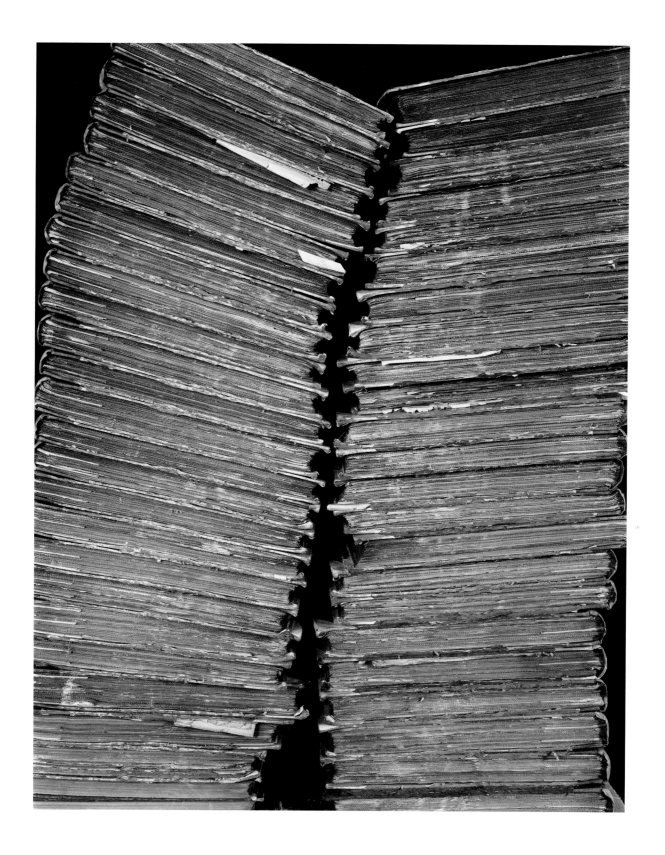

39. *Two Stacks of Bound Newspapers*, 2001

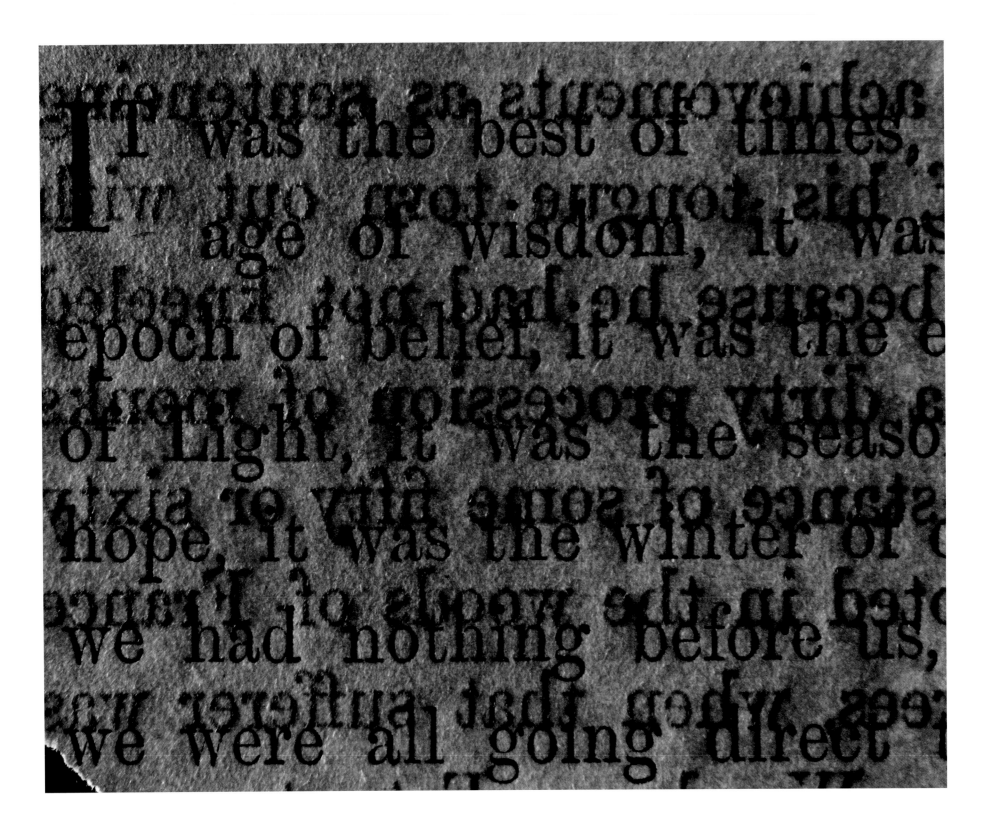

IT was the best of times, age of wisdom, it was epoch of belief, it was the of light, it was the seaso hope, it was the winter of we had nothing before us, we were all going direct

40. *A Tale of Two Cities*, 2001

41. *Thought*, 2001

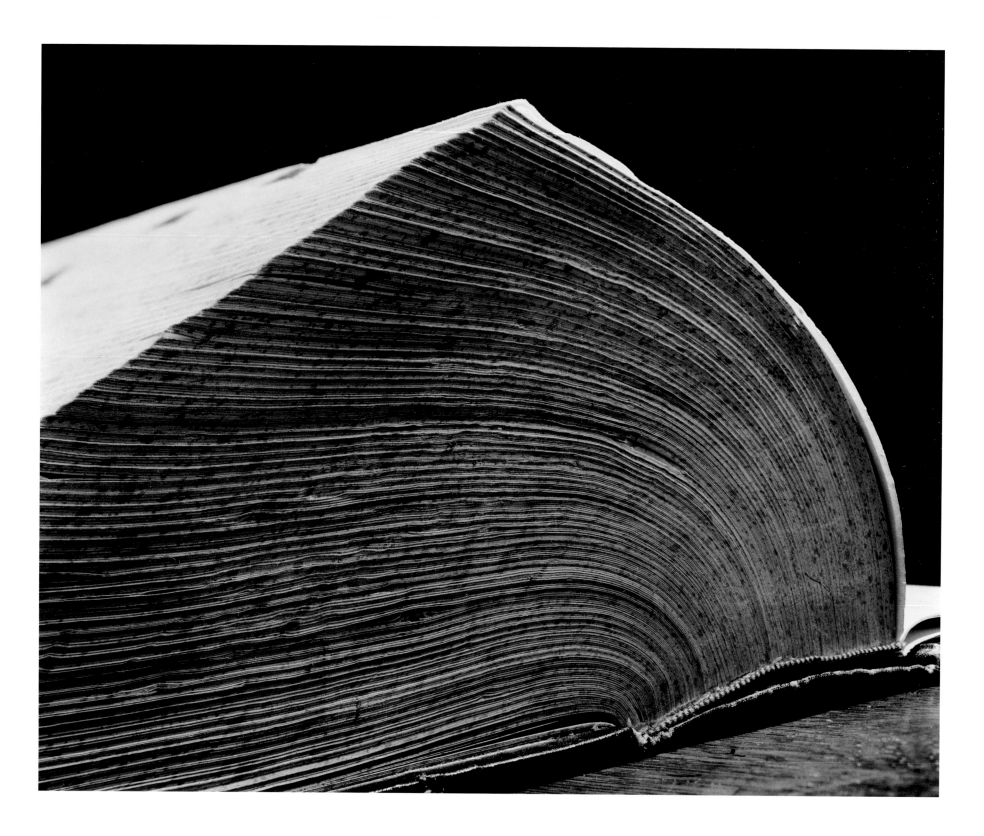

42. *Dictionary*, 1994

43. *Two Books*, 1994

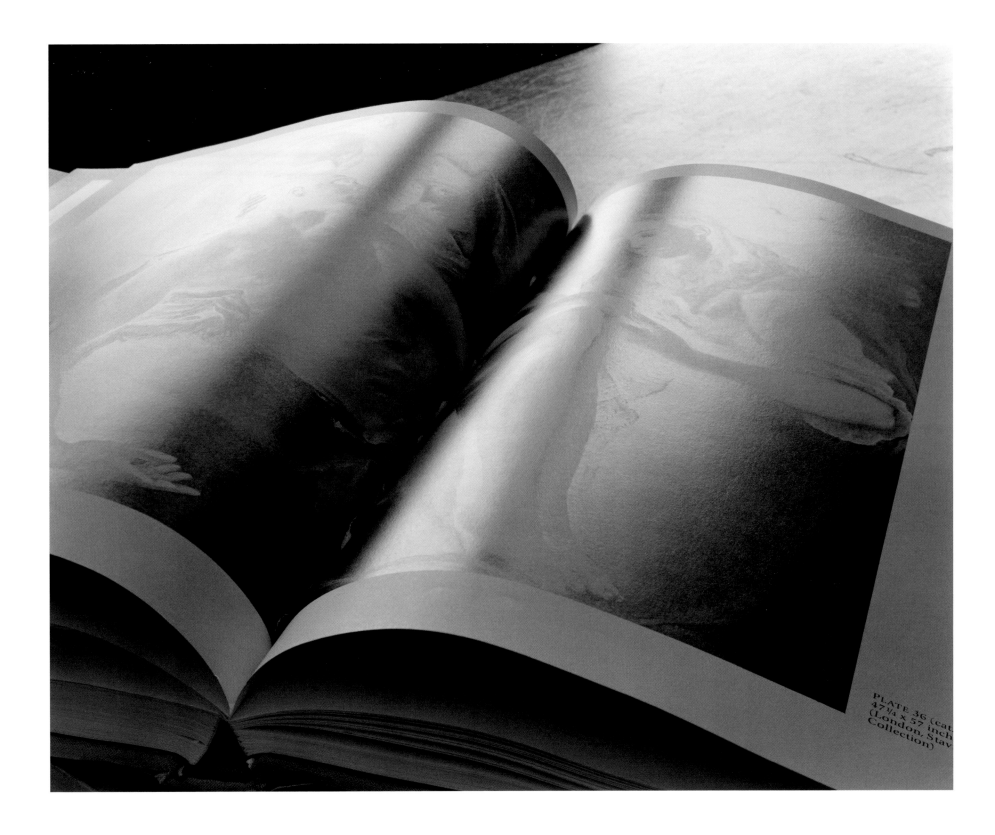

PLATE 36 (cat.
47¼ x 57 inch
(London, Stav
Collection)

44. *Pietà by El Greco*, 1993

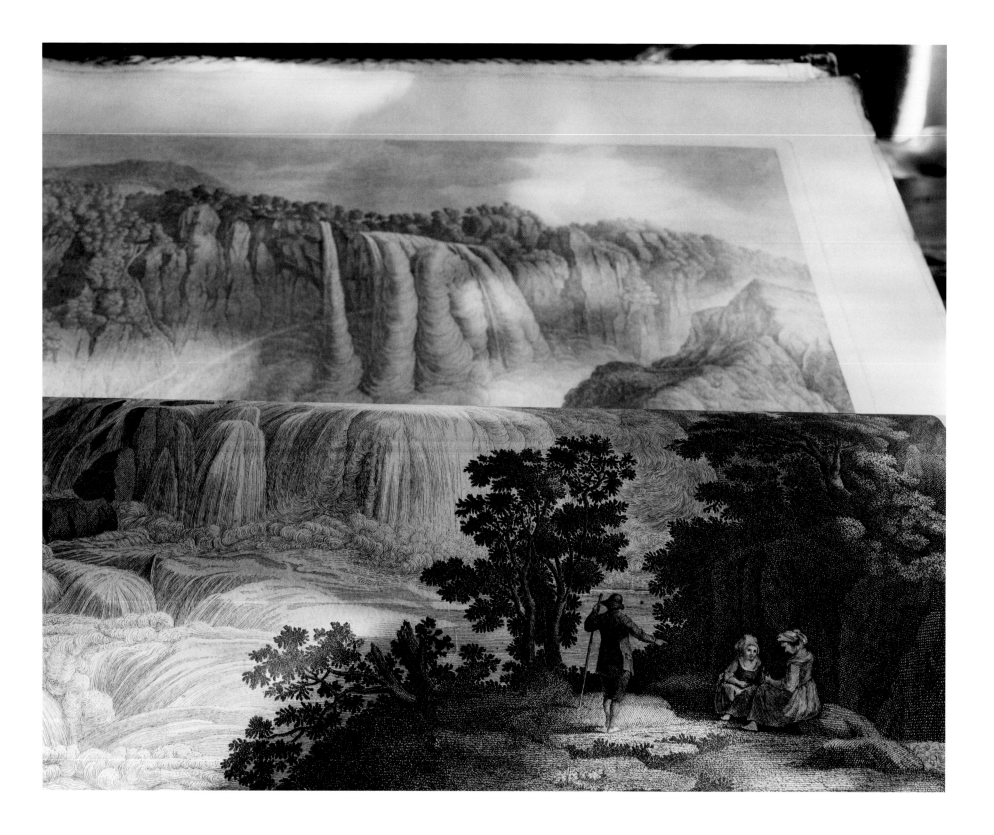

45. *Sunlight on Book of Landscapes*, 1995

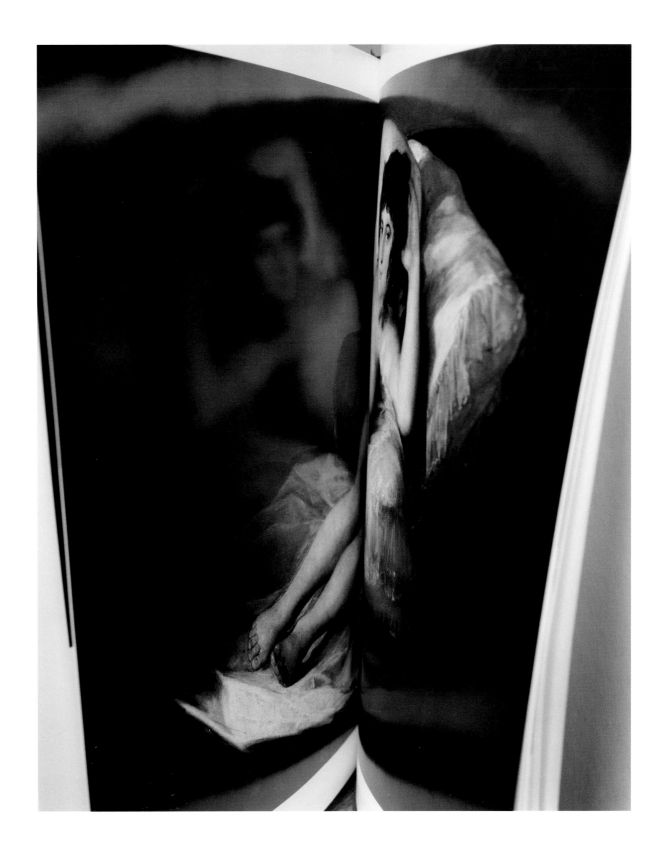

46. *Naked Maja by Goya*, 1994

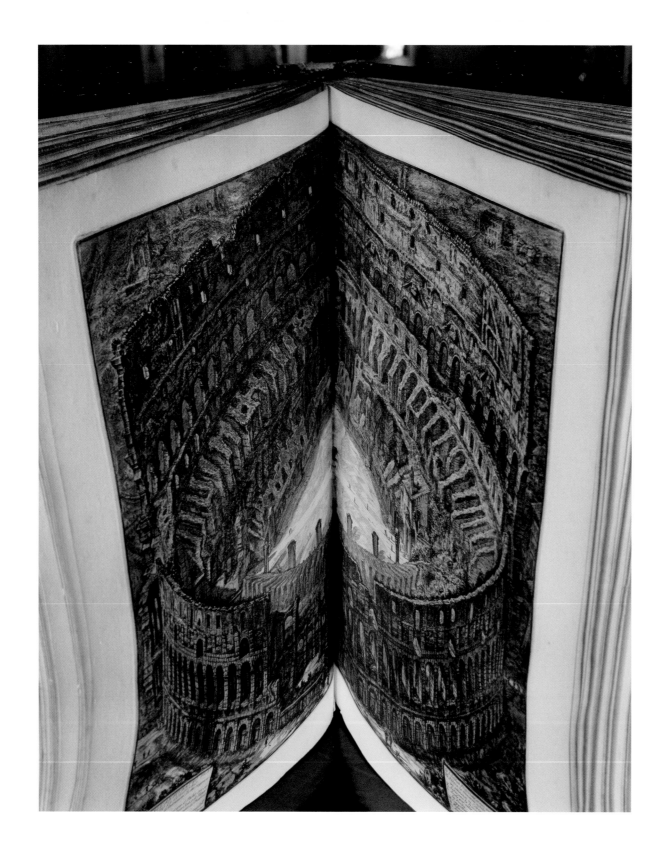

47. *The Colosseum by Piranesi #2, 1994*

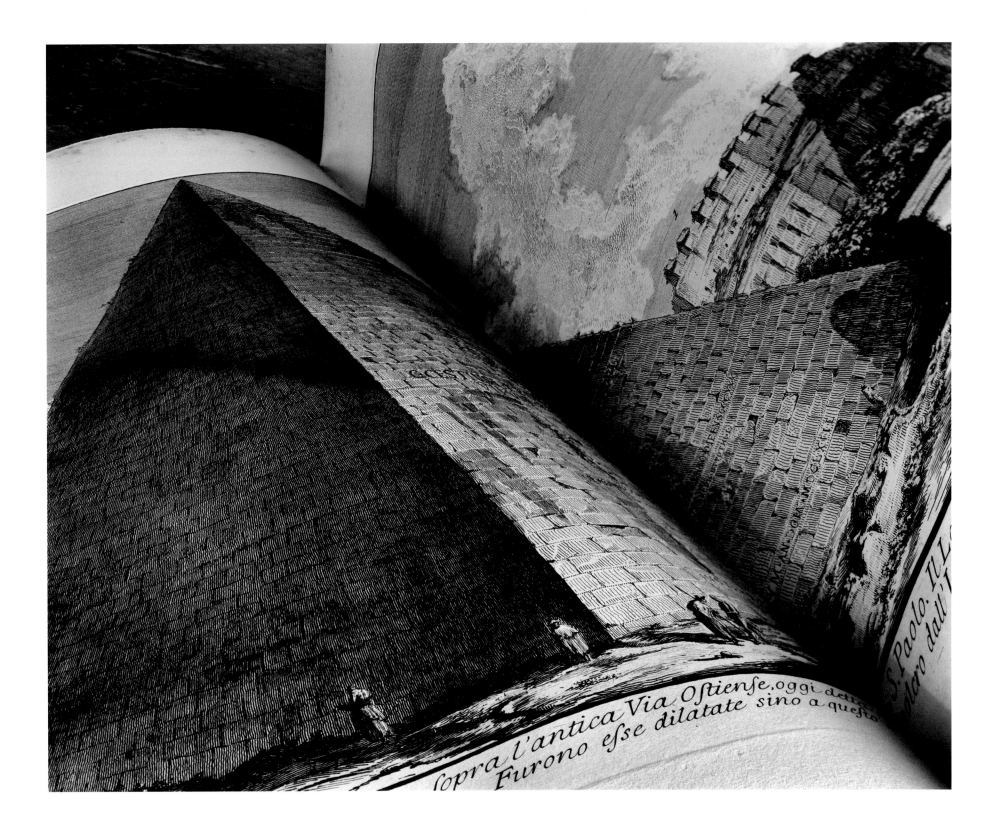

48. *Le Antichità Romane by Piranesi #1*, 1994

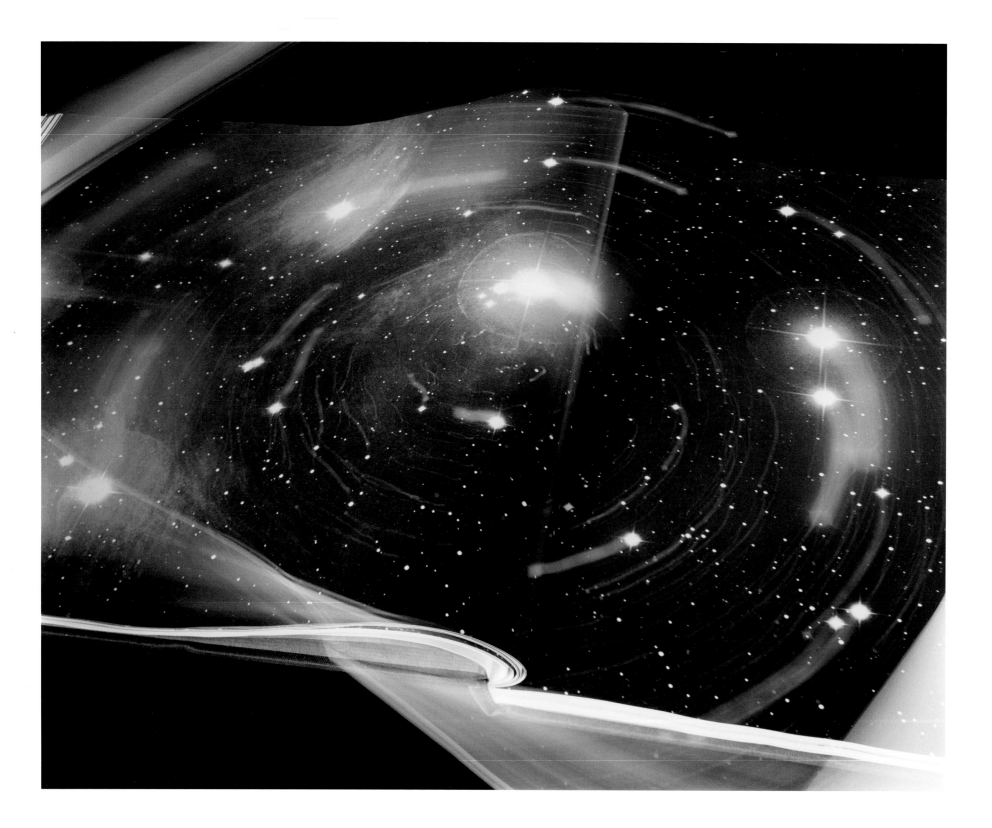

49. *Book of Revolving Stars,* 1994

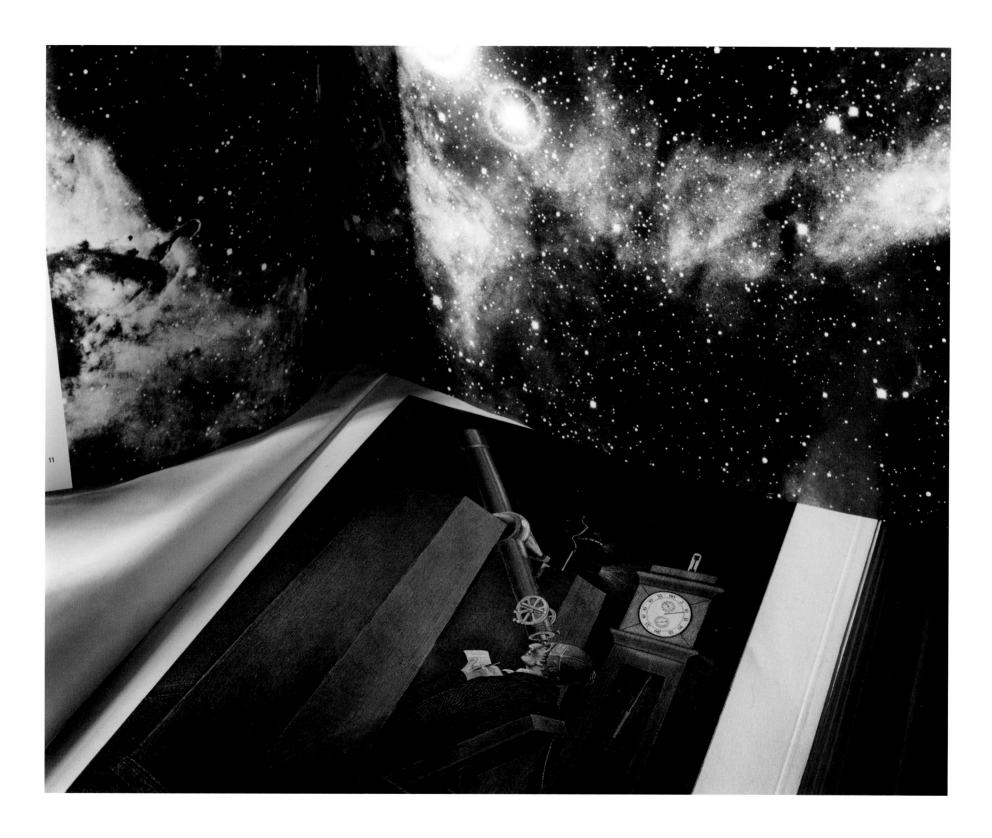

50. *Two Books of Astronomy*, 1996

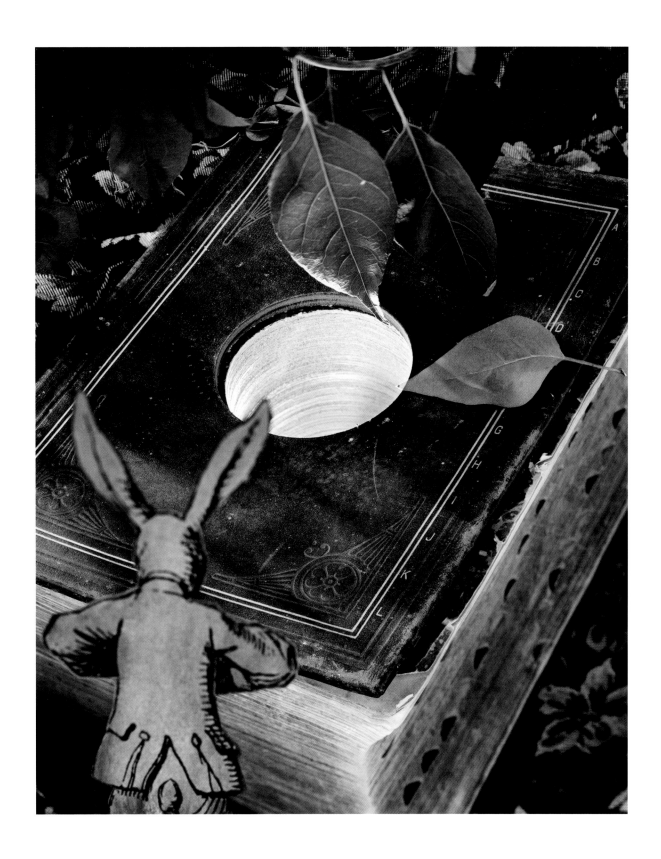

51. *Down the Rabbit Hole (from Alice's Adventures in Wonderland)*, 1998

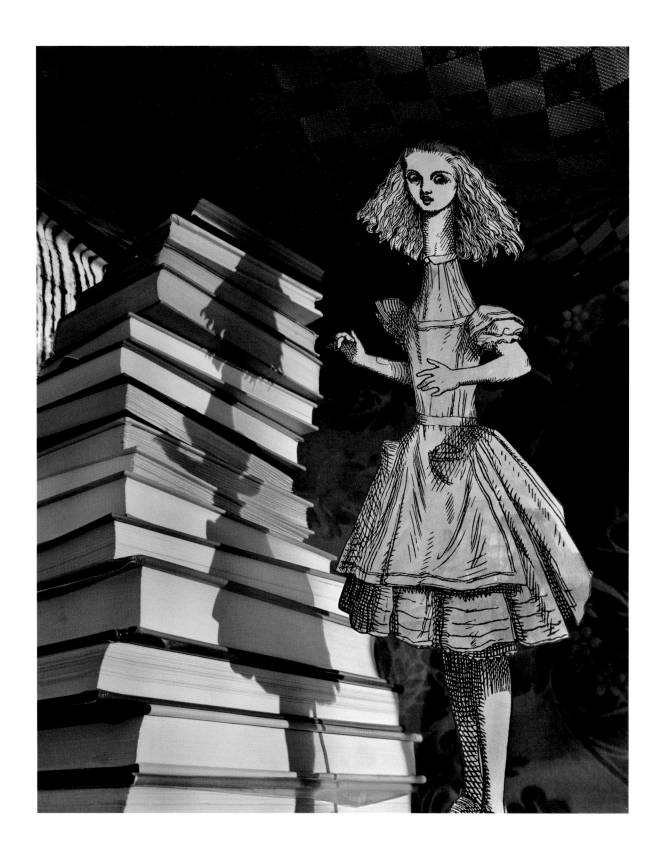

52. Curiouser and Curiouser (from Alice's Adventures in Wonderland), 1998

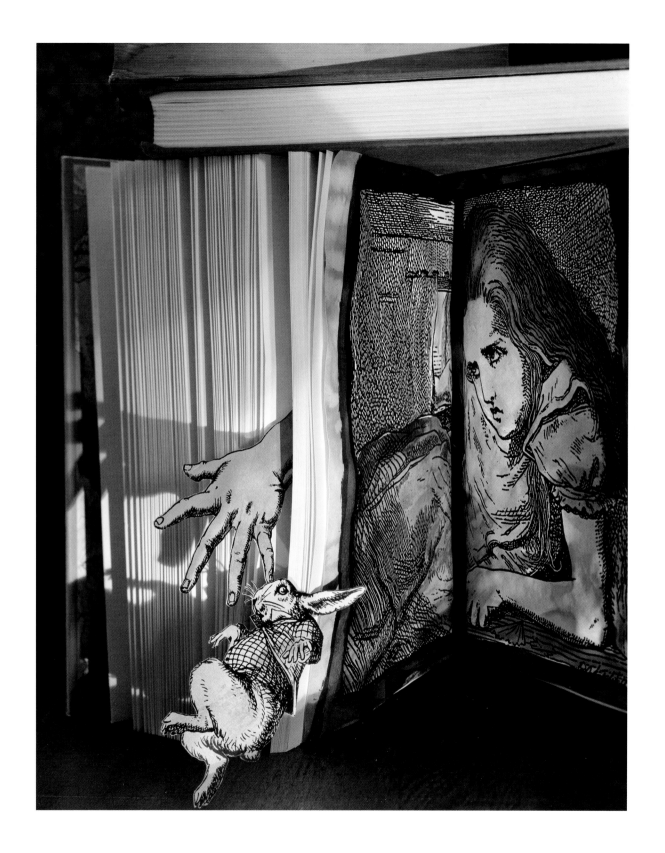

53. *It Was Much Pleasanter at Home (from Alice's Adventures in Wonderland)*, 1998

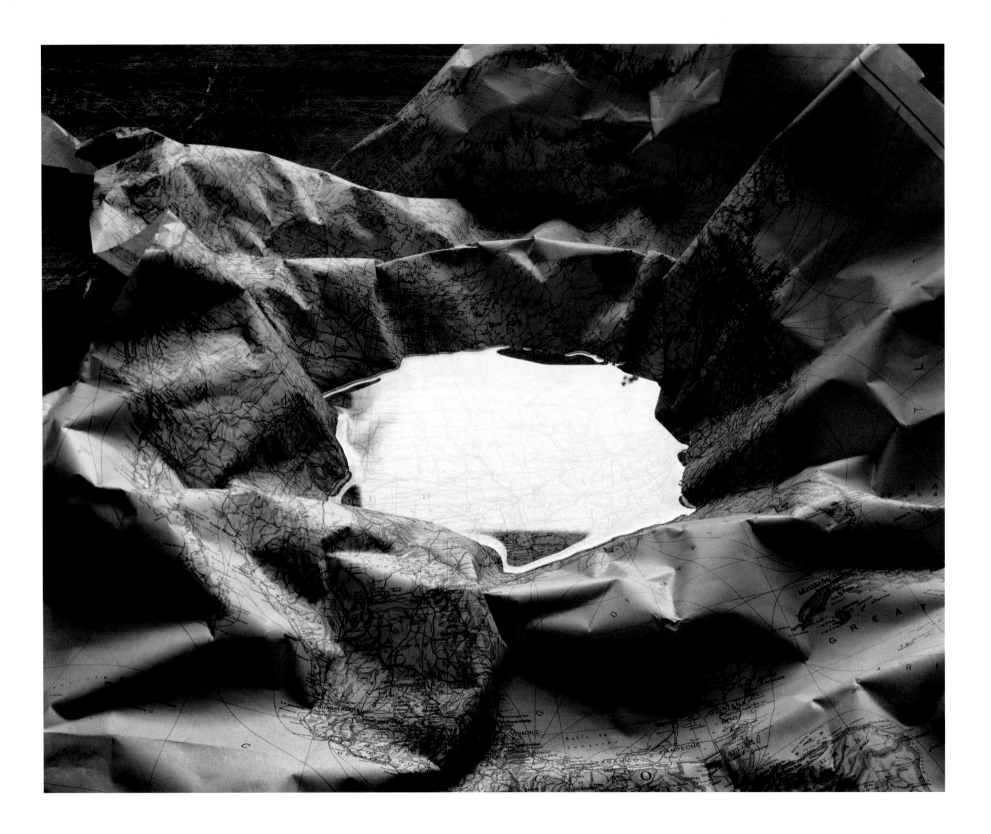

54. *Map of North America*, 1996

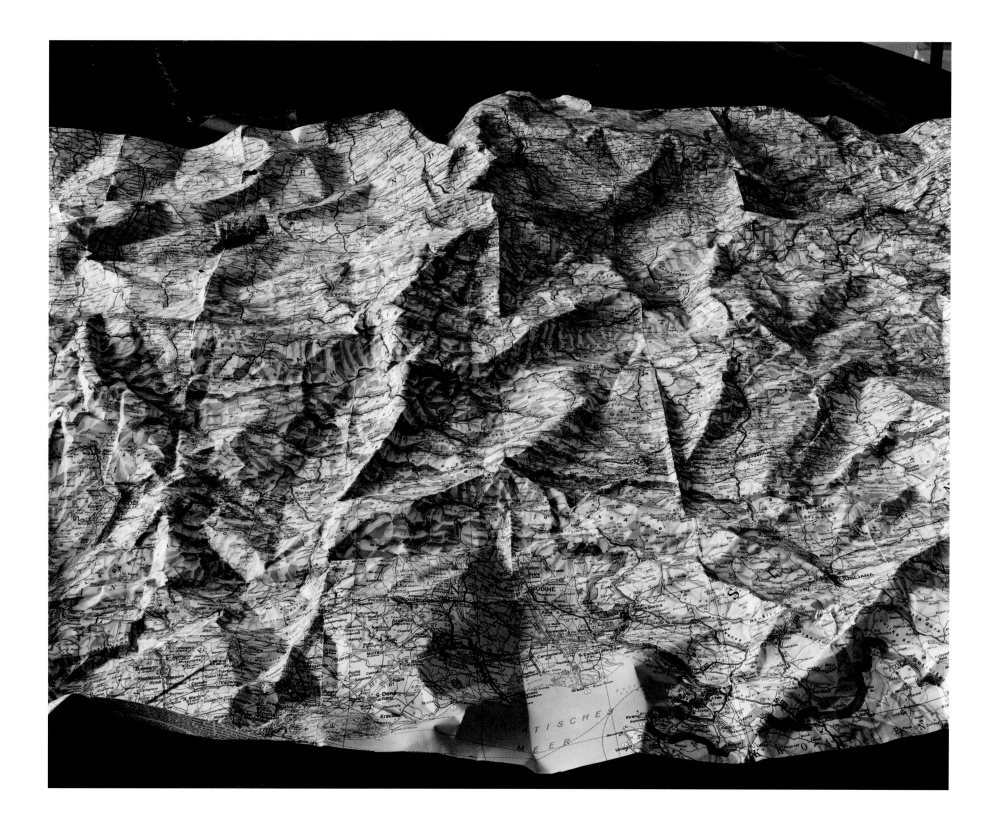

55. *Map #1*, 1996

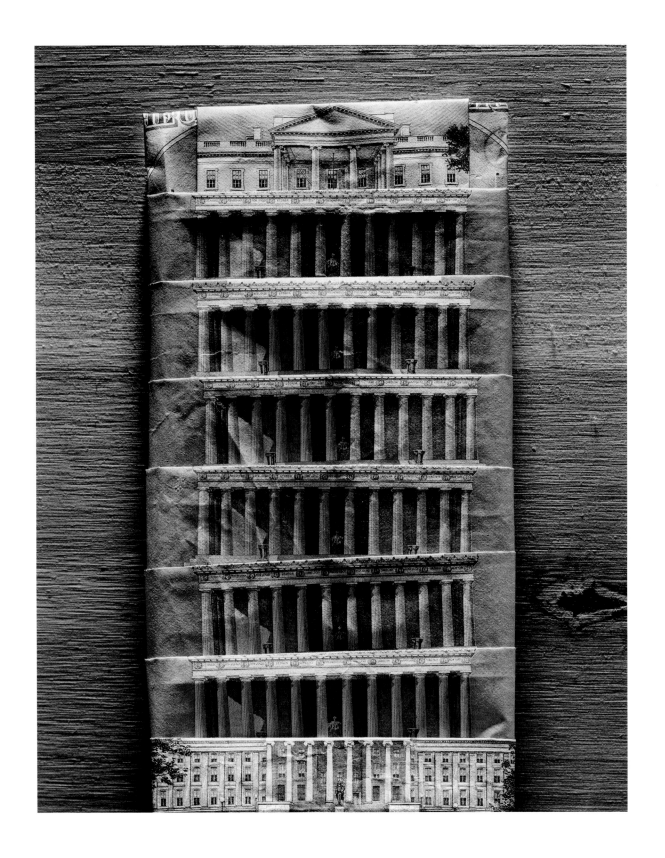

56. *$60*, 2002

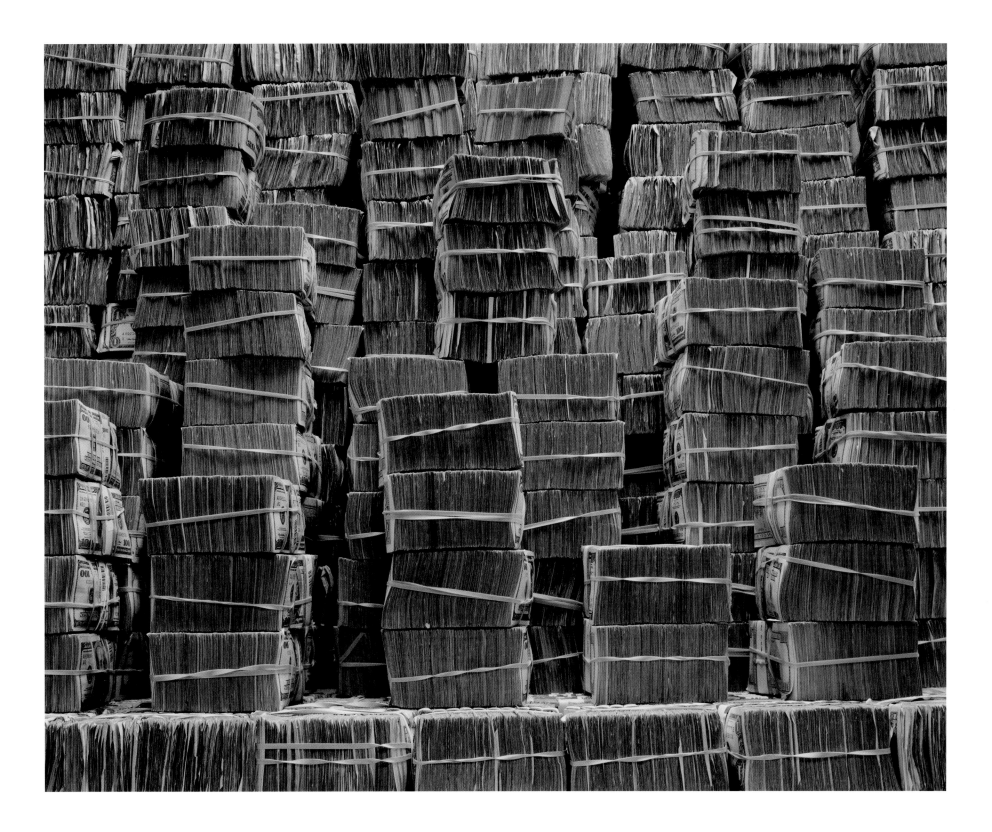

57. *$7 Million*, 2006

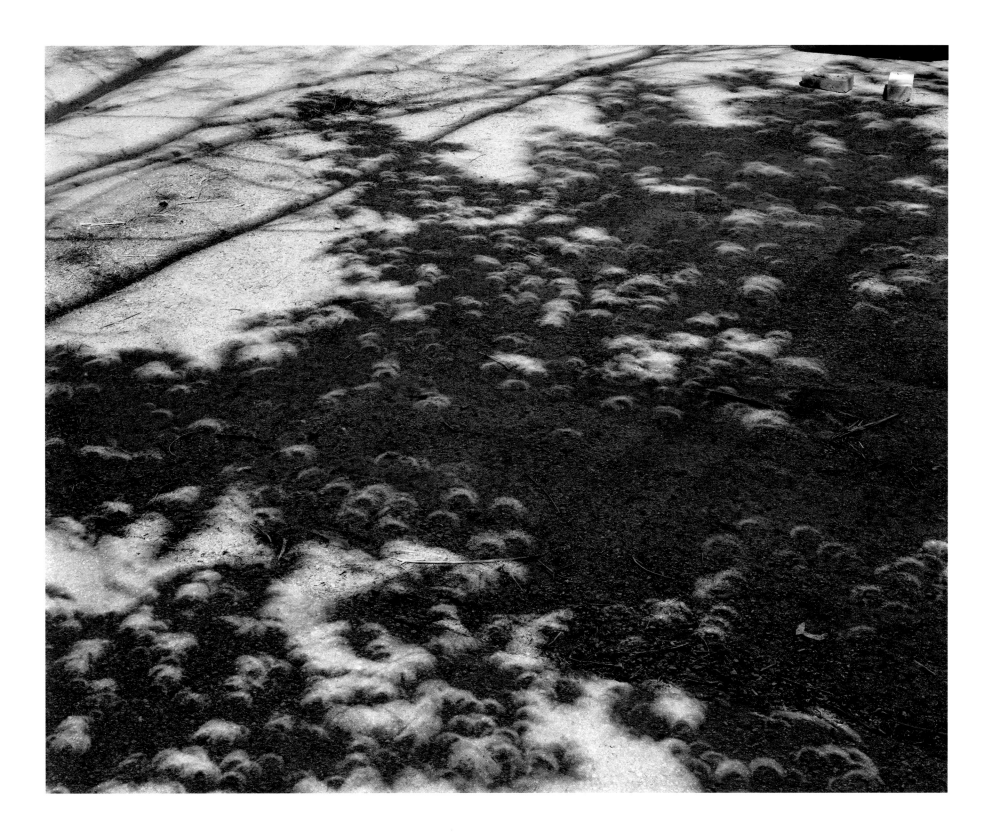

58. Shadows during Solar Eclipse, 1994

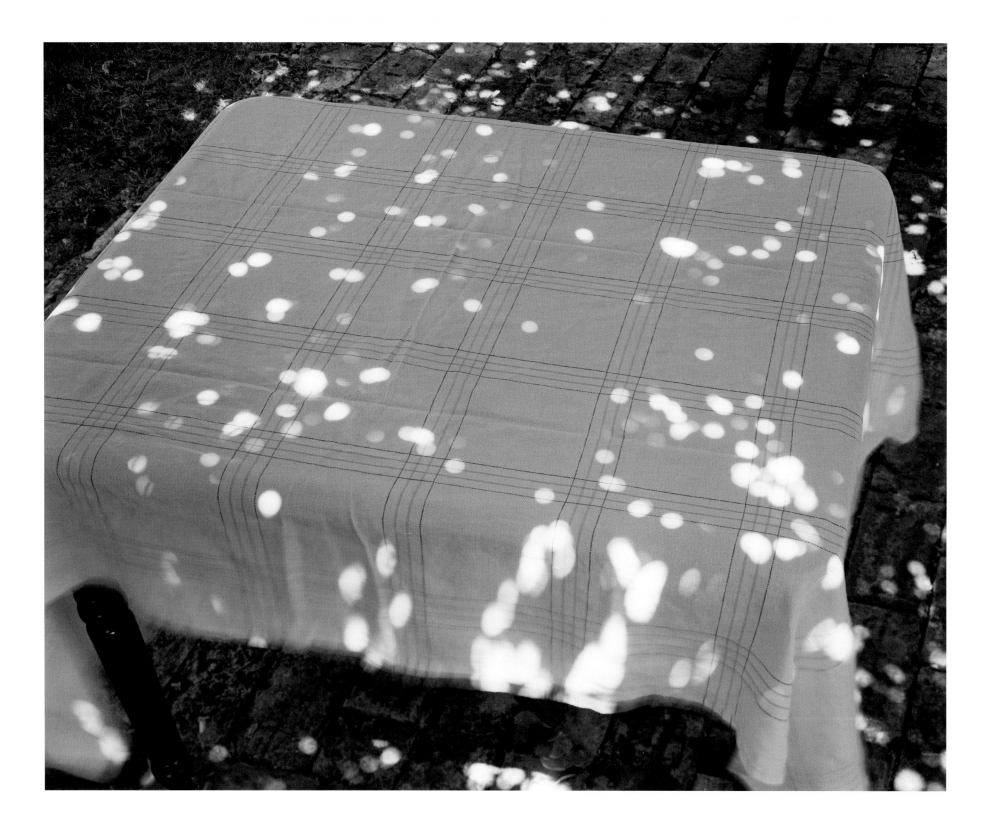

59. *Sunspots on Covered Table, Umbertide, Italy,* 2000

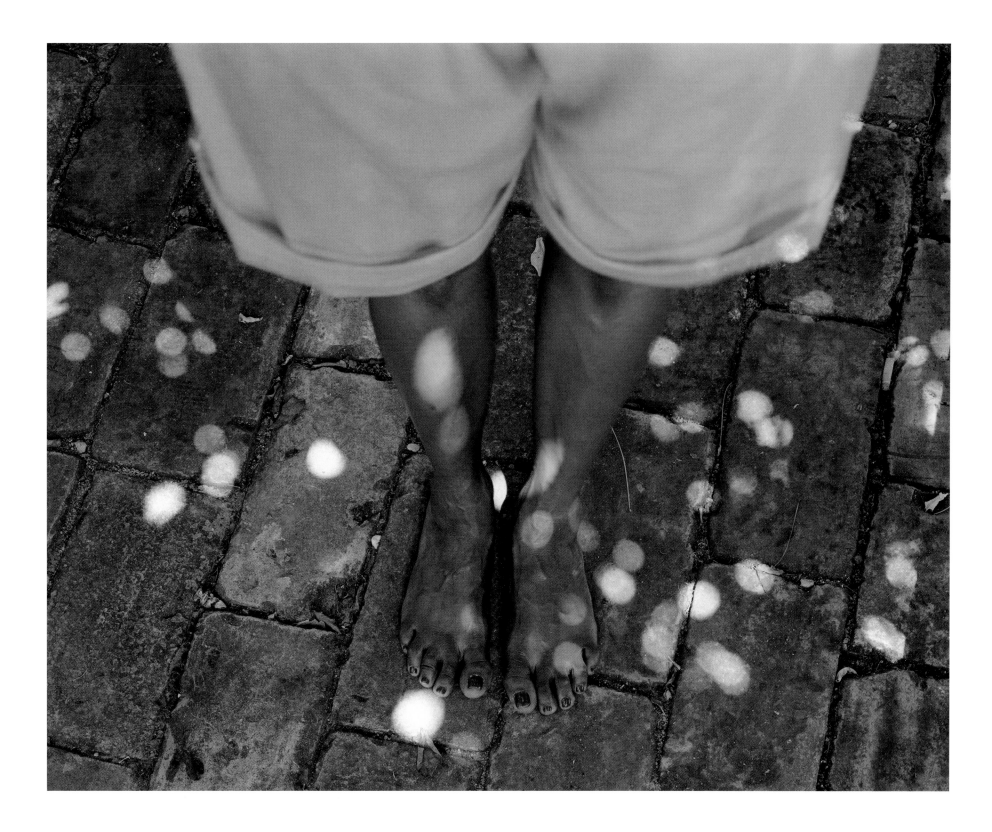

60. *Feet and Sunspots,* 2000

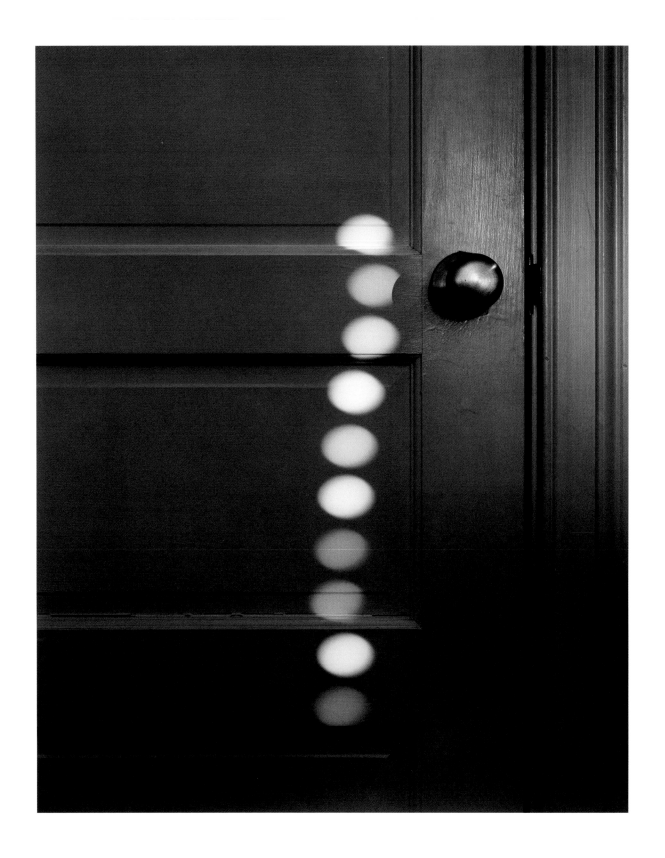

61. *Ten Sunspots on My Door*, 2004

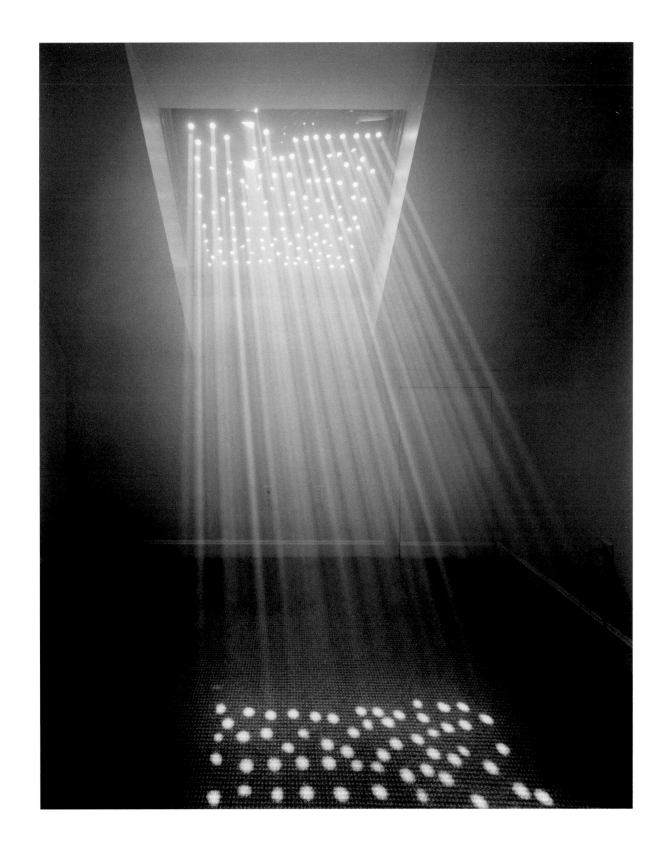

62. *Light Entering Our House*, 2004

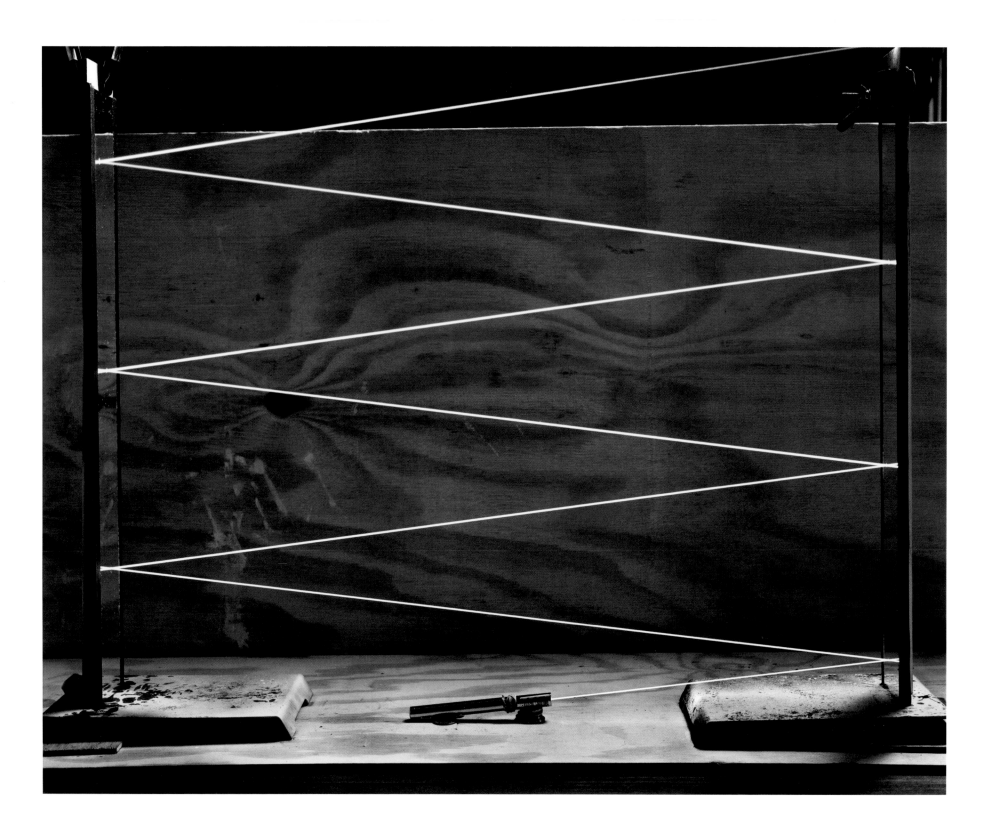

63. *Construction with Narrow Mirrors and Laser Pointer*, 2005

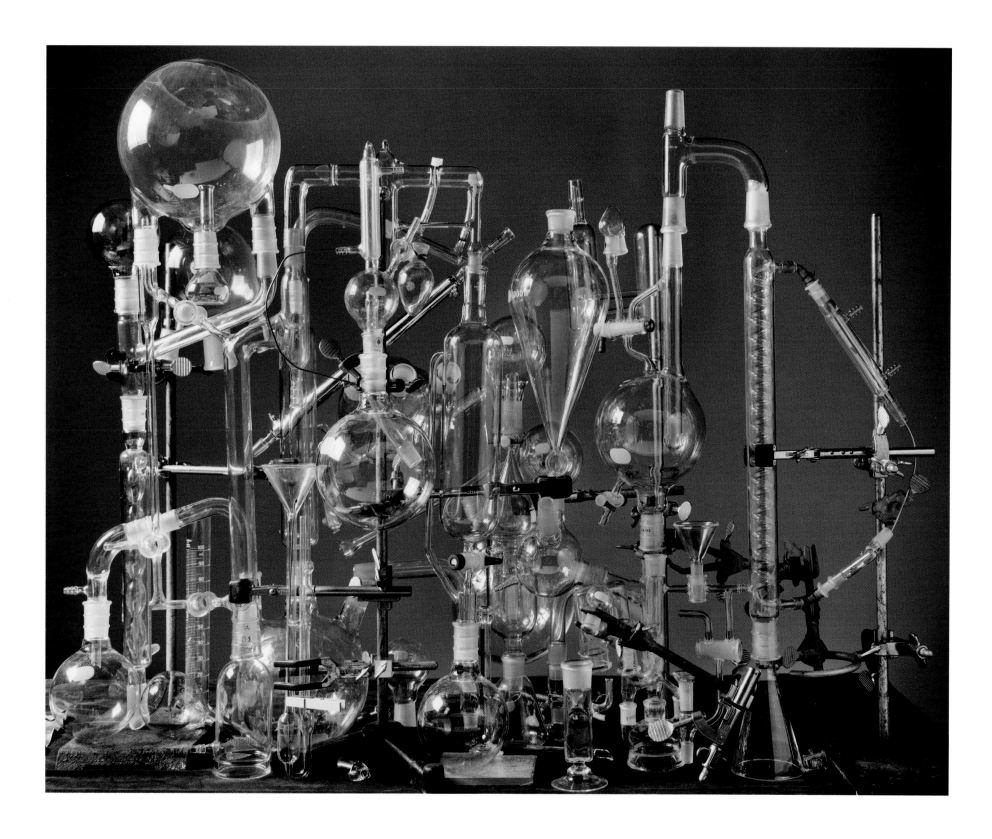

64. *Laboratory Glassware Construction*, 2004

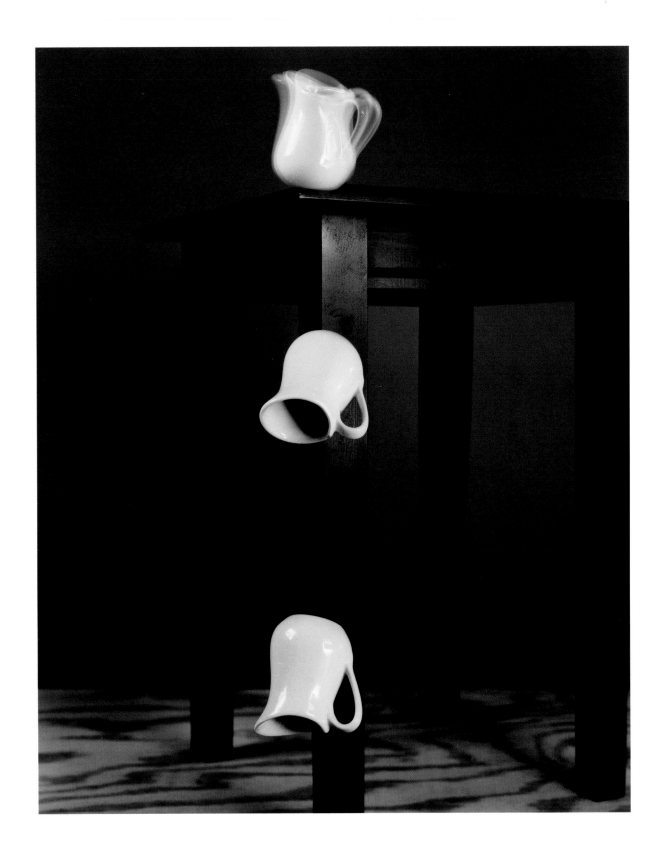

65. *Motion Study of Falling Pitchers*, 2004

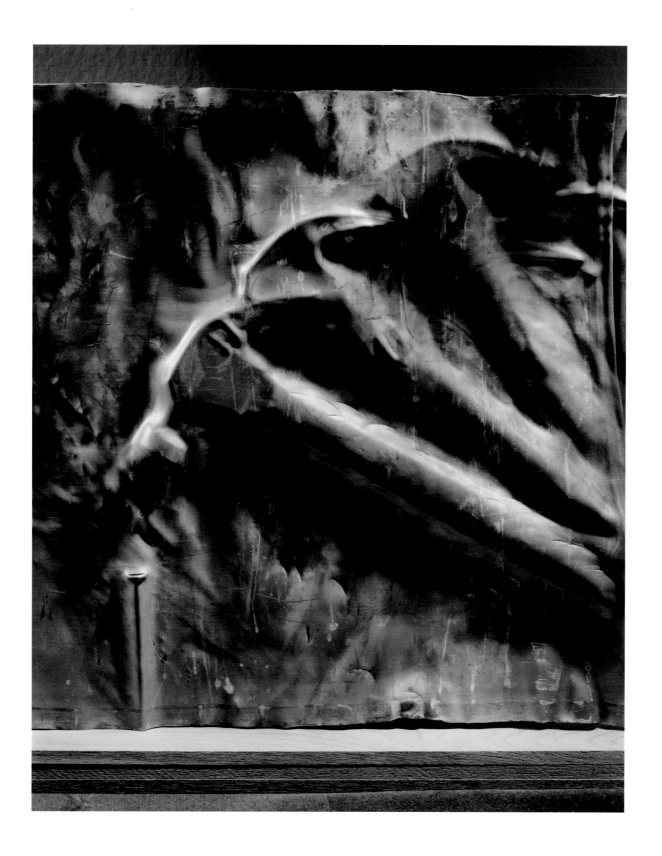

66. *Motion Study of Hammer Impressions on Lead*, 2004

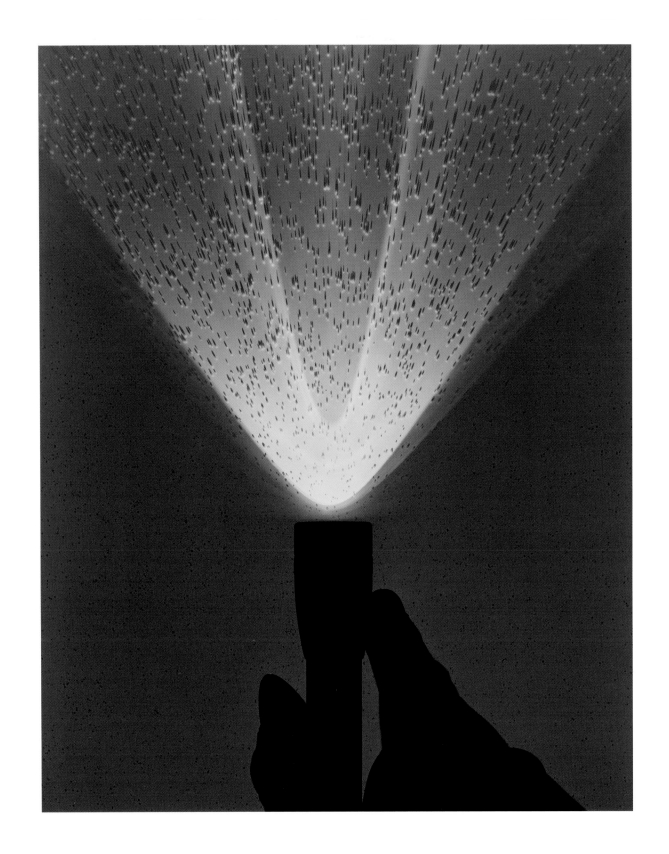

67. *Flashlight and Salt: Photogram on 8" × 10" Film*, 2006

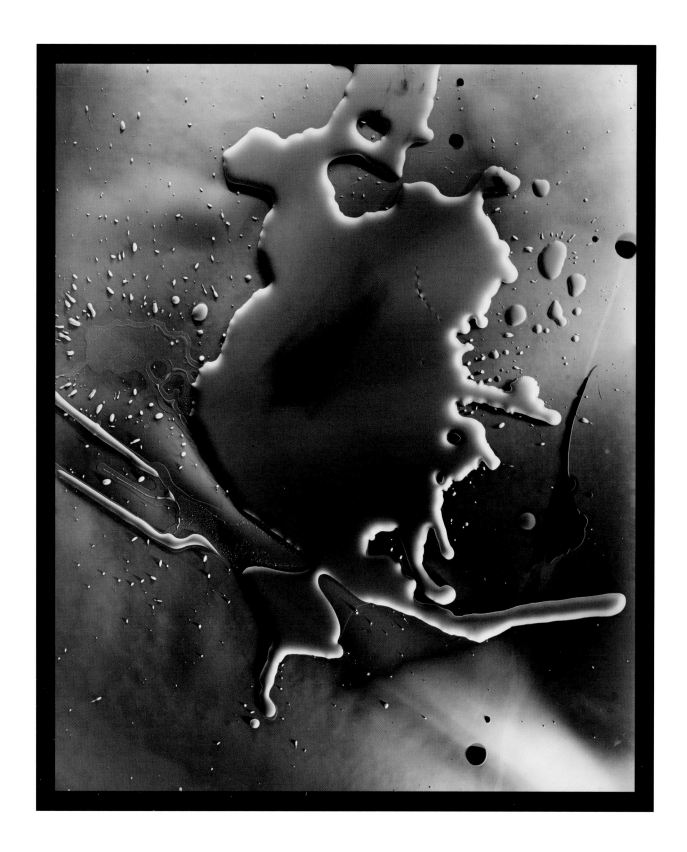

68. Water and Ink: Photogram on 20" × 24" Film, 2006

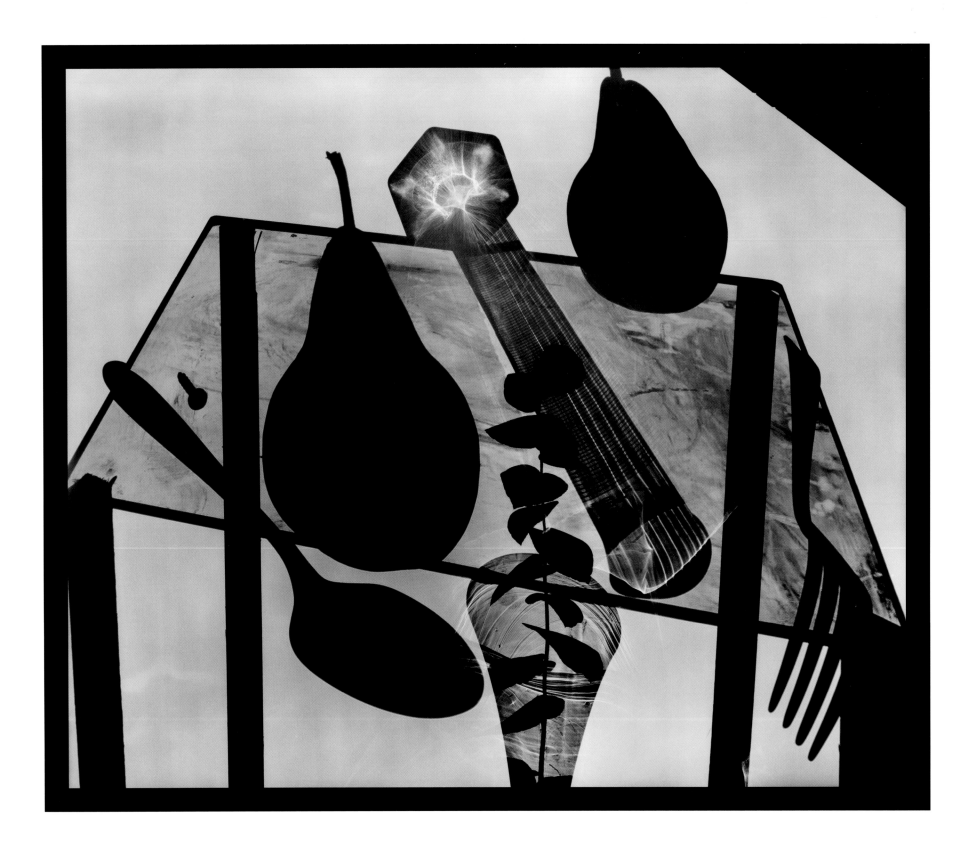

69. Still Life with Pears: Photogram on 20" × 24" Film, 2006

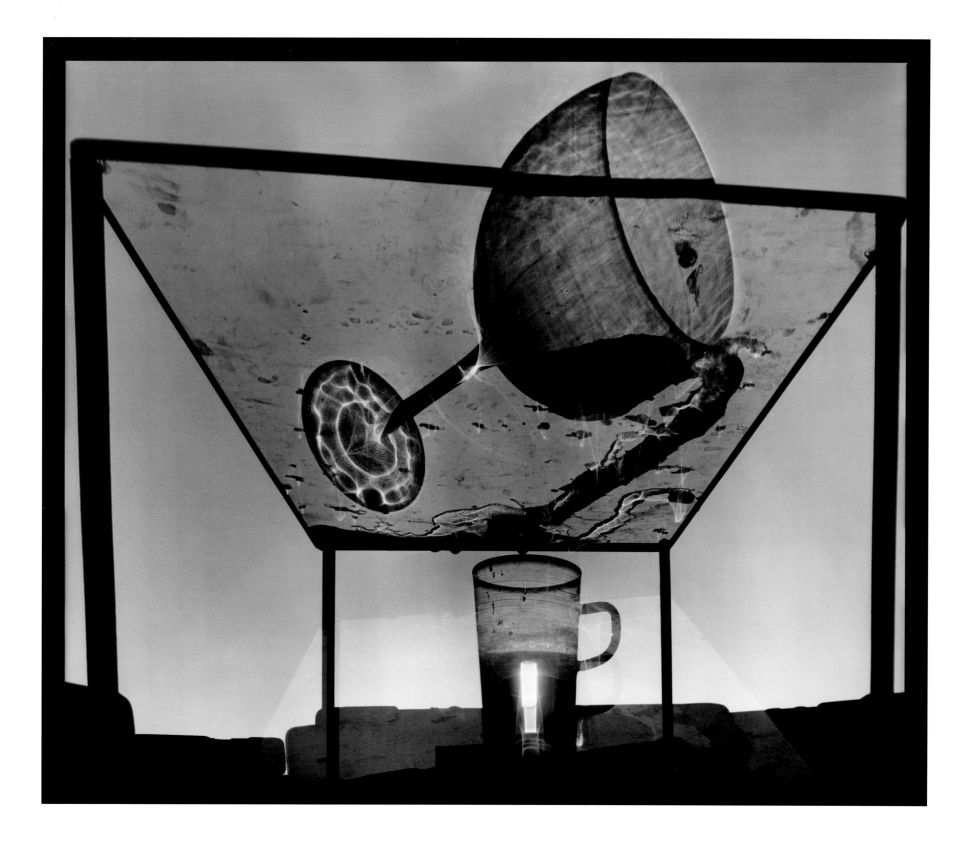

70. Still Life with Wine Glass: Photogram on 20" × 24" Film, 2006

71. *The Metropolitan Opera: Romeo and Juliet Set*, 2005

72. Two Paintings Sharing an Arch, Isabella Stewart Gardner Museum, 1998

73. Inghirami, Isabella Stewart Gardner Museum, 1998

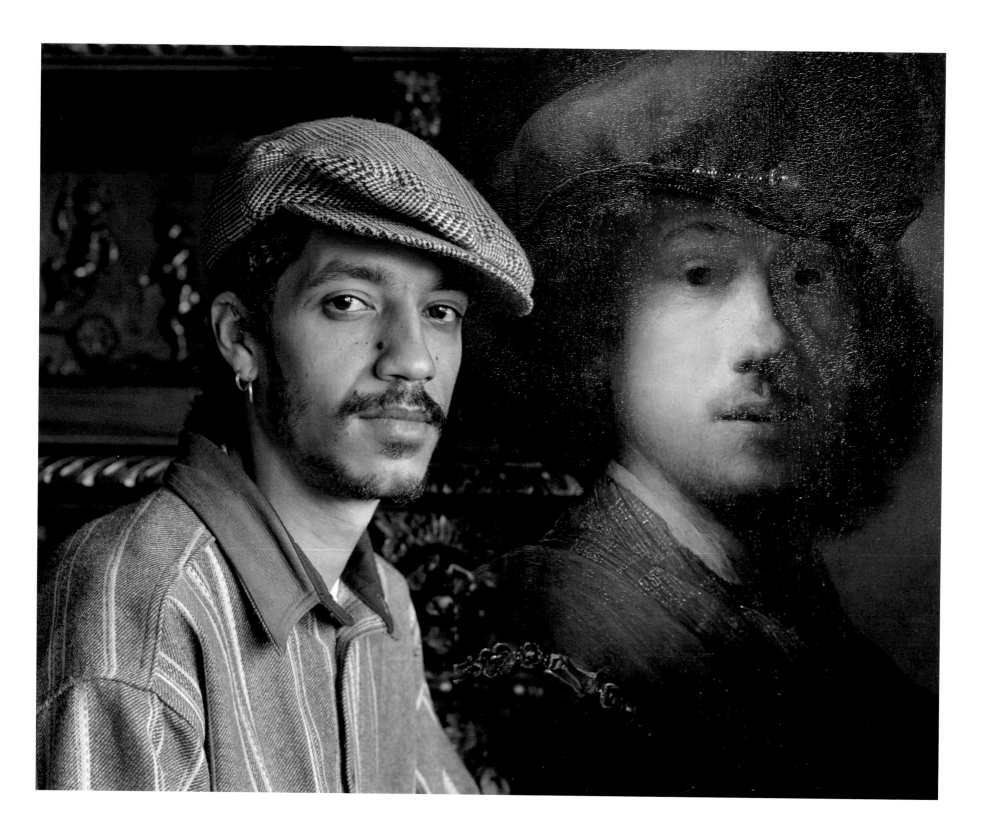

74. Tim and Rembrandt, Isabella Stewart Gardner Museum, 1998

75. *Nadelman/Hopper, Yale University Art Gallery,* 2008

76. Landscape and Figure, Lázaro Galdiano Museum, Madrid, Spain, 2009

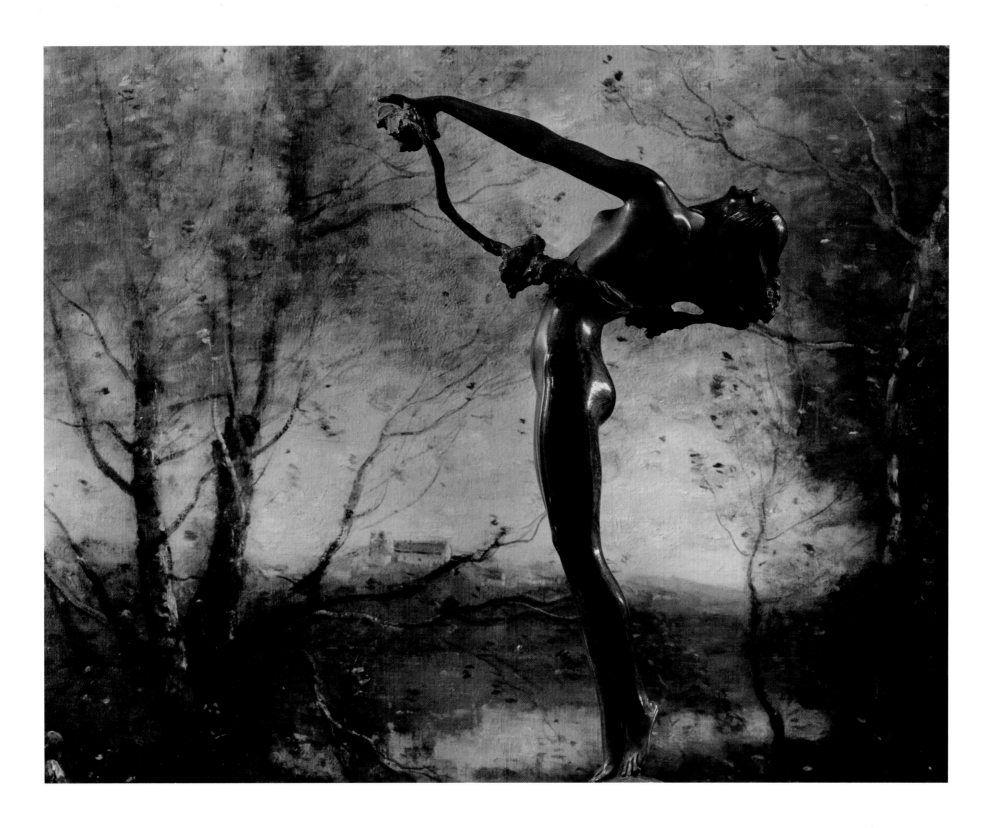

77. Frishmuth/Corot, Yale University Art Gallery, 2009

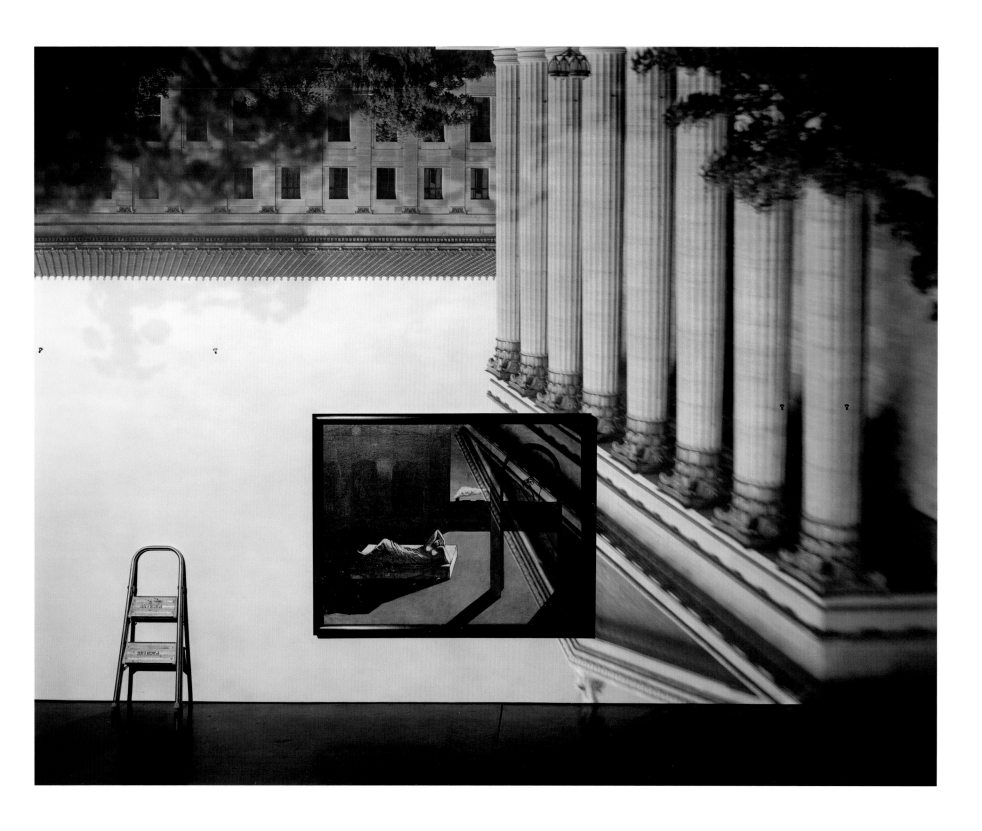

78. Camera Obscura: The Philadelphia Museum of Art East Entrance in Gallery #171 with a De Chirico Painting, 2005

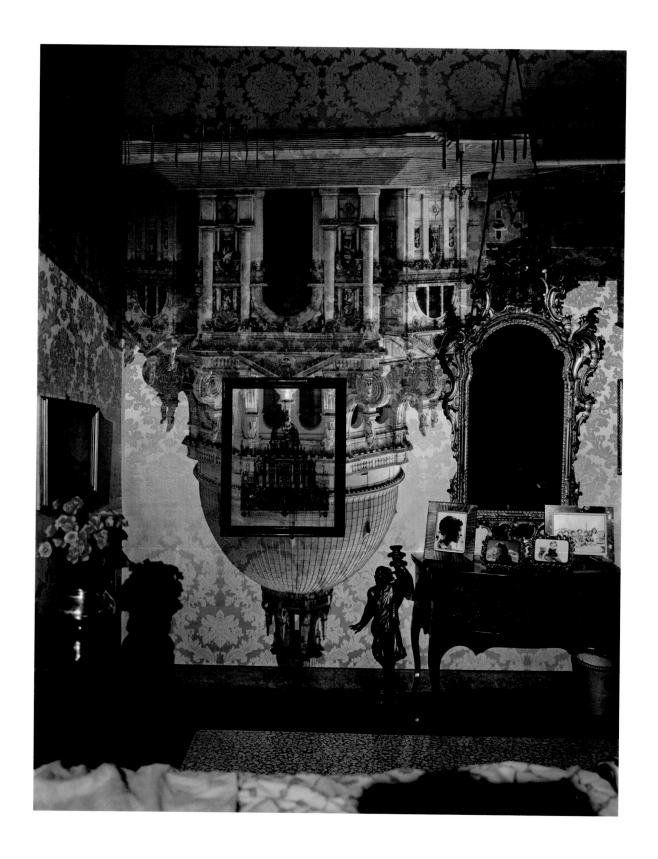

79. Camera Obscura: Santa Maria della Salute in Palazzo Bedroom, Venice, Italy, 2006

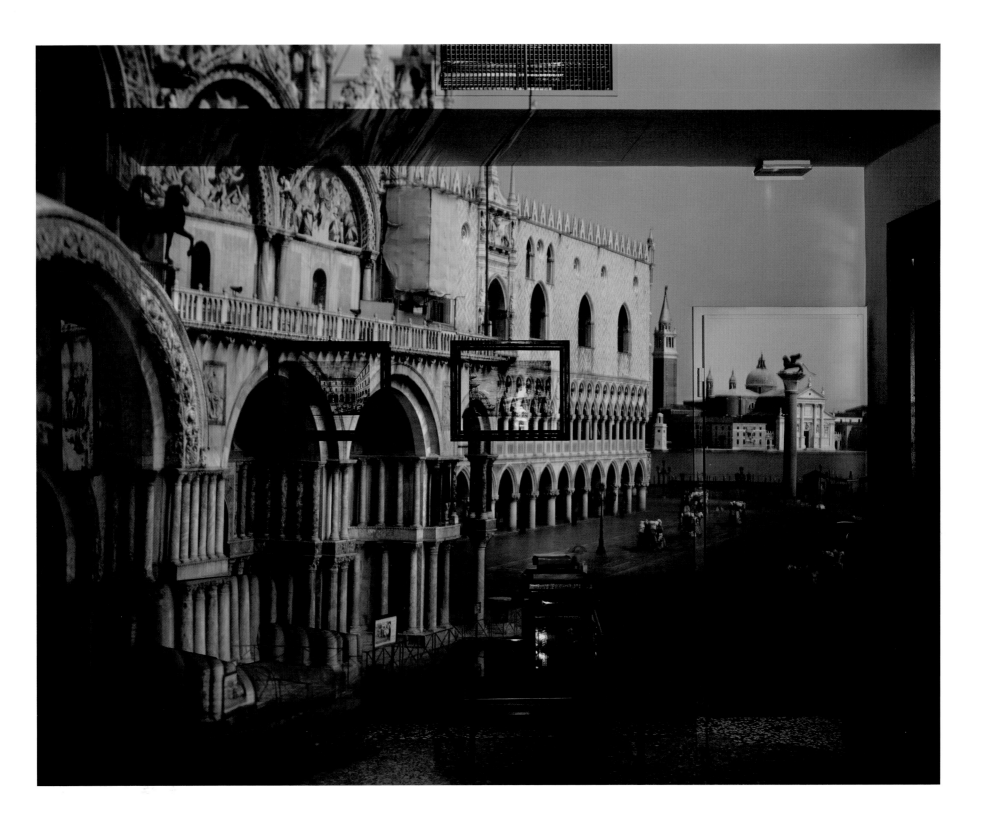

80. *Camera Obscura: The Piazzetta San Marco Looking Southeast in Office, Venice, Italy,* 2007

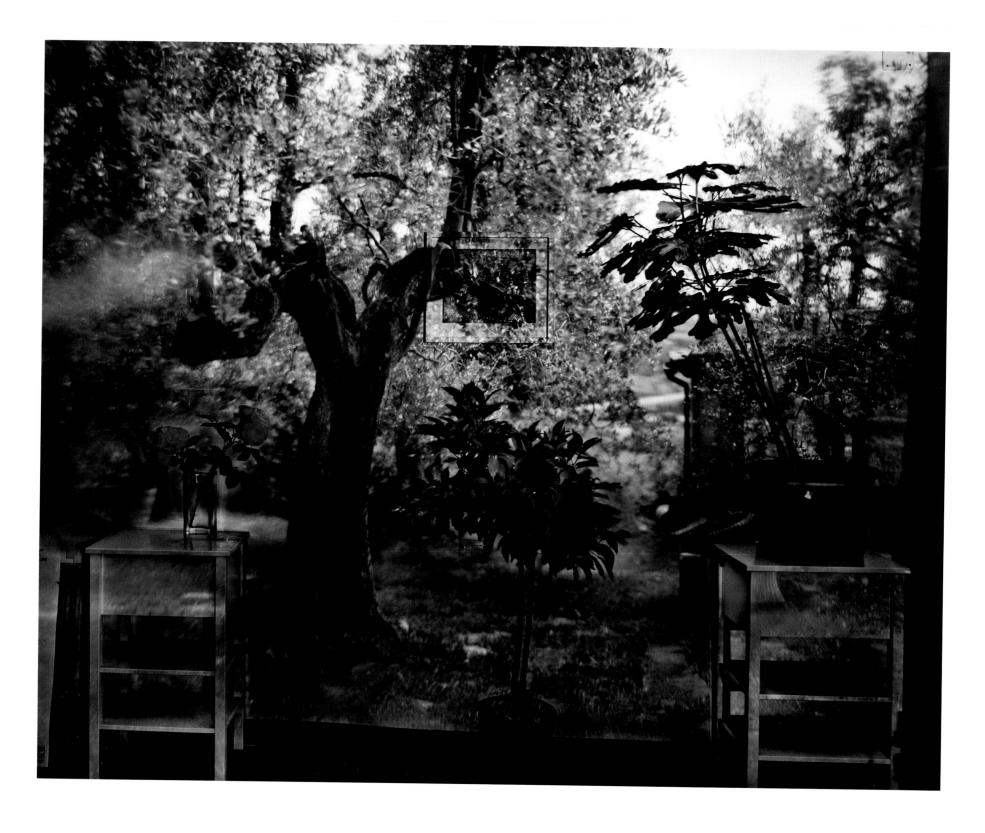

81. *Camera Obscura: Garden with Olive Tree inside Room with Plants, outside Florence, Italy,* 2009

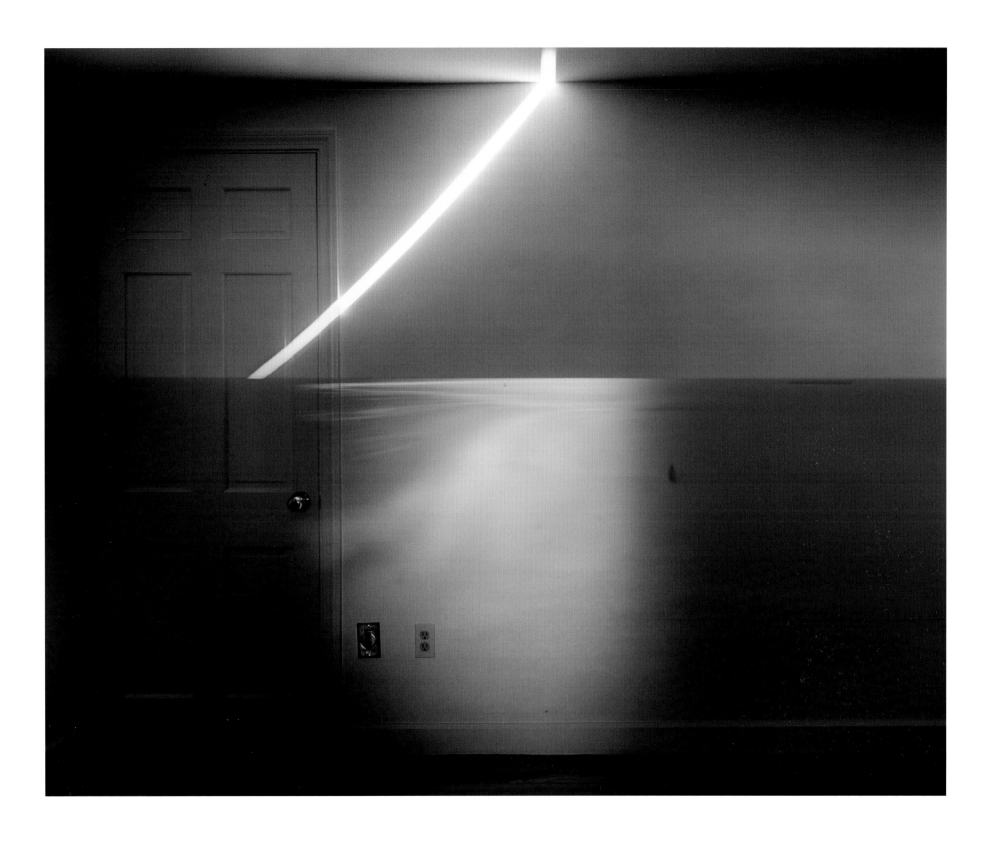

82. *Camera Obscura: 5:04 AM Sunrise over the Atlantic Ocean, Rockport, Massachusetts, June 17th, 2009*

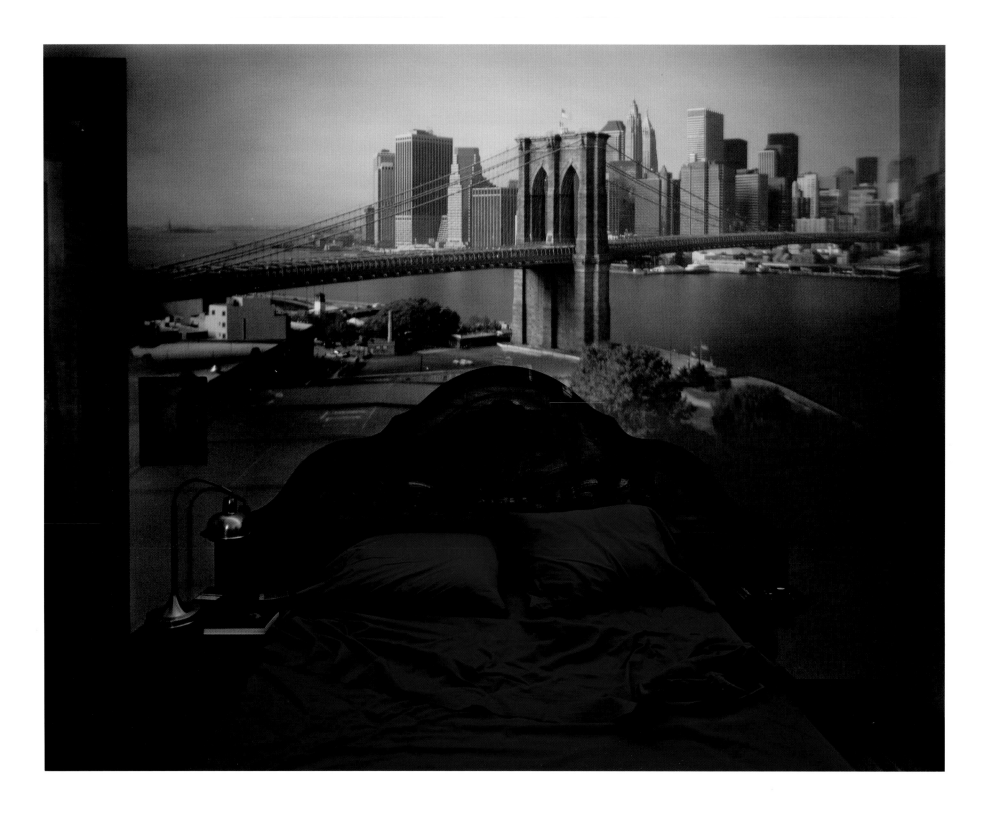

83. *Camera Obscura: View of the Brooklyn Bridge in Bedroom,* 2009

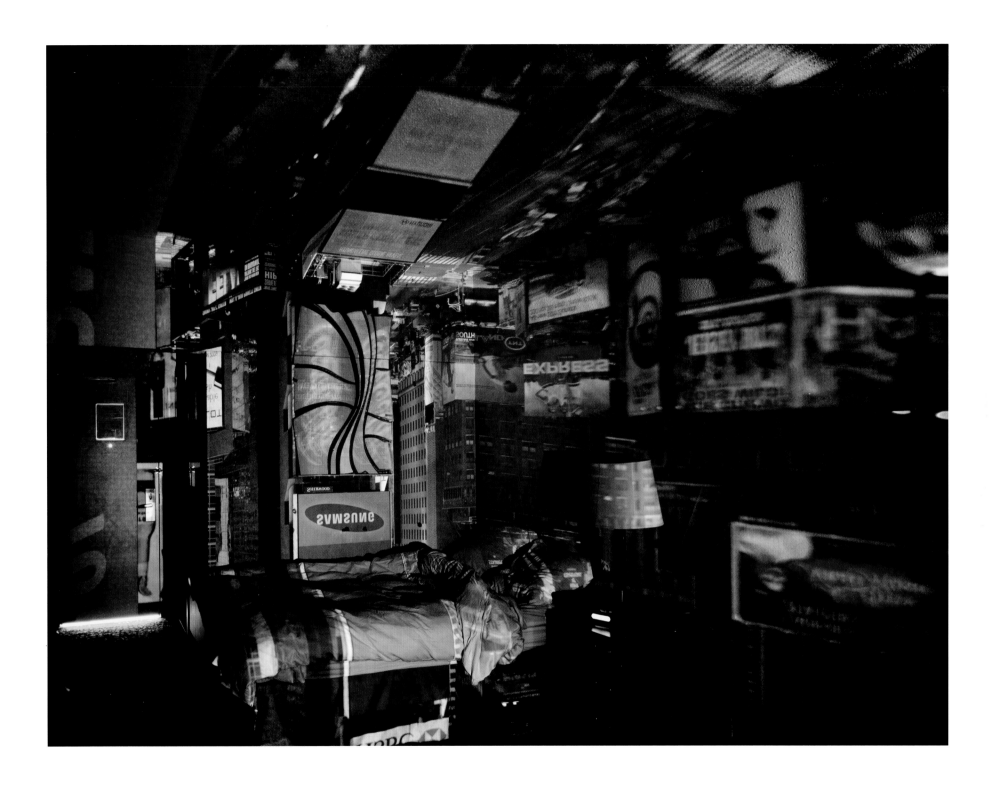

84. *Camera Obscura: Times Square in Hotel Room*, 2010

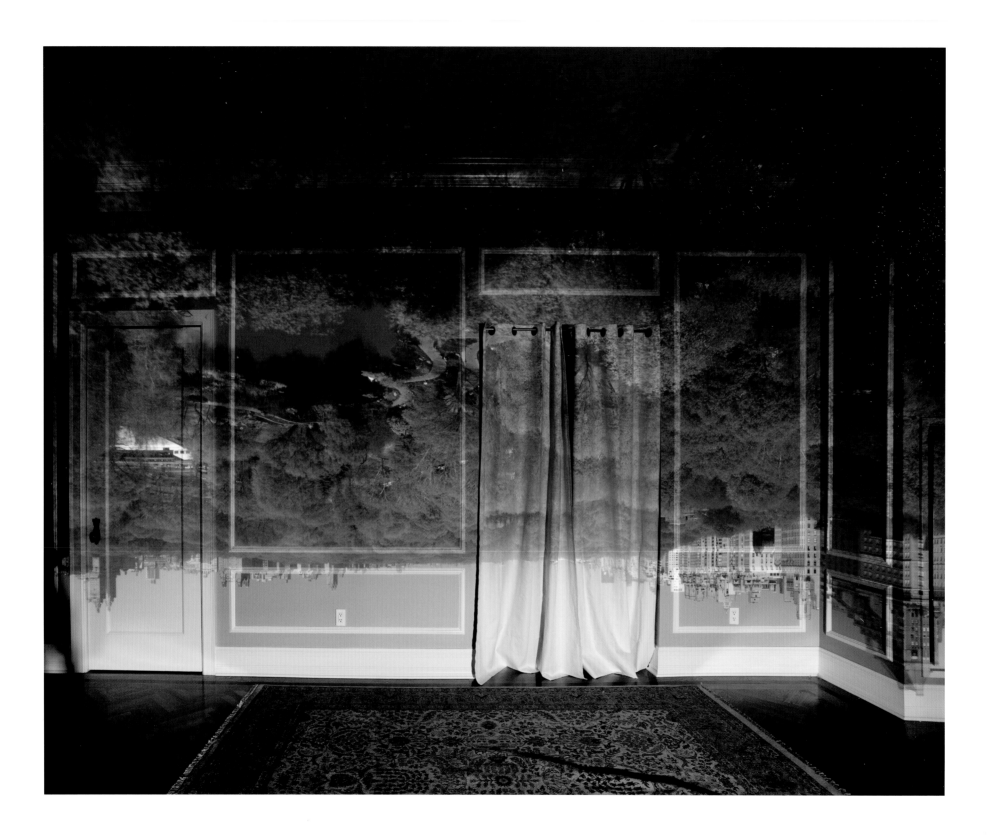

85. *Camera Obscura: View of Central Park Looking North — Spring,* 2010

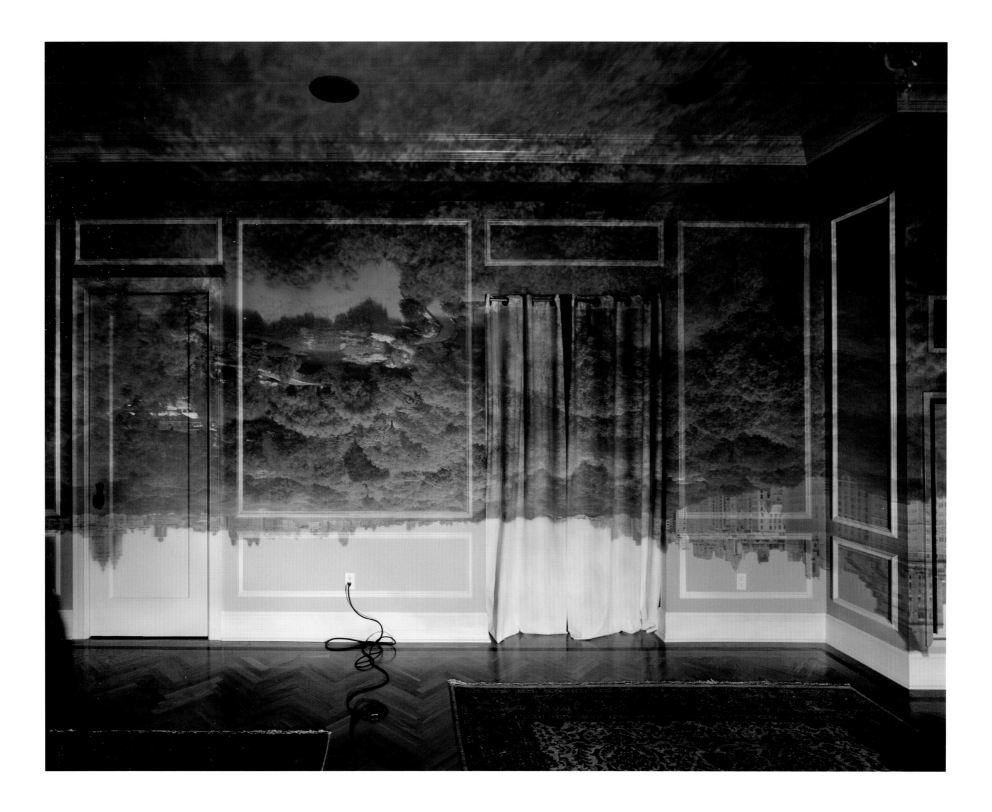

86. *Camera Obscura: View of Central Park Looking North — Summer*, 2008

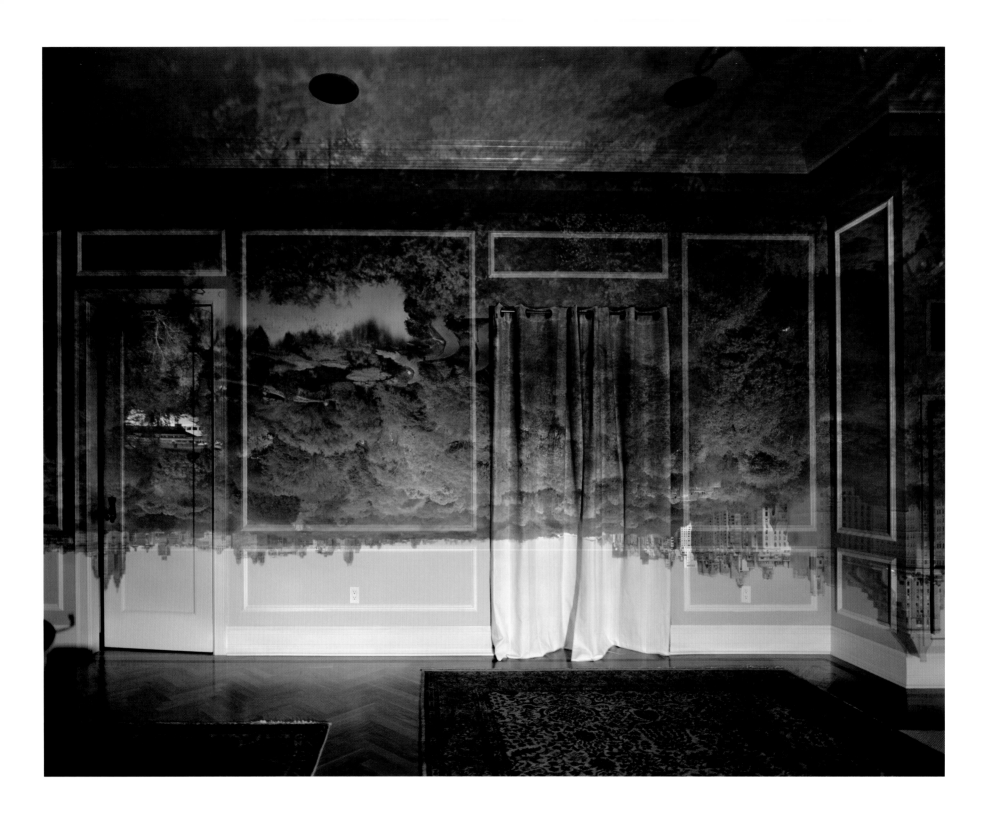

87. Camera Obscura: View of Central Park Looking North — Fall, 2008

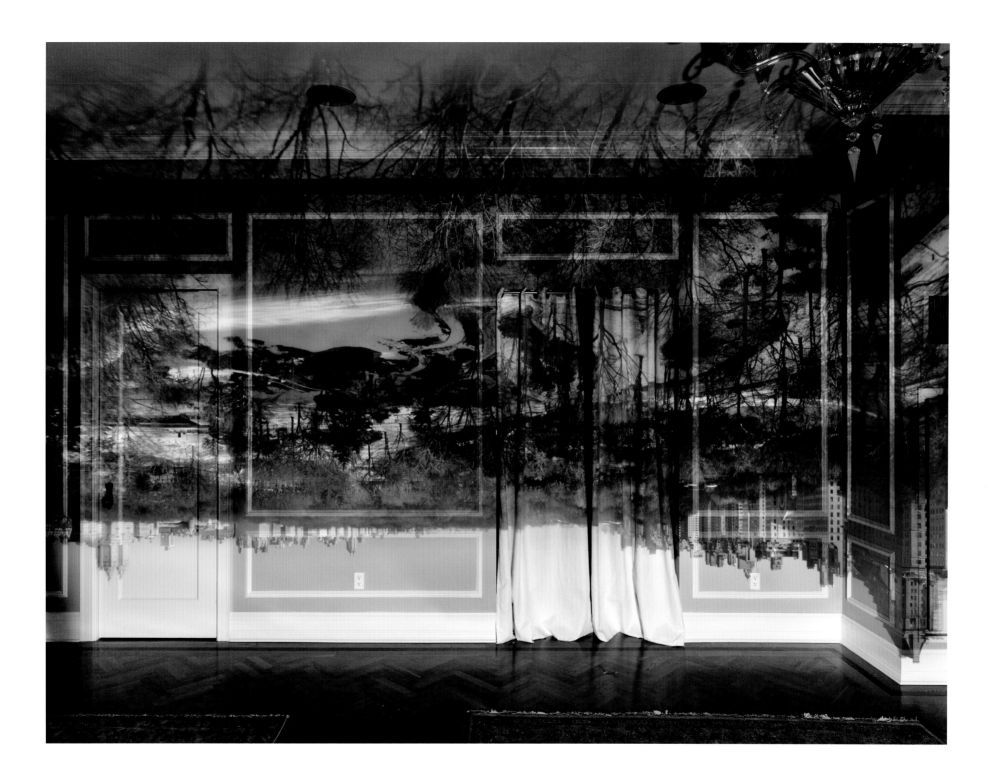

88. *Camera Obscura: View of Central Park Looking North — Winter,* 2013

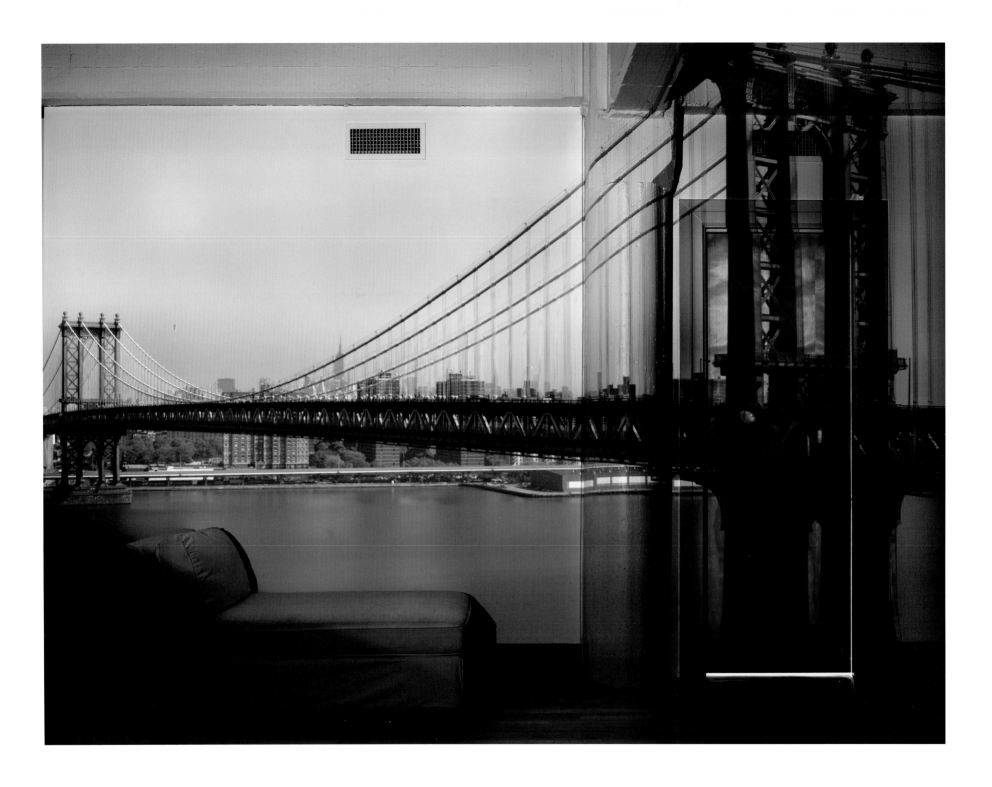

89. *Camera Obscura: View of the Manhattan Bridge — April 30th, Morning*, 2010

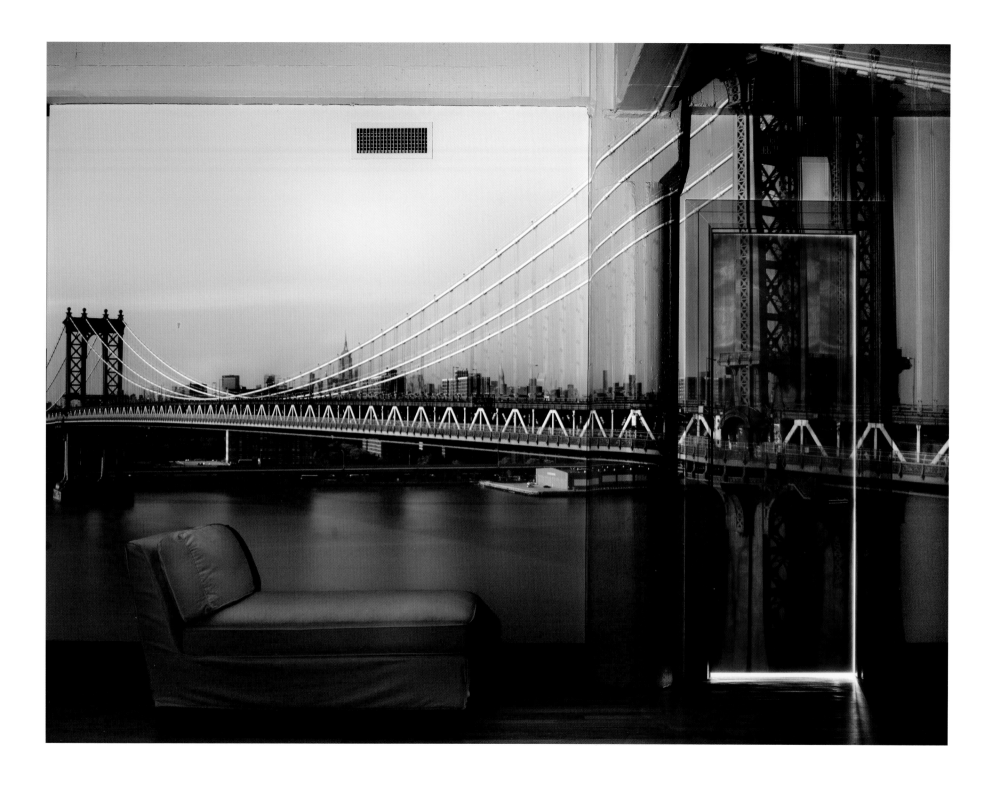

90. *Camera Obscura: View of the Manhattan Bridge — April 30th, Afternoon*, 2010

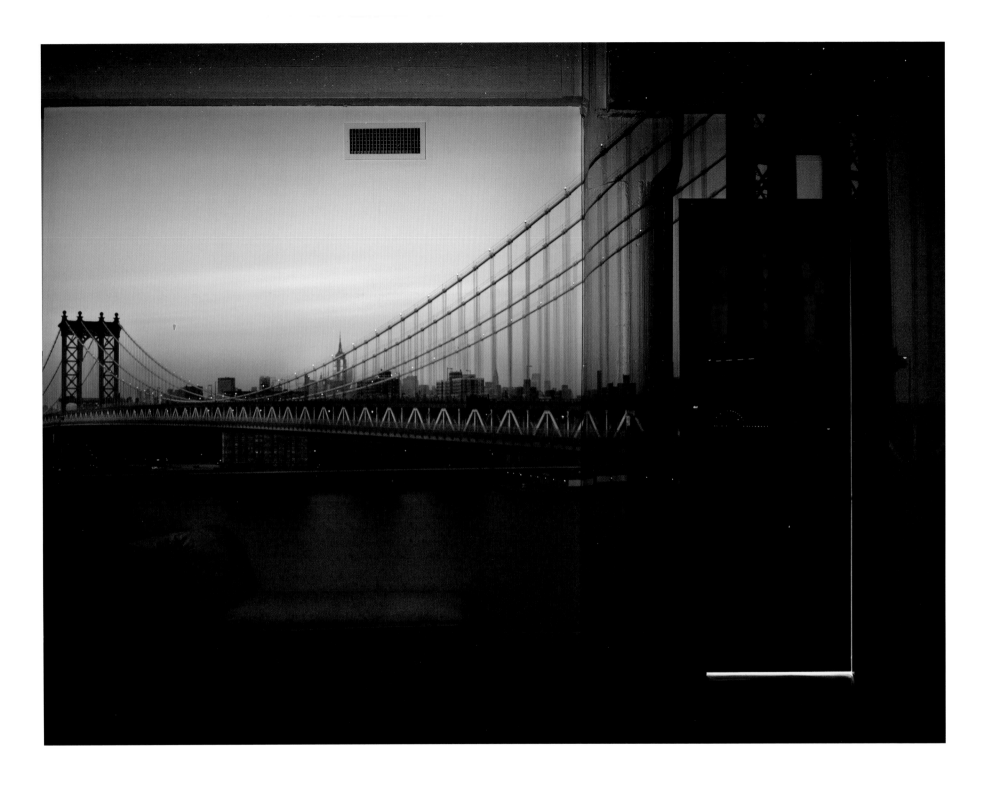

91. *Camera Obscura: View of the Manhattan Bridge — April 30th, Evening*, 2010

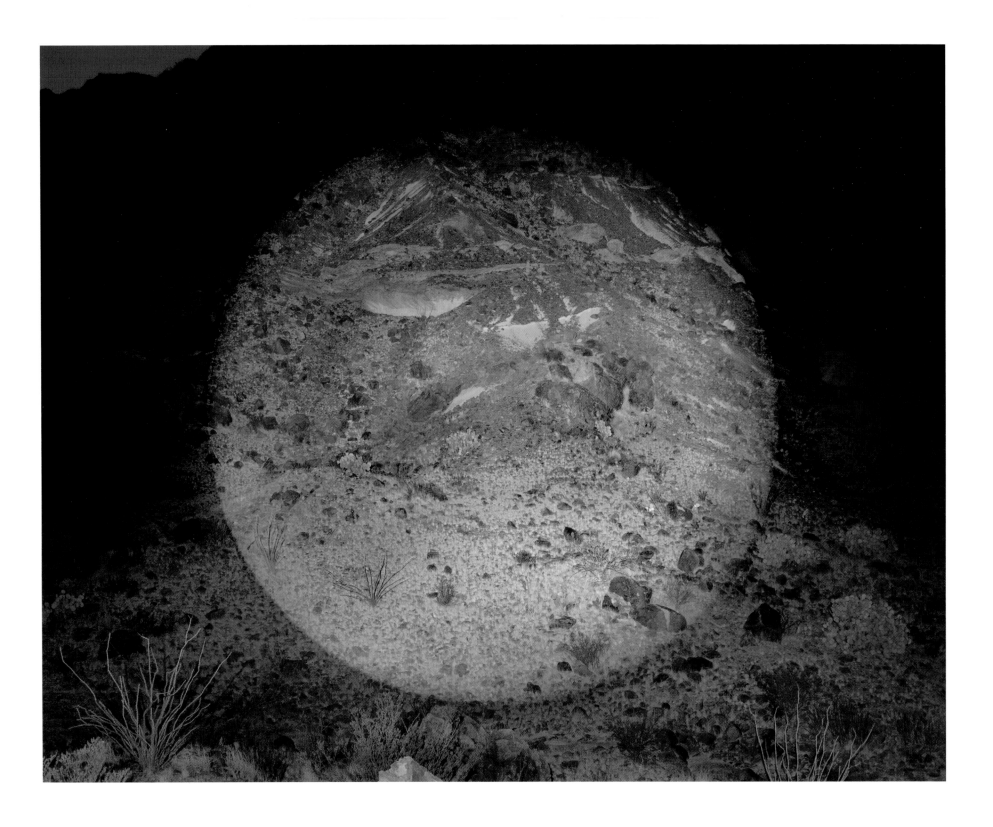

92. *Circular Light on Landscape, Big Bend National Park, Texas*, 2010

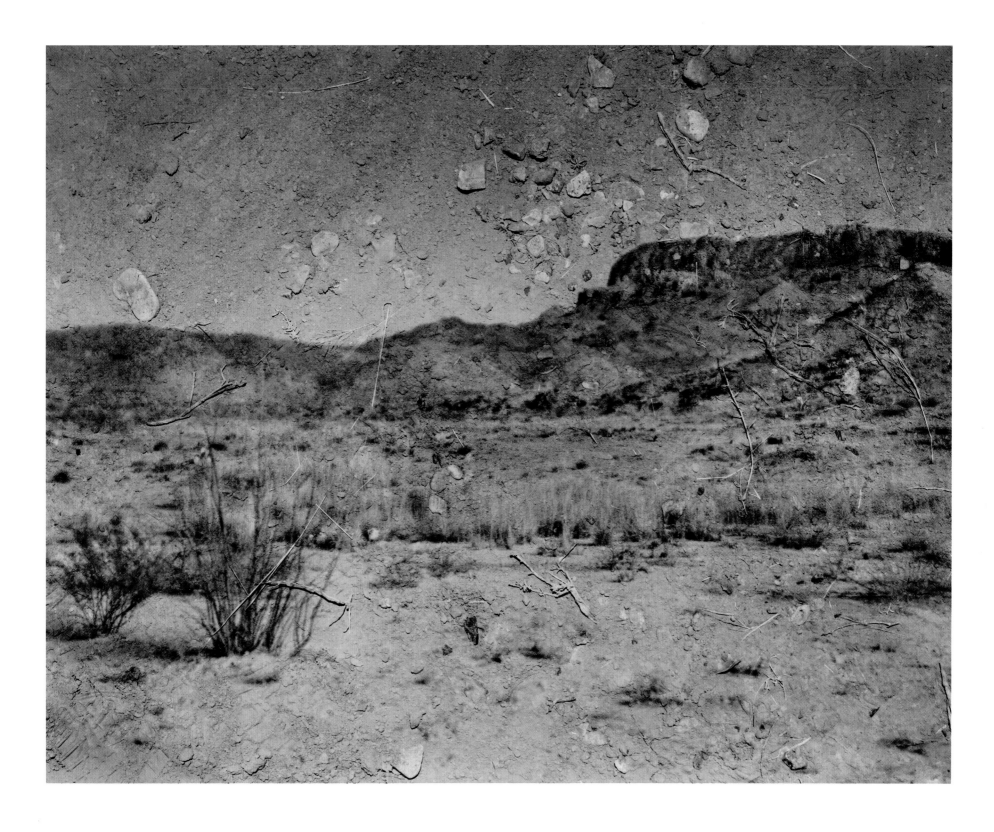

93. *Tent Camera Image on Ground: View Looking Southeast toward the Chisos Mountains, Big Bend National Park, Texas*, 2010

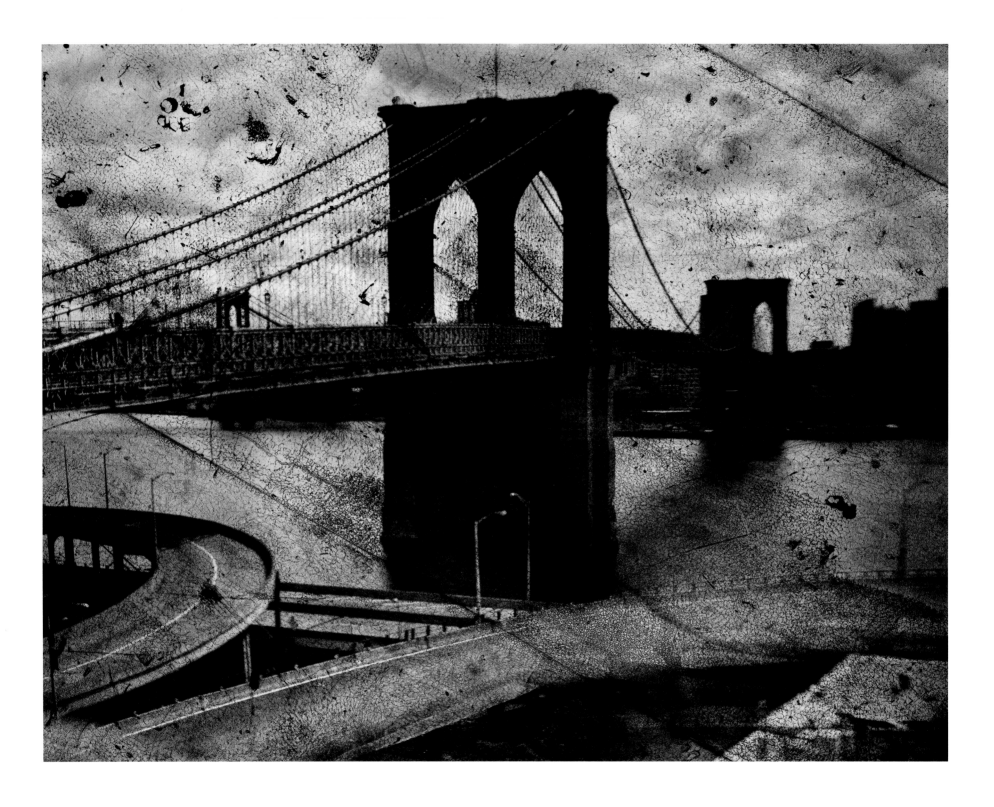

94. *Tent Camera Image on Ground: Rooftop View of the Brooklyn Bridge*, 2010

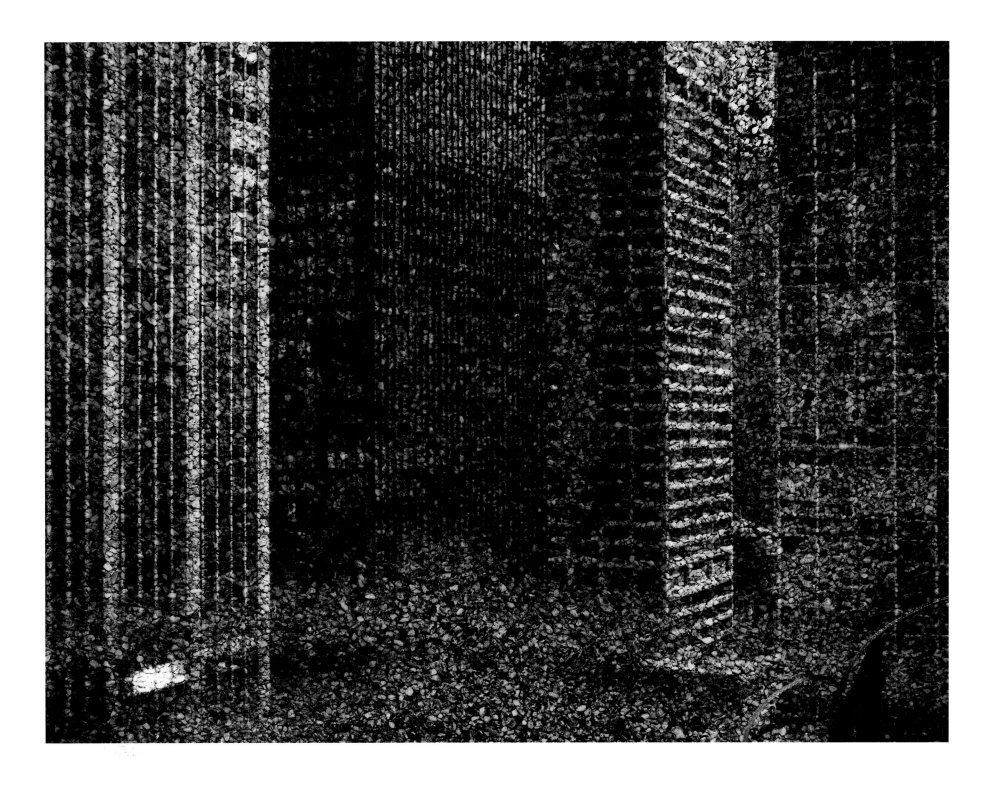

95. *Tent Camera Image on Ground: Rooftop View of Midtown Manhattan Looking Southeast*, 2010

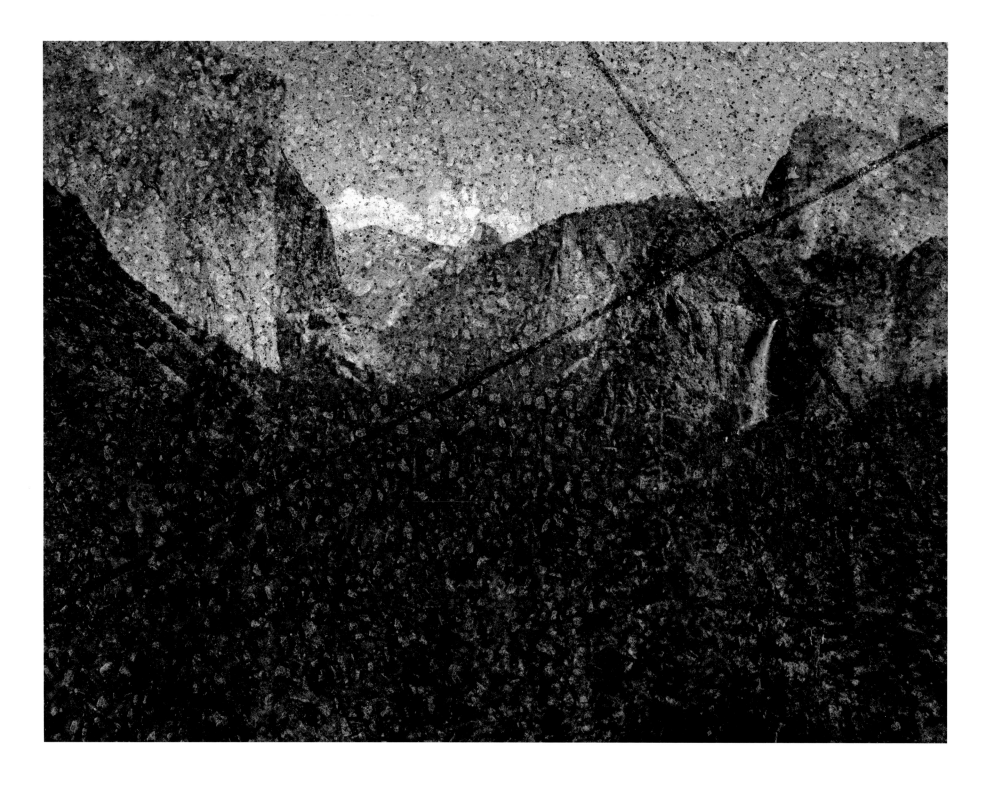

96. *Tent Camera Image on Ground: View of the Yosemite Valley from Tunnel View, Yosemite National Park, California*, 2012

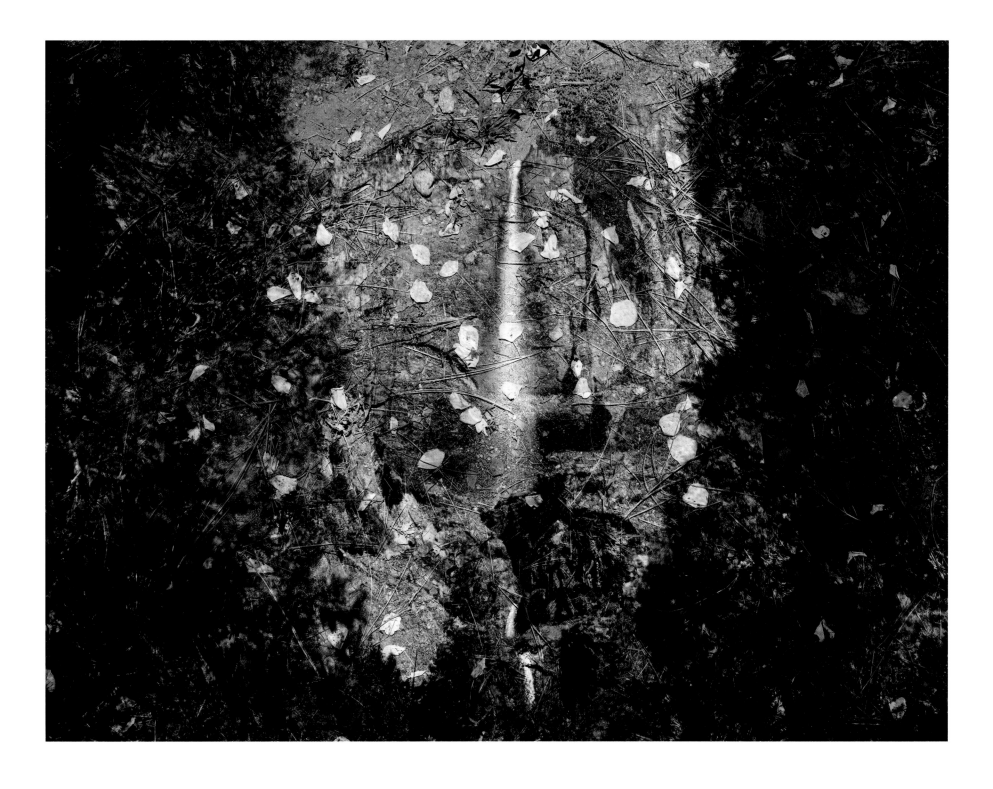

97. Tent Camera Image on Ground: View of Upper and Lower Yosemite Falls, Yosemite National Park, California, 2012

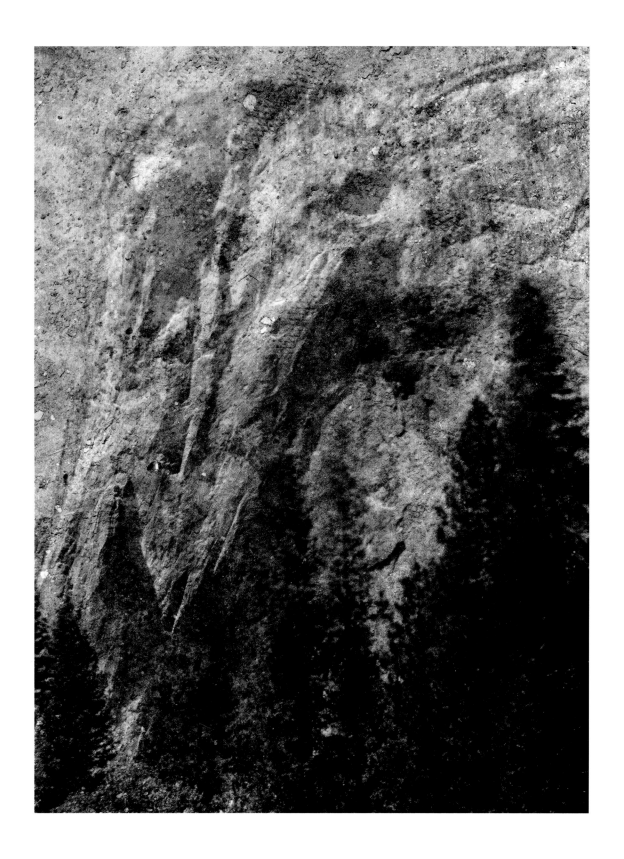

98. *Tent Camera Image on Ground: El Capitan from Cathedral Beach, Yosemite National Park, California,* 2012

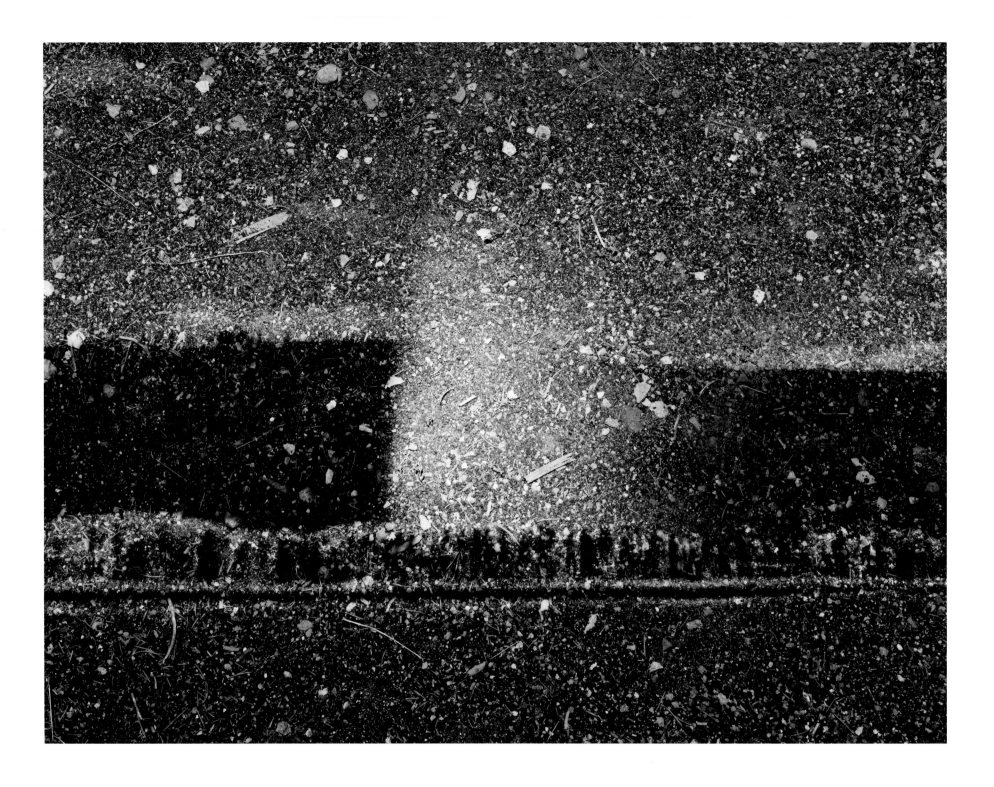

99. *Tent Camera Image on Ground: View of Old Faithful Geyser, Yellowstone National Park, Wyoming*, 2011

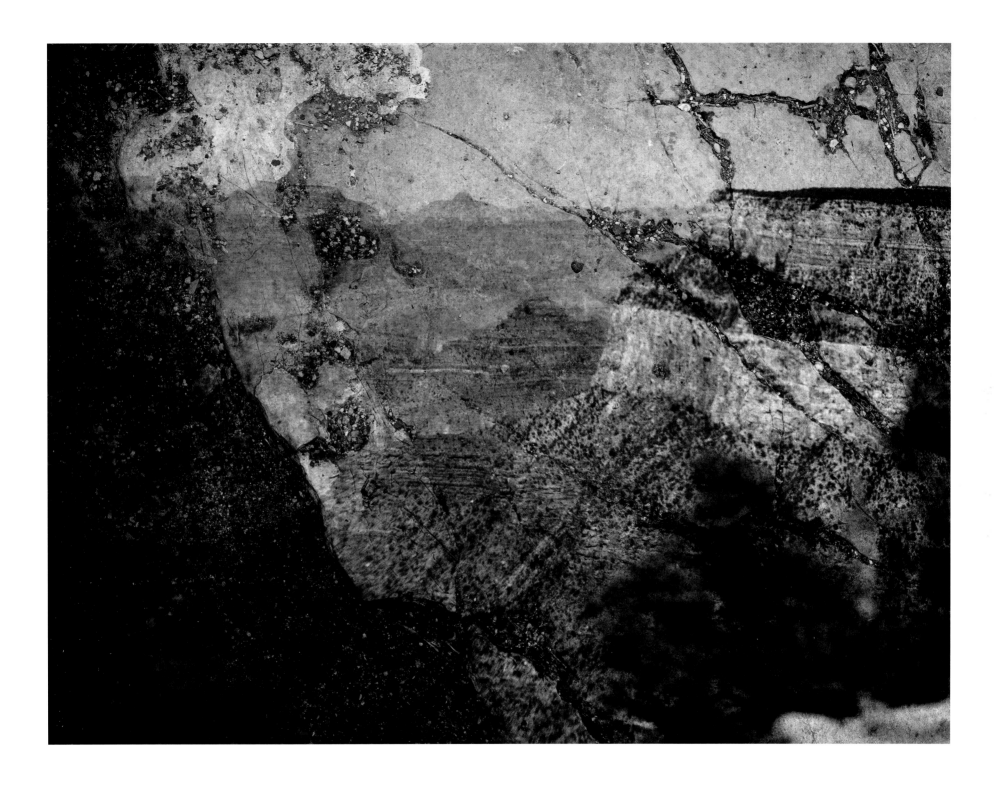

100. *Tent Camera Image on Ground: View of the Grand Canyon from Trailview Overlook, Grand Canyon National Park, Arizona, 2012*

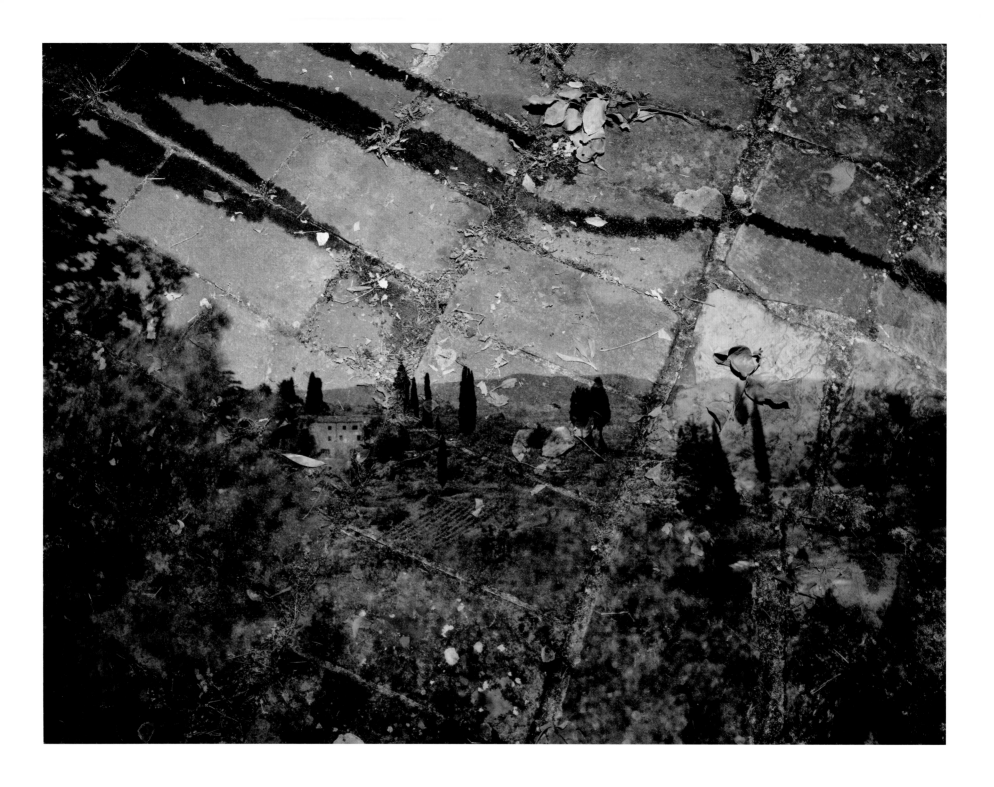

101. *Tent Camera Image on Ground: View of Landscape outside Florence, Italy*, 2010

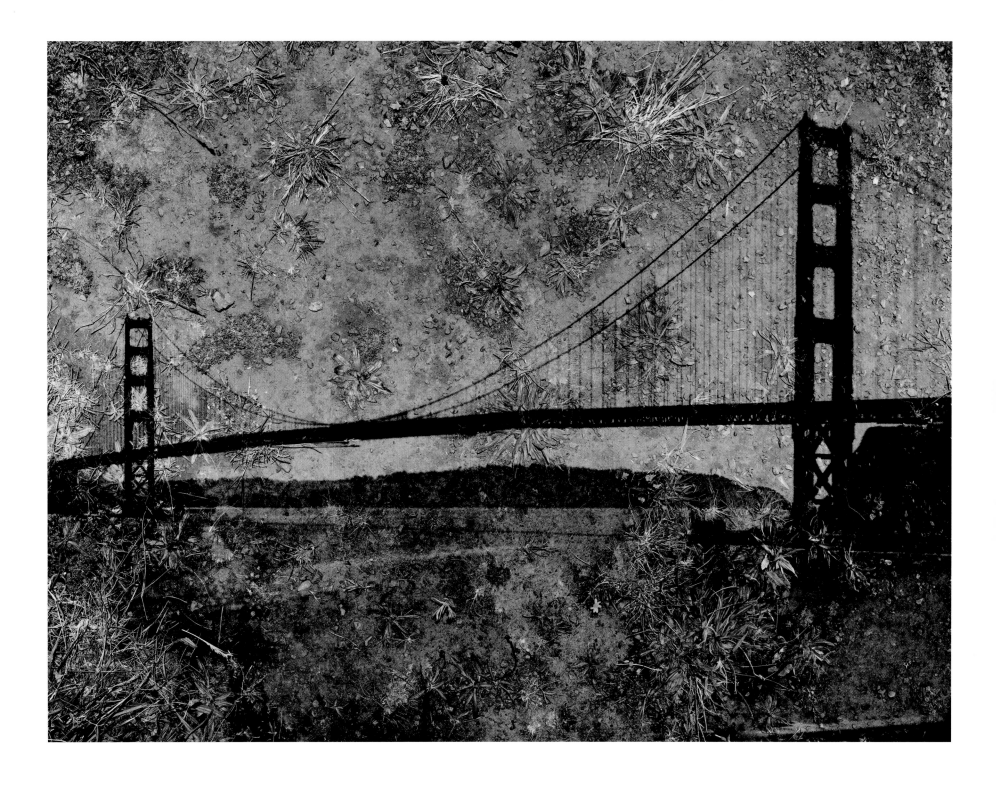

102. *Tent Camera Image on Ground: View of the Golden Gate Bridge from Battery Yates*, 2012

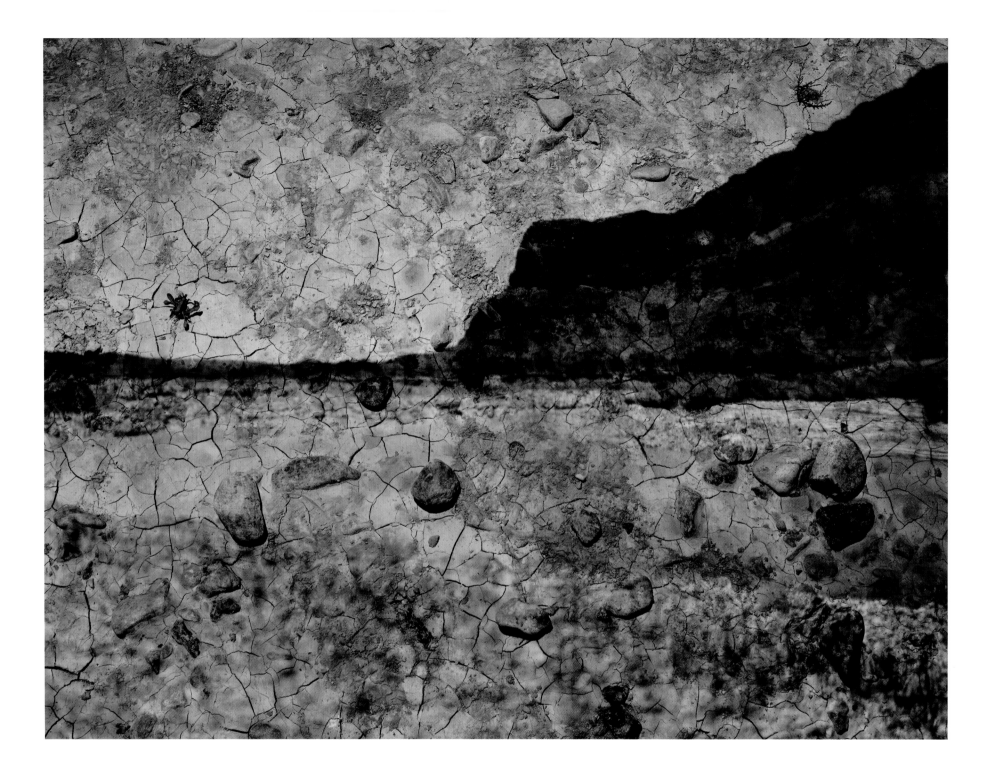

103. *Tent Camera Image on Ground: Rio Grande Looking Southeast near Santa Elena Canyon, Big Bend National Park, Texas*, 2011

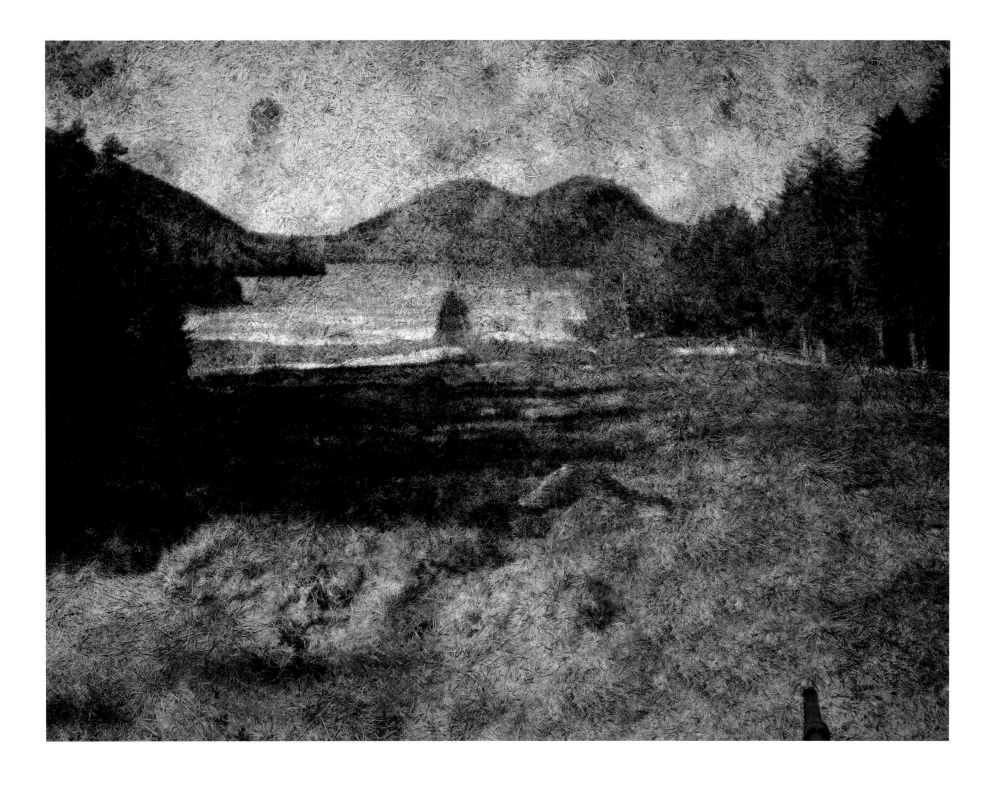

104. *Tent Camera Image on Ground: View of Jordan Pond and the Bubble Mountains, Acadia National Park, Maine, March 2010*

105. *Tent Camera Image on Ground: View of Sea from Winslow Homer's Studio Backyard, Prouts Neck, Maine, 2012*

In the late summer of that year we lived in a house in a village that looked across the river and the plain to the mountains. In the bed of the river there were pebbles and boulders, dry and white in the sun, and the water was clear and swiftly moving and blue in the channels. Troops went by the house and down the road and the dust they raised powdered the leaves of the trees. The trunks of the trees too were dusty and the leaves fell early that year and we saw the troops marching along the road and the dust rising and leaves, stirred by the breeze, falling and the soldiers marching and afterward the road bare and white except for the leaves.

The plain was rich with crops; there were many orchards of fruit trees and beyond the plain the mountains were brown and bare. There was fighting in the mountains and at night we could see the flashes from the artillery. In the dark it was like summer lightning, but the nights were cool and there was not the feeling of a storm coming.

Sometimes in the dark we heard the troops marching under the window and guns going past pulled by motor-tractors. There was much traffic at night and many mules on the roads with boxes of ammunition on each side of their pack-saddles and gray motor-trucks that carried men, and other trucks with loads covered with canvas that moved slower in the traffic. There were big guns too that passed in the day drawn by tractors, the long barrels of the guns covered with green branches

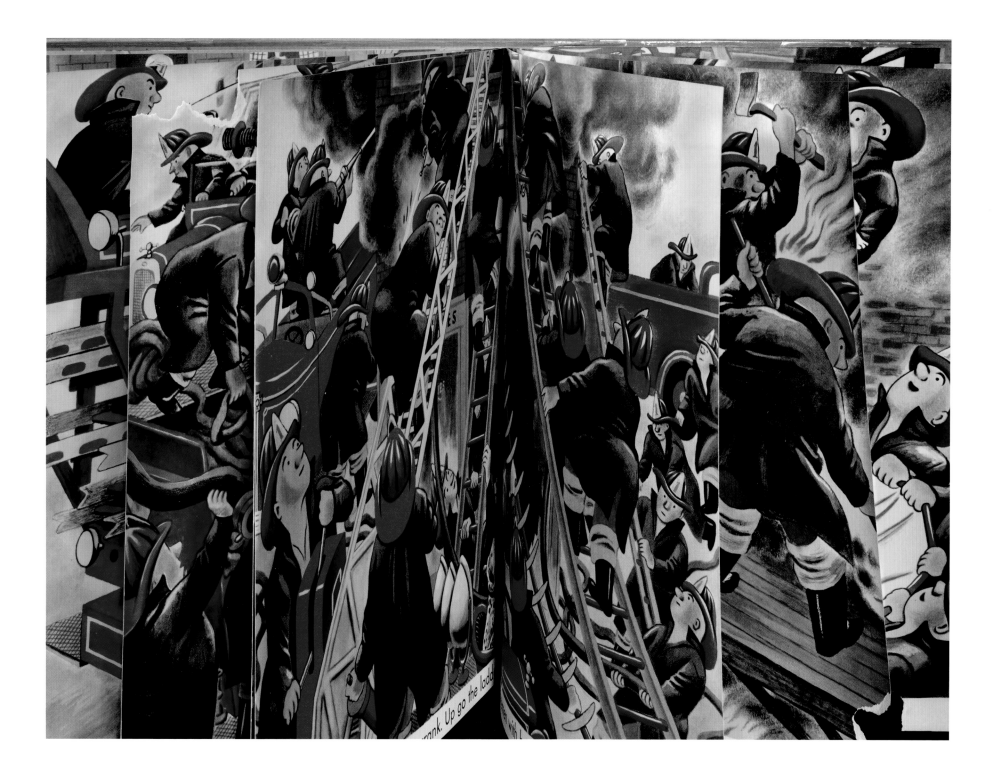

107. *The Great Big Fire Engine Book*, 2011

108. *Cutout: Piranesi Metropolis,* 2012

109. *Paper Self*, 2012

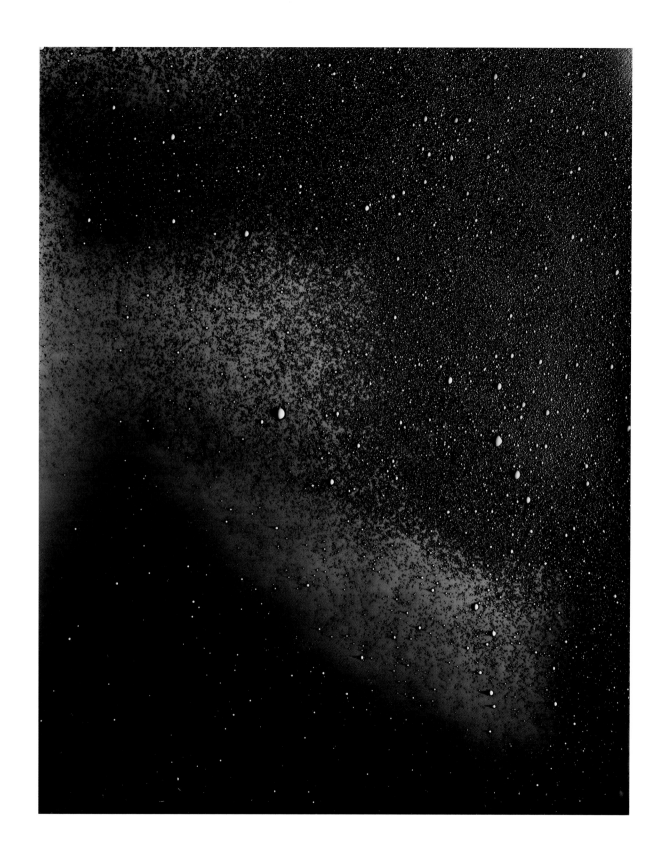

110. *Microcosmos: Photogram of Water on Film*, 2012

A CONVERSATION WITH ABELARDO MORELL
Paul Martineau

February 2012
Brookline, Massachusetts

MARTINEAU: Do you think that having come from Cuba, where there might have been fewer opportunities perhaps, that it was the promise of the American dream that gave you the hope to really achieve something?

MORELL: Yeah, although we didn't leave Cuba for economic reasons. It was a political thing. I was ambitious. I wasn't wearing it on my sleeve, but I guess I always thought that I could be something. Maybe that's just the illusion that I had to keep going. But coming to New York in 1962 was a real eye-opener. It was a little scary but it was also like—"Oh!" Like a door to something great. It was this overwhelming metropolis of crazy stuff and symbols and unknown codes.

Besides attending school, how else did you assimilate into American culture?

I was a delivery boy for a pharmacy in New York; that was one of my first jobs. So I waited at this pharmacy on Sixty-Ninth and Columbus and then I had to deliver prescription medication. And mostly, the clients at this place were on Central Park West, which was full of movie stars and high-class people.

What did you do with your free time?

Central Park was a block away, and it was a wonderful melting pot. So my family and I would have picnics every weekend in Central Park with Cuban food and that kind of thing. For us refugees, it felt like a real American experience. Sometimes I wonder if we had ended up somewhere else, I might have developed in a totally different way. New York City had a huge impact on me.

Do you recall first being attracted to art when you were in your teens?

Yeah, I remember buying a Brownie camera—I was fifteen or so—and I made some black-and-white pictures of my family and New York scenes. Not with the intention of being an artist, but I did like the idea of picturing things. At one point we bought a movie camera and I did a lot of filming around, too [see fig. 3 in the chronology]. So I definitely had a need to create images early on. In fact, when I do talks now I always begin with some of those early black-and-white pictures, which are crucial to my understanding of where I came from. They were part of how I survived adapting to a new country.

Did you go to any photography exhibitions?

Not early on. After I began photography in college, then I would go to the photography exhibitions at the Museum of Modern Art in New York. John Szarkowski was putting up all these wonderful shows, and I still remember the smell of those old galleries. It was a mecca for me. But I remember going there often to see paintings. Surrealist paintings were especially important. Between the time I was fifteen and twenty there were many visits to MoMA.

In 1967, you went to Bowdoin College in Maine on an academic scholarship. Did you have any art history classes there?

Not at first. Again, I did not really speak English that well. I had done well in a technical high school in engineering-type classes, and in the beginning, I thought I was going to be an engineer and took physics and calculus—and I flunked them both! [laughing] It was quite awful. It was a real wake-up call. When I got to college where really smart people were, I was a small fish in a big pond. I was quite shaken by that. And then I took a photography course in 1969. That was my first entry into it, and this wonderful man named John McKee taught it, and unusually so. He would play Bach sometimes and would show Zen paintings.

McKee mixed many different things having to do with photography, but photography wasn't always the point. I learned an expansive way of looking at art. I felt a sense of freedom and ambition I hadn't had before. I mean a sense of—"Oh, what I do is interesting and I can do what I want." All those things together felt really liberating. I owe John McKee a lot.

Photography helped you to express things that you might not be able to put into words?

Exactly. In fact my words were not very good to express feelings, because of my poor English. But visually I was quite daring, and I found a voice. And photography was at the heart of that. So very quickly, I think in two or three weeks, I knew this is what I wanted to do with my life.

Was there any doubt in your mind that you could succeed as an artist?

I didn't know how I would do it or get there or whether I could make a living at it. But the call to do it felt powerful. It was a total leap of faith. For many years I had jobs as a janitor, a doorman, and working as a ward clerk in a hospital so I could buy film.

You were doing black-and-white darkroom work at that point. Did you find that that was easy for you to pick up?

Yeah, I was a little maniac at first. I did a lot of solarizations and cut-up pictures and I would lift pictures from the garbage can that other students had discarded and paste them together with mine to create collages. So, my earliest pictures were really experimental and tried to look like the Surrealist paintings that I liked because I thought well, this is what art should look like. I thought in order to make it good you had to make it strange, but

one important picture that for me was a game changer was a picture I made of a girl in Spain who was wearing a white dress. I made that in 1970, and every time I used to print it I felt like I needed to solarize it. Then one day I made a really beautiful straight print of it and I realized that it didn't need anything else [fig. 7 in the chronology]. From then on I thought straight photography can get to that weirdness by itself, without the other gimmicky stuff. It's much more subtle and you're letting the viewer get to it in a slower way. I became a straight photographer right away. I felt the world is strange enough; why do I need to mess it up? So that was a great lesson for me.

So do you consider that's when you really discovered your style, or would you say that that came later?

No, at that time I wanted to be like Helen Levitt, Diane Arbus, Henri Cartier-Bresson, Robert Frank, and I wanted to photograph like them because I really loved their work. They were heroes and heroines, so I wanted to rise to that level. Years later, in 1979, when I went to Yale graduate school, I kept making straight 35 mm street pictures, and at that point street photography was "in," you had to cut your teeth on that [see fig. 9 in the chronology]. So that aesthetic stayed with me for a long time after graduate school.

And then after your son was born you had another key moment?

Yeah, it is rare in life that you get clear moments in which you know something is about to change. Well, first of all being a father was a huge thing for me. I felt, since now I'm a father then I get to decide what's important for me. Not necessarily to make pictures like some of my mentors or some of my teachers. It was a subtle liberation but it allowed me to slow down and start thinking. So from photographing in the streets to having a child, I changed cameras, directly. I started using medium-format cameras and 4 × 5 inch view cameras; the description was better and the looking was more deliberate. Emotionally, when you deliver your son, I'm convinced that there's nothing ever that matches that. If you're not going to feel anything at that point then you're really in trouble. And I did feel a lot and somehow I was able to allow this emotional thing to be part of photography.

One of the things I've always admired about your work is its authenticity. You don't seem to have gotten caught up in the rat race of the art world. Authenticity is a rare quality these days.

I wanted to be true to this world. And I really did feel like I had taken a different road from the Yale days and the whole hip and edgy approach. The only way to do well is to commit to a thing. Like my marriage to Lisa, to be dedicated to something and then grow from it. I let that family thing allow me to grow.

It's like how Degas tended to use certain motifs over and over again. He felt free to experiment with his technique because he didn't have to be so concerned with his subject.

That's right. I think Jasper Johns has a great line about that, "Take an object. Do something to it. Do something to it again." It's important for me to feel that I'm planted so I can be inventive. Within the confines of this apartment I felt liberated to experiment. I was on the floor a lot with the view camera, like an inventor or something. Just let's see what this corridor looks like if I'm on the ground. I loved those days.

Using a view camera in the mid-1980s was like going back into the past in terms of photographic history.

Absolutely. I wanted to be astonished like Talbot and Daguerre were in the early days when photography was new. I think it

was a new way to describe this complex reality that's almost without artifice. So I was crawling on the floor with a camera, like a newborn.

So many of the pictures from the mid-1980s are delightful in their expression of discovery and wonder, but there are some that seem melancholy or mournful. Was that your intention?

Yeah. Well, some of it was a reaction to graduate school where melancholia was not something to be dwelled on. I was doing something a little sweeter than it ought to be, just to test the boundaries of sentimentality. How far can I go with this?

I like *Toy Blocks* [plate 2]. That picture reminds me of childhood fears. It is a bit scary.

Yes. That's exactly what I felt at the time. It was a technical nightmare because the camera was on the ground. It's a big view camera, and to focus on something like that was almost impossible because the ground glass was touching the floor, so I had to tip it and try to guess what the exposure was. Then I also had to correct the back so that the thing didn't vanish into the vanishing point. But I knew that for Brady, being so little, being on the floor, a stack of blocks like that was quite imposing. I wanted to suggest the fears and the awesomeness of confronting certain things at an early stage in life. Around that time, I also was reading about theories of language and it struck me that, when you're a baby, you don't have many words for what you see. And, to a child, without language to calm things down, the world is full of odd-looking stuff. A sofa can become a monster or something. With language you can say *sofa* and then it becomes tame. I wanted to use the camera to deal with those pre-language shapes.

Toy Blocks and *Ball* [plate 5] also make me think of toys that are used by children and then abandoned.

Yeah, and it's sort of sad. *Ball* is the closest I've come to total sentiment. I was thinking about Rosebud in *Citizen Kane*. We've all had that ball, the memory stays there and our physical connection to it informs us for a long time.

Another photograph that intrigues me from this period is *Dollhouse* [plate 10]. It contains so many different layers.

Yeah, that picture's different because it has one foot inside and another out. To me that image sort of pits the security of our home with the lurkings of the outside—not quite dangerous but *other*.

By having that dollhouse in the front, you think of the girl who played with the dollhouse and then you think of her growing up within the house—and then going out and becoming part of the community, perhaps buying a house of her own.

Yeah, there's continuity in that. But it's also because the outside is super bright and out of focus. It's not quite certain. Maybe that photograph was a symbol of my own struggles and insecurities. How do I make it in the world? How do I *buy* a house? [laughing] I was doing the work, but I was also thinking, "What am I doing? Am I making baby pictures?" I was looking at what other people were doing, and I wondered if I was being left behind.

And how about *Pencil* [plate 13]? A pencil is a small object, but who would have guessed that it could cast such an imposing shadow?

Lisa and I were having breakfast. We were up pretty early and we were talking about taxes and kids, just boring stuff. There were some crumbs on the table, and as the sun was rising the crumbs were throwing enormous shadows and I said, "Check this out, Lisa! This is really wild." Then I took a pencil and I put it down and it really threw a gigantic shadow. And so the next day I got up early and waited for the sun to rise. I was fifty-two at

the time and I had never seen such a shadow from a pencil! It was a real lesson for me—there are surprises out there that we don't pay attention to because we're too preoccupied.

That composition reminds me of still lifes created by Paul Outerbridge and Ralph Steiner, Precisionist artists coming out of the Clarence White School in New York in the 1920s.

Yeah, modernist photography and painting were really important to me, like Paul Strand's still lifes early on. Something I love about the modernist works is their strong graphic sense, which to me is the skeleton of a good photograph.

Taking something ordinary and making it extraordinary.

Exactly. A pencil having that much *potential* feels good.

I was looking at *Small Vase at the Edge of a Table* [plate 20] and thinking about how wonderful that picture is, how much tension is in it. And I was curious how you went about constructing it.

I'm quite curious about the idea of instability in life, but not to the point where things break. I actually put a little piece of paper under the vase to make it tilt since it wouldn't have had that tension on its own. I had to find the angle of repose for the vase, and I found it after it fell a few times into some pillows down below. There's a certain sense of it being a kind of a conflicting cubistic scene and maybe the vase is out of hope. Who knows if it jumps or not?

I think it's very interesting that you've disproven the old saw, "those who can't do, teach," because you've really managed to do some amazing things, and it must have been tough juggling the demands of raising a family and teaching full time while trying to move yourself forward artistically.

Yeah, it's a funny juggling act, but the truth is that my family gave me inner strength, and teaching, just being with young people was great. I learned a lot from my students. You have to be clear about what you're saying, and that kind of clarity also helps you distill certain ideas. It was demanding, but it also kept me in touch with other people who were in the process of making art and that was very helpful. I was always trying to do stuff to make learning interesting for them. I taught for twenty-seven years before I stopped.

There's such a sense of magic in your camera obscura views that I can't look at them without thinking of you dressed as Charles Willson Peale, pulling back the curtain to reveal his museum. There was something of an impresario in you, I think, when you created *Lightbulb* [plate 23].

Yes! I made that picture around the time that there was a lot of postmodernist talk and writings by people who did not like or understand photography. What it came down to, basically, was photography is dead. It's all been done before.

So you created that device to teach your students about the humble beginnings of photography.

Yes, it's humble, but it's still magical. I wanted to show them a picture like Peale and make the challenge: "Oh yeah, so you think photography's dead? Check this out! What do you think about this?" This box could not be cruder. Yet it yields something almost Platonically perfect to me.

Did you experience difficulties when trying to make the picture?

It took me about a week because technically it's a nightmare trying to get a lightbulb that's so bright to show up at the same time as a dimmer one. I had to test all kinds of wattages and exposures and development times. My development time became

very short so that the contrast wouldn't overblow the picture. That picture came to my mind very quickly but realizing it took a lot of time. That's par for the course with me.

Well, it's apropos because the only way people have advanced the medium is through this kind of experimentation.

Right, the technology has to be tweaked all the time to make the right things happen. I often feel the joy of inventing something, but I'm also really troubled when things don't work.

Tell me about your first camera obscura views.

I made the first two in 1991 in Quincy, Massachusetts, when we lived there. They were of our living room and bedroom [fig. 14 in the chronology; plate 24]. I really felt like I had invented photography because I had never seen a picture like that.

How did you go about choosing some of the other places that you decided to picture? The idea of making a photograph inside a camera obscura was something new.

I thought, "Wow! What else can happen?" Then I thought, New York, my hometown from the past. My parents lived there, so I started calling people who I knew in New York.

But by picturing New York, you were making it your own, bringing it under your control.

Absolutely, these pictures were my way of getting my own private New York, a place that once seemed unknowable to me as a young immigrant.

You went back to Cuba in 2002. It was your first visit since your family left in the early 1960s. What was that like?

I'm totally against the regime in Cuba. I think that they've made a mess of things. People are struggling, but they're people. The demonization of Cubans as the Red Menace that was in my head before visiting there just went away. It was a very good trip for me in terms of finding Rosebud again.

When you got started with the childhood series, you were using your view camera and black-and-white sheet film. Is that correct?

Yes, sheet film, 4 × 5 and 8 × 10.

And then were you able to print them in your own darkroom?

Up to 20 × 24. That was the biggest I could make them in my own darkroom. Anything bigger would have to be printed in a lab in Concord.

A few years after you started creating your camera obscura views, we had the advent of digital photography. It seems as though art photographers started to feel sentimental about the potential loss of analog photography, and it became fashionable to mine nineteenth-century technology such as the daguerreotype and the wet collodion glass plate negative.

Yes, many of us were mining the past for ideas, which is a strategy that artists have used forever . . . Like the way Sally Mann made contemporary landscapes look like nineteenth-century ones.

You seemed to be ahead of the game; others came to that after you did. You had one foot in the past and one foot in the future.

When I made my first camera obscura pictures in 1991, I think I stumbled into something that hadn't been done in photography. I was rediscovering some of the tools of the past and using them to reshape the medium.

One of my favorite camera obscura views is of Lacock Abbey in Wiltshire, England [plate 33]. It's a great picture and it just happens to be the very place where Talbot invented the paper negative/positive process of photography.

Yes, I felt as though I had walked into the past. I remember finding that room where he made some of his famous early pictures. For me, it was akin to seeing the Big Bang.

It must have taken a long time to expose that picture.

It was an eight-hour exposure. A lot of those exposures with black-and-white film took six to eight hours—now it's a lot shorter, but what's nice is that you start an exposure, then you get to wander around. You go on a little hike, see a movie, have tea . . .

I read a great story in the *New Yorker* in 1996 about you written by Mark Singer.

Singer was writing about spending a day with me and in fact at one point we were lying on the floor looking at the image of Manhattan cast on the wall and we're talking about our college days when people took acid. It was like "Oh, this is what people were aiming for." I never took acid, but this was even better, we were sober. Then I came up with the idea—you know how Christo covers the buildings from the outside? Well, I'm doing the opposite of that by covering the room from the inside, so I said I'm the anti-Christo. Singer included that story and my mother read the article. And she was really upset that I was the anti-Christo! I'm going to fry in hell. I love the idea that Christo could spend all this time and money to cover a whole building and then I could just show up and poke a little hole in it.

When I was looking at some of the books on your work, I got the sense that your projects weren't discrete, but that they were often overlapping.

Yeah, I was making camera obscura views in New York. But then I would make an appointment at the Boston Athenæum, which I spent a good deal of time in, and they were willing to just show me anything.

You can focus on the details but still incorporate big-picture ideas into your work. You took a map and you turned it into a landscape [plate 55]. You made it into a piece of sculpture.

Yeah, I really like that. It's just a map of Europe but then I crushed it and then spread it out again. And that's part of that instability that I'm thinking about too in my photographs, that stability and instability at work.

It's an abstraction. I can't look at it without thinking of the powerful forces that shaped the Earth's crust. So when you were thinking about those ideas did you have the ideas and then find a way to express them, or did you start with the basic materials and manipulate them, play with them, and find some of the ideas seeping into the work?

I took a map and felt like I could do something with it. It's like the Jasper Johns thing—do something to it. And of course my instinct was to crumple it up. I like what you said about big ideas. The idea that a map is of a territory and a territory can be mountainous, and so in one simple step you could merge the two things.

Right. And there's something about the map and its demarcations of different territories and countries, that if you are manipulating that then now *you're* in control. You have the ultimate power.

That in fact I'm kind of a shaper of the world, which is a little bit scary.

I like *Map of North America* [plate 54] because you have this tumultuous crumpling of the map around some water in the center and the water is the thing that keeps that image calm.

Yeah, it's very still. Los Angeles and New York are fine, you notice, but the Midwest is totally sunk.

The series of photographs that features books is beautiful and the pictures within it have such a tactile quality about them that it almost seems as if you can smell them, see the dust coming off them, et cetera. Were you able to create those pictures in your studio or did you have to do it in situ?

I did the majority of them at the Boston Athenæum and the Boston Public Library—they were very generous. I would ask for certain books, from really tiny ones to big ones. They were willing to satisfy my curiosity.

What were you looking to communicate in your photographs of books?

I wanted to get to those primal feelings of how a child, my son or my daughter, would bite into the books and chew on them. I wanted to explore the materiality of books first and then get to the intellectual stuff later.

Dictionary [plate 42] is one of my favorites. It makes me think about the accumulation of knowledge since books are a kind of physical manifestation of knowledge.

Exactly, right. In fact my friend Nicholson Baker, the writer, he used that picture for a book of essays called *The Size of Thoughts*, which suggests that thoughts have a weight.

And what did you do in terms of lighting for those pictures?

Window light. If you move it the right way against the window, that's pretty much it. I'm not good at complex lighting, so I choose to keep it simple. And those were long exposures. They tend to be like thirty seconds to a couple minutes or so. With a long exposure even subtle, low lighting can become really present.

What are some of the connections that you see between the book series and the currency series?

Oh, well with the book pictures, it was the idea of paper having so many shapes and so many meanings attached to it. I love that something so humble as paper can take on so many qualities. And then I started thinking that books are a kind of especially symbolic paper. The more I looked closely at books, the more narrative possibilities emerged. I wanted to find what a book had to say to me not in words but in its material. It was the same with money. I remember seeing a dollar bill once, and I thought well, this is also symbolic paper. I decided I wanted to get into places where there was a lot of money. Once, I made a picture of seven million dollars [plate 57]. When I show that picture I know people are thinking, where is *that*? So I usually joke and say, "Well, it's in my basement." [laughing] I like getting access to things that people don't usually have access to. I spent time at a bank that shall go unnamed, that's how I got access to the room where I photographed the seven million dollars. I mean there was a billion dollars in there! At first I thought, "Oh my God, I want to *steal* this!" But after a while, the smell begins to get to you and this paper becomes quite ordinary.

I'm wondering what prompted you to shift from black and white to color, because it seems like you were resisting making that change for quite a few years.

Yeah, there definitely was some resistance on my part. In some ways, I guess I felt the way Walker Evans did when he said that color is vulgar. I remember making a picture at the Philadelphia Museum, a camera obscura view that I was commissioned to do. For that picture I had three cameras. I had an 8 × 10 and a 4 × 5 with black-and-white film. I also brought an 8 × 10 with color film because I was beginning to flirt with the idea. When I looked at the color print from that shoot, it felt very magical. I loved the ways colors met in that room. It took me a long time to convince them to take the paintings hanging in that gallery down and bring in a De Chirico from another gallery, to rehang it there. When the hangers came I asked them to hang the painting quite low. It's not at the regular height. I wanted all these tensions to meet there. Anyway, that picture [plate 78], in 2005 I think, was the first color picture and then I began to make more. There's also another technical advance in that picture. Before, my camera obscuras were made by just putting a hole in dark plastic. Then I decided to try to get specific diopters; these are optical tools that focus at certain distances. The advantage is that you get a lot more light and a focused light, so you can, if you have the right distance, make the image *extremely* sharp. The color was really quite vivid from this technique.

And how did you get the hole precise enough to achieve the right degree of sharpness?

The advantage of just a plain hole is that it's equally focused anywhere. So ten feet or thirty feet, it's the same sharpness, so there's no difference. Now I have to have a variety of lenses. If the room is thirty feet I have to have a diopter that focuses on thirty feet. And I've turned images right side up. Because up to a certain moment all the pictures were coming upside down, which is the natural way of optics.

Do you use a mirror to do that?

A prism. This brings me to an interesting point. I mean I get almost daily requests from all kinds of people, "Can you tell me how you do this? Give me the specs on the lenses and your technique, because I want to do this myself." I don't want to be nasty but it's a technical thing that I had to find a solution for, and the technical interest came from a philosophical, artistic need.

Can you say more about the work that you have done in museums? It interests me because of the complex layering and because it deals with the meaning and presentation of art in our culture.

Well, in a way I began doing this kind of thing with books by bringing a page from two different volumes together. I've always been interested in visual conversations that are not particularly historically *correct*, but they are imaginings or unlikely meetings of things. That kind of surrealism has interested me. It's impossible stuff, but game in art. When I was an artist in residence at the Yale University Art Gallery, they were in the process of rotating the collection, and I asked if it was feasible to move certain art objects in front of other art objects, and they were fine with it. So the Nadelman sculpture—it took about three guys to move it, but I asked them to position it as close as possible to the Hopper painting. I wanted an impossible conversation to happen. It seemed to me that the Hopper plus the Nadelman would become a Magritte [plate 75]. I am still quite interested in reconfiguring things to suggest a *third* work of art.

And you've done that elsewhere?

Yes, I've done it in museums in Spain, and at the Isabella Stewart Gardner Museum. That was fun because I could make photographs pairing paintings with workers in the museum. I photographed this guy named Tim who was cleaning the floors and gallery where the Rembrandt self-portrait is. It struck me that for a moment they were alike in some meaningful way, so I wanted to merge them [plate 74]. I did another where a guard looked like a soldier painted by Titian. I wanted to break the boundaries and hierarchies between paintings and workers at the museum by suggesting new relationships. So, reworking these things suggested to me hybrid works of art.

You mentioned the influence of Paul Strand on your work; does anyone else come to mind?

Frederick Sommer's work was an important influence—I saw it early on in my career. A good friend of mine, David Becker, who became a curator at the Museum of Fine Arts, Boston, was a year ahead of me at Bowdoin. He came from a wealthy family and he had Rembrandt etchings and a dozen Sommer photographs while we were in college. Sommer was sort of a strange, odd fellow in a way. I met him in 1971. A friend of mine knew him so we hung around the Upper East Side when one of his shows was up. His music was being played, strange music, it wasn't pleasant—but it was pretty on the page. We had lunch and he was just a joy to be around, grinning like a kid. Actually, some of the recent collage-like work that I've been making has been inspired by Sommer.

Who are the contemporary photographers that you most admire?

I like many photographers for different reasons—Vik Muniz, for instance. Although we have very different approaches, we're alike in some ways, fooling around with conventions. I also like painters very much—old and new. I'm reading Van Gogh's

biography now. So I'm looking at a lot of Van Gogh, especially the drawings. The tent camera work that I do, I think, has a painterliness that I'm quite fond of.

Do you like printmaking? Process seems to be very important in how you think about things.

Yes, I like prints very much—especially Piranesi, Rembrandt, and Goya. Recently, in my collages, I started making cutouts of Gustave Doré's Bible illustrations. I remember cutting into a Doré book, making a window, and then seeing what's below. There was, I don't know, some people fighting on one page and then there was somebody else swimming on the next. Then I cut a third one and there was a goat or something—so how interesting to be excavating a book to see what other messages are being sent from below.

How did you come to use the tent to create camera obscura views? Were you thinking of nineteenth-century artists and their mobile darkrooms?

I always wanted to make pictures of landscapes. I was inspired by the hundreds of Westerns I had seen as a kid in Cuba. I was fortunate to get a grant to do work from the Alturas Foundation, which has an interest in the American West. The tent camera idea came when I was in Texas in Big Bend National Park scouting. It's a wonderful park; it borders Mexico. I was wondering—how do I make pictures here? It's surreal. Before I went there, I had imagined the desert was full of nothing, when in fact it's rich with stuff. So, I thought it would be interesting to try to make an image on the desert floor, and how would I accomplish that? Well, a tent obviously. So it took me about a year to figure out how to do it. CJ Heyliger, who's my assistant, and I made a tent out of metal tubes. It was heavy as hell and the shape was terrible. We went to Texas with it, but it became like a sail in the

wind. We made a five-hour exposure, and it was barely readable. But that image, as bad as it was, reminded me of Niepce's first photograph: kind of junky, but something was coming through. And it was enough to think we could improve this. So we got a tent maker in California to help us make something light. We were able to develop the idea of a periscope on a large tripod with a prism and a lens to get a ninety-degree throw. This made it possible to capture the near landscape and project it onto the ground. It wasn't easy. It took months just to make sure that we had the right tripod and the right lens, but there's something fun about trying to be a civil engineer in that sense. And so then we went back to Texas one more time with it and we made a couple pictures there, and it was just wonderful. It was like "Wow! This is more than what I was hoping for."

Hearing about the difficulties makes me think of Francis Frith, who went to Egypt to photograph the pyramids. He had his tent, but sometimes it would heat up to 115 degrees and he'd be pouring the solution on the plate and it would boil off. With the tent camera obscura you've gotten rid of the room.

Yeah, so now it's portable and it lets the ground redefine what the view is, because if the ground has a lot of pebbles, the picture becomes pointillistic.

Why did you decide to transition away from using sheet film?

My exposures in the past have been five to eight hours long, so making tent pictures in the desert, having to hang around for six hours—it was tough. So I investigated digital technology, and I waited for it to look as good as film. And not until a couple of years ago did I find the right digital equipment. It's a digital back made by Phase One that has a forty-megapixel capability. And so now my exposures have been cut from five hours to five minutes. And I like the technology, not just because it's saving

me time, but also, in two to five minutes, I can catch a very specific light. *Now* I'm able to get clouds and certain angles of light, so that's very exciting to me. I've been thinking a lot about Monet recently. It's not only convenient, but it's also allowing me to get a moment that is very particular. I photographed Old Faithful at the moment the geyser went off [plate 99]—it's interesting because I love the idea that William Henry Jackson was there. So I'm feeling like I'm in that lineage, you know?

And finally we've come to the point in the history of photography when color photographs are really accepted as art. And it's been a long time in coming.

Absolutely, that's right. It was sort of a weird child. And now digitally you have an amazing degree of control. Sometimes people interview me and their sub-agenda is, well, basically you're inventing *everything*. And I say: No, I use the digital back like straight photography. I'm just recording what's there. Otherwise, I would be photographing the West in my home in Brookline, Massachusetts. I think it's important that a certain kind of truth and effort is still used to arrive at recording it. I had someone tell me, after a talk, "You know you don't have to work so hard. You can just take two frames and then sandwich them together in Photoshop."

Well, I suppose there are certain people who do that, and maybe they're able to bring something else to the table that makes those pictures interesting. But that's not where *you've* come from.

No, I like abiding by the rigor of reality. There's a nice Zen saying about how if you want to write about a tree, you have to go to it.

Some of the magic of photography is its ability to transport you to another time and place, and chipping away at the underpinnings of the real, within the photographic creation, deflates it.

Yeah, exactly. Everything that I do now is digital, and I have assistants who know how to help me do it.

Is there anything you think we've lost in the shift from analog to digital? Are there any warnings you'd give people?

Well, I did enjoy the meditative moments I had in the darkroom—listening to Bach and hearing water run. It was a little bit of a Zen retreat for me. I really enjoyed that. It's not the same when you're parked in front of a computer.

What would you like people to notice about your work that they may have overlooked in the past? Is there anything that comes to mind?

That I work really hard to make things look simple and beautiful. When I started photography I had no idea what the shape of my work would be. Now it's clear that one thing leads to another. I'm quite excited to be making new work. Whatever the next day brings is the most interesting to me.

What kind of advice would you give to someone who aspires to be an artist?

In photography, I never gave up. Even when things have been bad, I always had the sense to keep working through it, and that's been helpful. I like what Goethe said: "What you can do, or dream you can do, begin it. Boldness has genius, power, and magic in it."

ABELARDO MORELL:
A CHRONOLOGY
Brett Abbott

1948

Born September 17 in Havana, Cuba, to Abelardo Morell Armenteros, a sergeant in the Cuban Navy, and Carmen Morell Oliver. The family settles in the small coastal town of Guanabo.

1962

On March 8, a little less than a year after the Bay of Pigs Invasion, the family (now including a younger sister, Maria) immigrates to the United States to escape political persecution (see fig. 1). During six months in Miami, begins learning English with the help of flashcards. After two months in New Orleans, the family moves to New York City, where his father finds a job as the superintendent of five apartment buildings on West Sixty-Ninth Street. Takes an after-school job as a delivery boy for a pharmacy on Sixty-Ninth Street and Columbus Avenue.

Fig. 1. Morell's 1962 passport used for entry into the United States

Fig. 2. *My Parents in Boiler Room*, 1963. All photographs by Abelardo Morell appear with their titles in italics.

1963

With his first camera—a Brownie purchased from the pharmacy where he works—begins making photographs of his family, his apartment, and tourist attractions like Central Park (see figs. 2–4).

1966

After a recruiter visits his Manhattan high school, Charles Evans Hughes High School, in search of applicants, is awarded a scholarship by Bowdoin College, in Brunswick, Maine, which is seeking to diversify its student body.

1967

Matriculates at Bowdoin College to work toward a degree in physics.

Fig. 3. Morell in Central Park with his 8 mm movie camera, 1963

1969

Fails first-year physics and enrolls in a photography course with Professor John McKee, who is instrumental in encouraging his artistic and photographic abilities. Is especially interested in alternative photographic processes, including solarization and photomontage, and begins creating collage work from cut-up negatives and prints.

Hosts a show for the college's radio station, exploring what will become a lifelong interest in music as an expressive medium. Drawn to avant-garde instrumental compositions, especially by John Cage and John Coltrane, begins mixing music from established genres to create original hybrid arrangements. This interventionist approach gets him kicked off the radio station on several occasions.

Introduced to the work of Diane Arbus, Henri Cartier-Bresson, and Robert Frank, who become his photographic role models (see fig. 5).

1970

Revisits a photograph made while traveling in Galicia, Spain, and finds it more effective

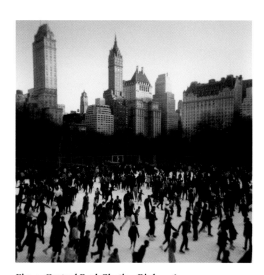

Fig. 4. *Central Park Skating Rink*, 1963

Fig. 5. *Twins*, 1969

when printed without his customary solarization (fig. 7). Abandons darkroom manipulation, instead harnessing the "straight" approach as a powerful way of conveying the strangeness of everyday life (see fig. 6).

At the end of his junior year, drops out of Bowdoin but remains in Brunswick, serving as a photographer and security guard for the college.

1973

Moves to New York City to live with his parents. Works as a ward clerk at a hospital and sets up a darkroom in the basement of a building his father manages. Further studies the history of photography and art independently at the New York Public Library. Robert Frank's *The Americans* and Henri Cartier-Bresson's *The Decisive Moment* remain important inspirations.

1974–75

Relocates to Miami intending to photograph the Cuban expatriate experience (see fig. 8). Works on a cleaning crew. Unhappy with the results of his project, returns to New York six months later.

1975–76

Joins Minority Photographers and is included in two exhibitions curated by Alex Harsley at his Fourth Street Gallery in New York.

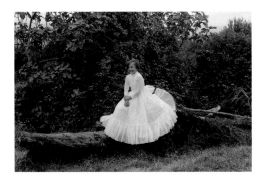

Fig. 7. *First Communion, Galicia, Spain,* 1970

Fig. 6. *Self-Portrait,* 1970

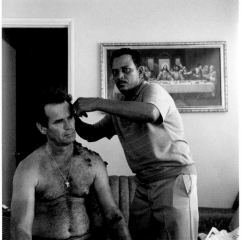

Fig. 8. *Haircut,* 1974

1976

Returns to Bowdoin to complete his undergraduate education. Meets fellow student Lisa McElaney and the two become a couple.

1977

Graduates from Bowdoin with a BA in Comparative Religion. Religious philosophy, particularly the quest to understand life through simple means, will remain of special interest.

1978

Travels with McElaney to England, Ireland, and Scotland for several months, developing his work and preparing to enroll in graduate school.

1979–80

Enters Yale University School of Art, focusing on street photography. Studies with Tod Papageorge and Richard Benson. Classmates include Lois Conner, Robert Lisak, Mike Smith, and Mary Tortorici. Studies overlap with those of Philip-Lorca di Corcia and Stephen Scheer. Is especially drawn to the legacy of Walker Evans and the work of contemporary photographers Josef Koudelka and Garry Winogrand; their influences are apparent in his work (see fig. 9).

1981

Graduates from Yale with an MFA in Photography.

1982

Takes a one-year teaching position at Bowdoin while his former professor, John McKee, is on sabbatical. Marries McElaney.

1983

Moves to Boston to take a position as a professor of photography at the Massachusetts College of Art and Design (MassArt), where his colleagues include Laura McPhee, Nick Nixon, and Barbara Bosworth. Continues to pursue street work in Boston.

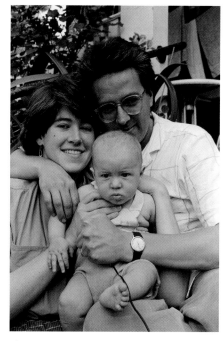

Fig. 10. *Me, Lisa, and Brady,* 1986

1986

Birth of his first child, Brady (see fig. 10), an event that leads to a significant turning point in his photographic career. While teaching photography and caring for Brady, begins to notice the creative potential of his interior environments. Adopts the curious perspective of his young son and reexamines seemingly insignificant household objects with newfound appreciation. Crayons, refrigerator magnets, shadows, and toys become objects of fascination and wonder before his lens, as do the simple textural and optical properties of light and water. With this rebirth of his photographic

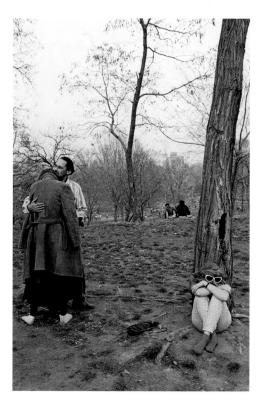

Fig. 9. *Central Park,* 1980

Fig. 11. *Children's Book*, 1987

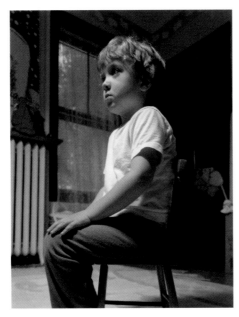

Fig. 12. *Brady Sitting*, 1989

eye, changes his equipment from a small-format 35 mm camera to a medium-format 6 × 9 centimeter camera. Invests in a large-format 4 × 5 inch view camera as well. Does not pursue street photography again.

1987
Photographs many subjects in black and white that he will later return to in color (see fig. 11, plate 107).

1988–90
His first two significant solo exhibitions open. The first, curated by Jeff Keogh, is at the public gallery of MassArt, the North Gallery in Boston; the second, curated by Michael Spano, is at the Midtown Y Photography Gallery in New York City. Both shows focus on his new interior work.

Begins making pictures that explore the wonder of optics, focusing on subjects like eyeglasses and the ground glass of his own view camera (plates 21 and 22).

To illustrate the basic operation of a camera, initiates a recurring practice of transforming his classroom at MassArt into a camera obscura, to the amazement of his students.

1991
His photograph *Brady Sitting* (fig. 12) is included in the Museum of Modern Art's exhibition, *Pleasures and Terrors of Domestic Comfort.*

Birth of his daughter, Laura. Takes a sabbatical to embark on a portrait project documenting the residents of Royal Street in Quincy, Massachusetts. Dissatisfied with the results, and with only a few weeks left on his leave, abandons the project in hope of finding fresh inspiration at home. Remembering his classroom demonstrations that harnessed optical principles known since the Renaissance (see fig. 13), transforms his own living room into a camera obscura and attempts to photograph the results from the inside with his large-format

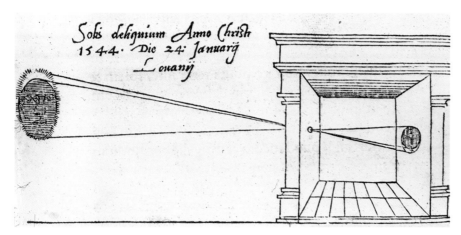

Fig. 13. Schematic drawing of the functioning of the camera obscura, from Reinerus Gemma-Frisius, *De Radio Astronomica et Geometria* (Antwerp, 1545)

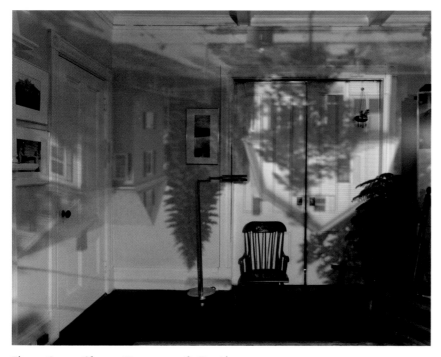

Fig. 14. *Camera Obscura: Houses across the Street in Our Living Room, Quincy, Massachusetts,* 1991

camera. Experiments intensely with the exposure time needed to document the fantastical scene of the outside world, upside down and laterally reversed, streaming into the room. Eventually determines that an eight-hour exposure produces a strong negative of a camera obscura image projected through an aperture three-eighths of an inch in size. Creates his first successful picture in the camera obscura series (fig. 14), thus embarking on a major body of work in his career.

1992
Awarded the Cintas Foundation Fellowship in Visual Arts, an honor granted annually to an artist of Cuban descent.

His photograph of a lightbulb reflected through a lens into an empty box (plate 23) is exhibited at the Museum of Modern Art in Peter Galassi's group show *More Than One Photography*. Major institutions around the country, including the Metropolitan Museum of Art in New York, begin to collect his work.

Meets Bonni Benrubi, who offers him his first formal gallery representation, beginning a long, dedicated professional partnership that lasts for the next twenty years.

1993

Receives the John Simon Guggenheim Memorial Fellowship in photography, an award previously bestowed on such artists as Diane Arbus, Walker Evans, and Edward Weston.

Becomes intrigued by the materiality of paper and printed text, including children's books, maps, and old manuscripts, and spends considerable time researching subjects to photograph in the Boston Public Library and the Boston Athenæum. With carefully staged and lit setups, depicts the interiors and exteriors of both unique and familiar publications (see plates 35–43). Develops a particular interest in art books and the way in which reproductions of paintings are themselves manipulations (see plates 44–50). By photographing printed images in recontextualized and disorienting ways, generates oblique narratives, initiating a series that will bear robust results through 1998 and beyond.

1994

His work is featured in the Museum of Modern Art's *New Photography* exhibition series.

To further develop his camera obscura series, begins to research interior spaces that face historical monuments and compelling cityscapes and landscapes around the world. Over the next decade and beyond, consistently pursues this body of work.

Many of the resulting photographs are made in bedrooms, symbolically imbuing his pictures with a dreamlike quality. Despite the pictures' unmediated appearance, the objects in the rooms are in fact carefully arranged to orchestrate the visual conversation between the interior and exterior spaces (see plates 24–34).

1995

Named artist in residence at the Boston Athenæum, where he continues his series of book photographs.

First publication on his work, *A Camera in a Room*, is completed; it includes an essay and interview by critic Richard B. Woodward (Smithsonian Institution Press). The compendium includes photographs from the late 1980s of his home and his son, camera obscura images, and selected early depictions of books and paper.

1996

Invited by Leonard S. Marcus, a children's book historian and critic, to illustrate a new edition of Lewis Carroll's *Alice's Adventures*

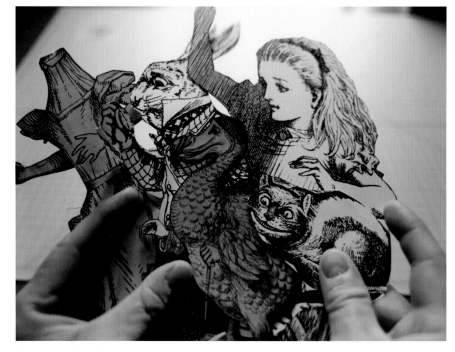

Fig. 15. Morell holding his handmade props for the *Alice's Adventures in Wonderland* series

in Wonderland. Accepts the challenge and begins scanning and printing British illustrator John Tenniel's drawings from the original 1865 edition, which he uses to inventively re-create scenes from the story. Cuts the figures into props (see fig. 15), assembles them in still-life format, and photographs them in combination with books, plants, teapots, and puddles of water, allowing the two-dimensional cutouts to interact in surreal ways with the three-dimensional world (see plates 51–53). The series becomes an extension of his efforts to depict the physicality of books in fresh, unusual, and transformative ways.

1997
Awarded an honorary Doctor of Fine Arts degree from Bowdoin College.

Commissioned by *New York Times Magazine* photography editor Kathy Ryan to make a camera obscura image of Times Square for a special Times Square–themed issue of the publication (plate 28).

1998–99
Begins an artist residency at the Isabella Stewart Gardner Museum in Boston and is inspired to make work arising directly from his interactions with the museum's collection and staff. Explores the creative potential of double exposures, juxtaposing pictures of painted portraits with depictions of museum staff who resemble the

historical likenesses (see plate 74). This project culminates in the book *Abelardo Morell, Face to Face: Photographs at the Gardner Museum* (Isabella Stewart Gardner Museum, 1998), with essays by the poet Charles Simic and the exhibition's curator, Jennifer Gross.

His illustrations for *Alice's Adventures in Wonderland* are published with an introduction by Marcus (Dutton Children's Books, 1998). Inspired by Alice's spunk, dedicates the book to his daughter, Laura.

The Museum of Photographic Arts, San Diego, organizes a mid-career retrospective accompanied by a catalogue, *Abelardo Morell and the Camera Eye*, with an essay by curator Diana Gaston (Museum of Photographic Arts, 1998). The show tours extensively throughout the United States.

2000
Begins working in residence at the Civitella Ranieri Foundation in Umbria, Italy. There, creates a series of camera obscura photographs inside private homes that look out onto the countryside of Umbertide.

Becomes a citizen of the United States.

2002
In connection with *Cuba on the Verge: An Island in Transition*, a book (Bulfinch Press, 2003) and subsequent exhibition at the

International Center of Photography, New York, curated by Terry McCoy, is invited to visit Cuba for the first time since he immigrated to the United States. Returns to his childhood hometown, meets old friends, and creates work for the camera obscura series in Havana (see plates 31 and 32). The trip is recorded by filmmaker Allie Humenuk for her feature-length documentary on Morell's work.

Release of *A Book of Books* with an essay by writer Nicholson Baker (Bulfinch Press, 2002).

Begins working on a series of photographs of money (see plates 56 and 57). By folding, crumpling, and juxtaposing bills before the lens, focuses on the tactile elements of this symbolic material.

2004
Elected to the Board of Overseers of the Museum of Fine Arts, Boston.

Releases his fourth book, *Camera Obscura*, which showcases an extensive collection of his camera obscura photographs from around the world and includes an introduction by writer and critic Luc Sante (Bulfinch Press, 2004).

Inspired by the work of Eadweard Muybridge, Etienne-Jules Marey, and Harold "Doc" Edgerton, turns to issues of light, motion,

and time. Investigates the manipulation of light beams across reflective surfaces (plate 63), documents clocks and hourglasses (see fig. 16), and explores the simulation of motion through recording successive impressions of a hammer and nail in lead (plate 66).

The exhibition *Vision Revealed: Selections from the Work of Abelardo Morell* opens at the Patricia and Phillip Frost Art Museum in Miami, and tours internationally in 2006–07 to institutions in Argentina, Brazil, Chile, and Mexico.

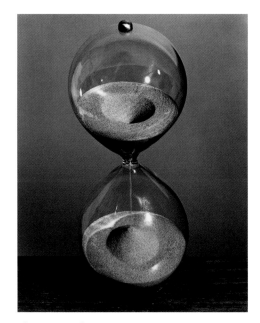

Fig. 16. *Hourglass*, 2004

2005

Creates a series of photographs in theaters. Focusing primarily on the Metropolitan Opera for a commission from the *New York Times Magazine*, explores backstage spaces, backdrops, and seating areas to demonstrate the theatricality of the space devoid of a performance (see plate 71).

While working at the Philadelphia Museum of Art, makes his first color camera obscura image (plate 78). Over the course of the following two years, color film slowly becomes his medium of choice, although continues to work in black and white on occasion. Embraces inkjet printing for his color output, but continues to print with traditional gelatin silver paper from his black-and-white negatives.

Publishes his fifth book, *Abelardo Morell*, which surveys his career to date and includes an introduction by Richard B. Woodward (Phaidon, 2005). The Art Institute of Chicago mounts the exhibition *A View with a Room: Abelardo Morell's Camera Obscura Photographs*.

2006

Awarded the Rappaport Prize by the DeCordova Museum, Lincoln, Massachusetts.

Explores ways of making camera-less photographs, drawing inspiration from the work of William Henry Fox Talbot and Man Ray. Aiming to render a depth and

perspective unusual in photograms, sets up still-life compositions and uses a flashlight to cast shadows from them onto large sheets of film that are affixed to an easel (see plates 67–70).

Begins experimenting with placing a prism and diopter lens at the aperture of his camera obscura setups. The prism reorients the projected image of the outside world right side up, while the lens renders that image brighter and more sharply focused, reducing exposure time with his large-format camera to between four and five hours.

2007

During a sabbatical from MassArt, joins the faculty of Princeton University as a Visiting Professor in the Humanities and a Class of 1932 Fellow in Visual Arts.

Release of *Shadow of the House*, Humenuk's feature-length documentary on Morell's life and work. The film, which was made over the course of seven years, focuses on his unique photographic practice, but also covers his personal history and family life, while conveying his sense of humor.

2008

Returns to Yale University School of Art as the Happy and Bob Doran Artist in Residence. Furthers his work in museums at the Yale University Art Gallery, juxtaposing

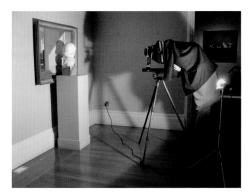

Fig. 17. **Morell at work in the Yale University Art Gallery,** 2008

formulating the concept for a tent camera that could function as a mobile camera obscura in outdoor locations.

In a project overseen by editor May Castleberry, collaborates with author and neurologist Oliver Sacks and designer Ted Muehling on a limited edition book to be published by the Library Council of the Museum of Modern Art, New York. The book, called *The Island of Rota*, unites Sacks's

writings on the ancient ferns and cycads of this geographically isolated Micronesian island with original photographs by Morell and design by Muehling. For his contribution, begins a series of *cliché-verre* prints made with plant specimens collected from Rota (see fig. 19). Adds and subtracts layers of ink and fronds on glass plates and then uses the plates as negatives to create photographic prints. The technique derives from a similar process used in the

sculptures, paintings, and frames to deconstruct conventional ways of looking at art and activate new narratives (see fig. 17). The resulting work is shown in *Behind the Seen: The Photographs of Abelardo Morell*, an exhibition organized by Anna Hammond and Christine Paglia at the Yale University Art Gallery.

2009
Begins a residency at Alturas Foundation, San Antonio, Texas, and explores the concept of composition in landscape art. Superimposing wood frames against picturesque vistas in the desert, photographs these arrangements from a distance just beyond the margins of the frame, thereby calling attention to the subjectivity and abstraction inherent in two-dimensional transcriptions of the world (see fig. 18). Also experiments with projecting light onto the landscape at night (see plate 92) and begins

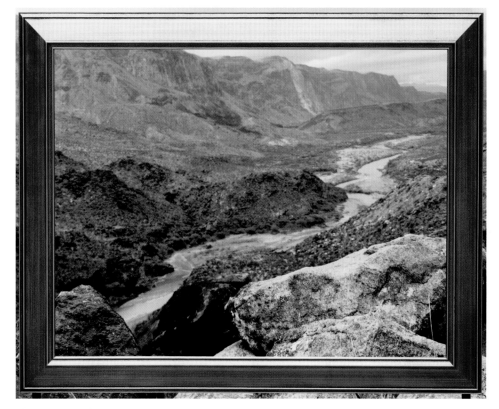

Fig. 18. *Frame: Rio Grande, West Texas,* 2009

171

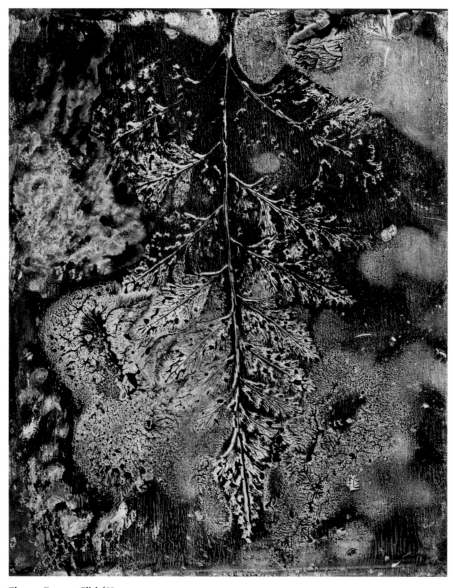

Fig. 19. *Fern #2: Cliché Verre*, 2009

nineteenth century by French painters like Corot, Daubigny, and Millet to create hand-drawn negatives by etching scenes of nature on soot-coated glass surfaces. Unlike his predecessors, however, scans his glass plates and prints them digitally, in a modernization of this traditional medium.

A major show of his work is held at the Pingyao International Photography Festival in Pingyao, China.

2010
With his assistant CJ Heyliger, and following historical practice (see fig. 20), succeeds in designing an innovative tent camera (fig. 21), with the intention of making images similar to his camera obscura series but in outdoor areas devoid of structures. The movable equipment consists of a custom tent topped by a lens that projects a transposed view of the landscape down onto the textured ground inside the tent. Documents the image with his large-format camera. This new process will occupy him for years. Working with the tent camera prompts him to embrace digital technology, attaching a digital back to his medium-format camera. This reduces his exposure time from hours to minutes, allowing him to capture dynamic subjects in his frame, including specific rather than generic lighting, transient weather patterns, and people.

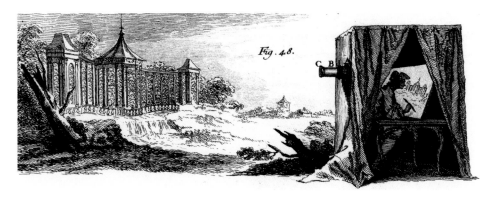

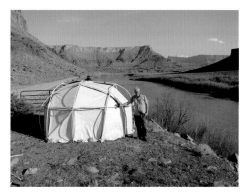

Fig. 20. Engraving of a tent camera obscura, from Alexandre Savérien, *Dictionnaire universel de mathématique et de physique* (C. A. Jombert, 1753)

Fig. 21. Morell with his tent camera, Moab, Utah, April 2011

2011

Wins the Infinity Award in Art from the International Center of Photography, New York.

Stops teaching at MassArt after twenty-seven years to pursue art-making full time. Selected as an artist in residence by Pasadena City College, Pasadena, California, where he furthers existing projects. Begins photographing books and other still-life subjects in color.

2012

Participates in the FOR-SITE Foundation exhibition project, *International Orange*, which comprises new work by contemporary artists responding to the Golden Gate

Bridge in honor of its seventy-fifth anniversary. As part of his contribution, sets up a temporary camera obscura installation titled *Vertigo* at historic Fort Point and produces three tent camera views of the bridge (see plate 102).

Having experimented with inkjet printing for some of his black-and-white work since 2010, makes the decision to cease working with gelatin silver prints and completely embrace digital technology for his output.

2013

Abelardo Morell: The Universe Next Door, a major retrospective of Morell's work organized by the Art Institute of Chicago

in collaboration with the J. Paul Getty Museum and the High Museum of Art, begins its national tour.

Continues to make new work and joins the Edwynn Houk Gallery, New York.

1. *Lisa and Brady behind Glass*, 1986. Inkjet print; 57.2 × 45.8 cm (22 ½ × 18 ¹/₁₆ in.). Courtesy of the artist and Edwynn Houk Gallery, New York.

2. *Toy Blocks*, 1987. Inkjet print; 57.2 × 45.8 cm (22 ½ × 18 ¹/₁₆ in.). Courtesy of the artist and Edwynn Houk Gallery, New York.

3. *Refrigerator*, 1987. Inkjet print; 57.2 × 45.8 cm (22 ½ × 18 ¹/₁₆ in.). Courtesy of the artist and Edwynn Houk Gallery, New York.

4. *Crayons*, 1987. Inkjet print; 46.6 × 58.2 cm (18 ³/₈ × 22 ¹⁵/₁₆ in.). Courtesy of the artist and Edwynn Houk Gallery, New York.

5. *Ball*, 1987. Inkjet print; 45.8 × 57.2 cm (18 ¹/₁₆ × 22 ½ in.). Courtesy of the artist and Edwynn Houk Gallery, New York.

6. *Slide*, 1988. Inkjet print; 46.6 × 58.2 cm (18 ³/₈ × 22 ¹⁵/₁₆ in.). Courtesy of the artist and Edwynn Houk Gallery, New York.

7. *Footprints*, 1987. Gelatin silver print; 57 × 46 cm (22 ⁷/₁₆ × 18 ¹/₈ in.). High Museum of Art, purchase with funds from the Friends of Photography, 2012.213.

8. *Brady Looking at His Shadow*, 1991. Gelatin silver print; 57.2 × 45.7 cm (22 ½ × 18 in.). High Museum of Art, purchase with funds from Bert and Cathy Clark, 2012.214.

9. *Empty Playhouse*, 1987. Inkjet print; 58.2 × 46.6 cm (22 ¹⁵/₁₆ × 18 ³/₈ in.). Courtesy of the artist and Edwynn Houk Gallery, New York.

10. *Dollhouse*, 1987. Gelatin silver print; 56.8 × 45.5 cm (22 ³/₈ × 17 ¹⁵/₁₆ in.). The J. Paul Getty Museum, Los Angeles, 2011.48.1.

11. *New Year's Eve*, 1989–90. Gelatin silver print; 57 × 46 cm (22 ⁷/₁₆ × 18 ¹/₈ in.). The Art Institute of Chicago, gift of Abelardo Morell, 2004.140.

12. *Laura and Brady in the Shadow of Our House*, 1994. Gelatin silver print; 46 × 57 cm (18 ¹/₈ × 22 ⁷/₁₆ in.). The Art Institute of Chicago, gift of Abelardo Morell, 2004.139.

13. *Pencil*, 2000. Gelatin silver print; 57 × 45.5 cm (22 ⁷/₁₆ × 17 ¹⁵/₁₆ in.). The J. Paul Getty Museum, Los Angeles, 2011.48.2.

14. *Pencil Demonstration*, 2002. Inkjet print; 45.8 × 57.2 cm (18 ¹/₁₆ × 22 ½ in.). Courtesy of the artist and Edwynn Houk Gallery, New York.

15. *Paper Bag*, 1992. Inkjet print; 57.2 × 45.8 cm (22 ½ × 18 ¹/₁₆ in.). Courtesy of the artist and Edwynn Houk Gallery, New York.

16. *Wine Glass*, 1993. Inkjet print; 57.2 × 45.8 cm (22 ½ × 18 ¹/₁₆ in.). Courtesy of the artist and Edwynn Houk Gallery, New York.

17. *Two Forks under Water*, 1993. Inkjet print; 57.2 × 45.8 cm (22 ½ × 18 ¹/₁₆ in.). Courtesy of the artist and Edwynn Houk Gallery, New York.

18. *Water Pouring out of a Pot*, 1993. Inkjet print; 57.2 × 45.8 cm (22 ½ × 18 ¹/₁₆ in.). Courtesy of the artist and Edwynn Houk Gallery, New York.

19. *Water Alphabet*, 1998. Inkjet print; 45.8 × 57.2 cm (18 ¹/₁₆ × 22 ½ in.). Courtesy of the artist and Edwynn Houk Gallery, New York.

20. *Small Vase at the Edge of a Table*, 2002. Gelatin silver print; 57.2 × 45.7 cm (22 ½ × 18 in.). High Museum of Art, purchase with funds from the Friends of Photography and Marian and Benjamin A. Hill, 2012.212.

21. *My Broken Glasses and Me*, 1994. Inkjet print; 45.7 × 57.2 cm (18 × 22 ½ in.). High Museum of Art, purchase with funds from the Friends of Photography and Ellen and George Nemhauser, 2012.215.

22. *My Camera and Me*, 1990. Gelatin silver print; 45.7 × 57.2 cm (18 × 22 ½ in.). The Art Institute of Chicago, promised gift of Daniel Greenberg and Susan Steinhauser, obj. 210888.

23. *Lightbulb*, 1991. Gelatin silver print; 45.5 × 57.3 cm (17 ¹⁵/₁₆ × 22 ⁹/₁₆ in.). The Art Institute of Chicago, Comer Foundation Fund, 1994.40.

24. *Camera Obscura: Houses across the Street in Our Bedroom, Quincy, Massachusetts*, 1991. Gelatin silver print; 79.2 × 103.2 cm (31 ³/₁₆ × 40 ⁵/₈ in.). The J. Paul Getty Museum, Los Angeles, promised gift of Daniel Greenberg and Susan Steinhauser.

25. *Camera Obscura: Brookline View in Brady's Room*, 1992. Gelatin silver print; 45.6 × 57.3 cm (17 ¹⁵/₁₆ × 22 ⁹/₁₆ in.). The Art Institute of Chicago, Comer Foundation Fund, 1994.39.

26. *Camera Obscura: The Empire State Building in Bedroom*, 1994. Gelatin silver print; 81.3 × 101.6 cm (32 × 40 in.). The Art Institute of Chicago, promised gift of Daniel Greenberg and Susan Steinhauser, obj. 210886.

27. *Camera Obscura: Manhattan View Looking South in Large Room*, 1996. Gelatin silver print; 45.7 × 57.2 cm (18 × 22 ½ in.). The J. Paul Getty Museum, Los Angeles, promised gift of Daniel Greenberg and Susan Steinhauser.

28. *Camera Obscura: Times Square in Hotel Room*, 1997. Gelatin silver print; 81.2 × 102.2 cm (32 × 40 ¼ in.). Courtesy of the artist and Edwynn Houk Gallery, New York.

29. *Camera Obscura: The Tower Bridge in the Tower Hotel, London, England*, 2001. Gelatin silver print; 45.7 × 57.2 cm (18 × 22 ½ in.). The Art Institute of Chicago, promised gift of Daniel Greenberg and Susan Steinhauser, obj. 210885.

30. *Camera Obscura: View of St. Louis Looking East in Building under Construction*, 2000. Gelatin silver print; 45 × 57 cm (17 ¹¹/₁₆ × 22 ⁷/₁₆ in.). The J. Paul Getty Museum, Los Angeles, 2011.48.3.

31. *Camera Obscura: La Giraldilla de la Habana in Room with Broken Wall, Havana, Cuba*, 2002. Gelatin silver print; 45.9 × 57 cm (18 ¹/₁₆ × 22 ⁷/₁₆ in.). The Art Institute of Chicago, restricted gift of Kay and Matthew Bucksbaum, 2004.109.

32. *Camera Obscura: El Vedado Looking Northwest, Havana, Cuba*, 2002. Gelatin silver print; 45.8 × 57.2 cm (18 ¹/₁₆ × 22 ½ in.). Courtesy of the artist and Edwynn Houk Gallery, New York.

33. *Camera Obscura: Courtyard Building, Lacock Abbey, England, March 16, 2003*. Gelatin silver print; 45.5 × 57 cm (17 15/16 × 22 7/16 in.). The J. Paul Getty Museum, Los Angeles, 2011.48.4.

34. *Camera Obscura: The Sea in Attic*, 1994. Gelatin silver print; 45.7 × 57.2 cm (18 × 22 1/2 in.). The Art Institute of Chicago, promised gift of Daniel Greenberg and Susan Steinhauser, obj. 210889.

35. *Shiny Books*, 2000. Gelatin silver print; 45.7 × 55.9 cm (18 × 22 in.). The J. Paul Getty Museum, Los Angeles, promised gift of Daniel Greenberg and Susan Steinhauser.

36. *1841 Book of Proverbs for the Blind*, 1995. Inkjet print; 57.2 × 45.8 cm (22 1/2 × 18 1/16 in.). Courtesy of the artist and Edwynn Houk Gallery, New York.

37. *Three Dictionaries*, 2000. Gelatin silver print; 50.8 × 61 cm (20 × 24 in.). The J. Paul Getty Museum, Los Angeles, promised gift of Daniel Greenberg and Susan Steinhauser.

38. *Book with Wavy Pages*, 2001. Gelatin silver print; 57.2 × 45.8 cm (22 1/2 × 18 1/16 in.). Courtesy of the artist and Edwynn Houk Gallery, New York.

39. *Two Stacks of Bound Newspapers*, 2001. Inkjet print; 57.2 × 45.8 cm (22 1/2 × 18 1/16 in.). Courtesy of the artist and Edwynn Houk Gallery, New York.

40. *A Tale of Two Cities*, 2001. Gelatin silver print; 45.7 × 57.2 cm (18 × 22 1/2 in.). The Art Institute of Chicago, promised gift of Daniel Greenberg and Susan Steinhauser, obj. 210884.

41. *Thought*, 2001. Gelatin silver print; 45.7 × 57.2 cm (18 × 22 1/2 in.). The Art Institute of Chicago, promised gift of Daniel Greenberg and Susan Steinhauser, obj. 210887.

42. *Dictionary*, 1994. Inkjet print; 45.8 × 57.2 cm (18 1/16 × 22 1/2 in.). Courtesy of the artist and Edwynn Houk Gallery, New York.

43. *Two Books*, 1994. Inkjet print; 45.8 × 57.2 cm (18 1/16 × 22 1/2 in.). Courtesy of the artist and Edwynn Houk Gallery, New York.

44. *Pietà by El Greco*, 1993. Inkjet print; 45.8 × 57.2 cm (18 1/16 × 22 1/2 in.). Courtesy of the artist and Edwynn Houk Gallery, New York.

45. *Sunlight on Book of Landscapes*, 1995. Inkjet print; 45.8 × 57.2 cm (18 1/16 × 22 1/2 in.). Courtesy of the artist and Edwynn Houk Gallery, New York.

46. *Naked Maja by Goya*, 1994. Inkjet print; 57.2 × 45.8 cm (22 1/2 × 18 1/16 in.). Courtesy of the artist and Edwynn Houk Gallery, New York.

47. *The Colosseum by Piranesi #2*, 1994. Gelatin silver print; 55.9 × 45.7 cm (22 × 18 in.). The J. Paul Getty Museum, Los Angeles, promised gift of Daniel Greenberg and Susan Steinhauser.

48. *Le Antichità Romane by Piranesi #1*, 1994. Gelatin silver print; 77.6 × 99.7 cm (30 9/16 × 39 1/4 in.). High Museum of Art, promised gift of Daniel Greenberg and Susan Steinhauser.

49. *Book of Revolving Stars*, 1994. Inkjet print; 45.8 × 57.2 cm (18 1/16 × 22 1/2 in.). Courtesy of the artist and Edwynn Houk Gallery, New York.

50. *Two Books of Astronomy*, 1996. Inkjet print; 45.7 × 57.2 cm (18 × 22 1/2 in.). Courtesy of the artist and Edwynn Houk Gallery, New York.

51. *Down the Rabbit Hole (from Alice's Adventures in Wonderland)*, 1998. Inkjet print; 57.2 × 45.8 cm (22 1/2 × 18 1/16 in.). Courtesy of the artist and Edwynn Houk Gallery, New York.

52. *Curiouser and Curiouser (from Alice's Adventures in Wonderland)*, 1998. Inkjet print; 57.2 × 45.8 cm (22 1/2 × 18 1/16 in.). Courtesy of the artist and Edwynn Houk Gallery, New York.

53. *It Was Much Pleasanter at Home (from Alice's Adventures in Wonderland)*, 1998. Gelatin silver print; 57 × 45.8 cm (22 7/16 × 18 1/16 in.). The Art Institute of Chicago, Horace W. Goldsmith Foundation Fund, 2001.66.

54. *Map of North America*, 1996. Gelatin silver print; 46 × 57 cm (18 1/8 × 22 7/16 in.). The Art Institute of Chicago, Horace W. Goldsmith Foundation Fund, 2001.67.

55. *Map #1*, 1996. Inkjet print; 45.8 × 57.2 cm (18 1/16 × 22 1/2 in.). Courtesy of the artist and Edwynn Houk Gallery, New York.

56. *$60*, 2002. Inkjet print; 57.2 × 45.8 cm (22 1/2 × 18 1/16 in.). Courtesy of the artist and Edwynn Houk Gallery, New York.

57. *$7 Million*, 2006. Gelatin silver print; 80.8 × 102.2 cm (31 13/16 × 40 1/4 in.). Courtesy of the artist and Edwynn Houk Gallery, New York.

58. *Shadows during Solar Eclipse*, 1994. Inkjet print; 45.8 × 57.2 cm (18 1/16 × 22 1/2 in.). Courtesy of the artist and Edwynn Houk Gallery, New York.

59. *Sunspots on Covered Table, Umbertide, Italy*, 2000. Gelatin silver print; 45.7 × 57.2 cm (18 × 22 1/2 in.). The J. Paul Getty Museum, Los Angeles, promised gift of Daniel Greenberg and Susan Steinhauser.

60. *Feet and Sunspots*, 2000. Inkjet print; 45.7 × 57.2 cm (18 × 22 1/2 in.). High Museum of Art, purchase with funds from the Friends of Photography, 2012.216.

61. *Ten Sunspots on My Door*, 2004. Gelatin silver print; 57.2 × 45.8 cm (22 1/2 × 18 1/16 in.). Courtesy of the artist and Edwynn Houk Gallery, New York.

62. *Light Entering Our House*, 2004. Gelatin silver print; 57.2 × 45.7 cm (22 1/2 × 18 in.). The Art Institute of Chicago, promised gift of Daniel Greenberg and Susan Steinhauser, obj. 210879.

63. *Construction with Narrow Mirrors and Laser Pointer*, 2005. Inkjet print; 45.8 × 57.2 cm (18 1/16 × 22 1/2 in.). Courtesy of the artist and Edwynn Houk Gallery, New York.

64. *Laboratory Glassware Construction*, 2004. Gelatin silver print; 80.8 × 102.2 cm (31 13/16 × 40 1/4 in.). Courtesy of the artist and Edwynn Houk Gallery, New York.

65. *Motion Study of Falling Pitchers*, 2004. Gelatin silver print; 57.2 × 45.7 cm (22 1/2 × 18 in.). The Art Institute of Chicago, promised gift of Daniel Greenberg and Susan Steinhauser, obj. 210881.

66. *Motion Study of Hammer Impressions on Lead*, 2004. Gelatin silver print; 57.2 × 45.7 cm (22 1/2 × 18 in.). The Art Institute of Chicago, promised gift of Daniel Greenberg and Susan Steinhauser, obj. 210880.

67. *Flashlight and Salt: Photogram on 8" × 10" Film*, 2006. Inkjet print; 57.2 × 45.8 cm (22 1/2 × 18 1/16 in.). Courtesy of the artist and Edwynn Houk Gallery, New York.

68. *Water and Ink: Photogram on 20" × 24" Film*, 2006. Gelatin silver print; 48.3 × 58.5 cm (23 1/16 × 19 in.). Courtesy of the artist and Edwynn Houk Gallery, New York.

69. *Still Life with Pears: Photogram on 20" × 24" Film*, 2006. Gelatin silver print; 47.4 × 58.3 cm (18 11/16 × 22 15/16 in.). The J. Paul Getty Museum, Los Angeles, 2011.48.5.

70. *Still Life with Wine Glass: Photogram on 20" × 24" Film*, 2006. Gelatin silver print; 47.2 × 58 cm (18 5/8 × 22 7/8 in.). High Museum of Art, purchase with funds from the Friends of Photography, 2012.217.

71. *The Metropolitan Opera: Romeo and Juliet Set*, 2005. Inkjet print; 45.8 × 57.2 cm (18 1/16 × 22 1/2 in.). Courtesy of the artist and Edwynn Houk Gallery, New York.

72. *Two Paintings Sharing an Arch, Isabella Stewart Gardner Museum*, 1998. Inkjet print; 45.8 × 57.2 cm (18 1/16 × 22 1/2 in.). Courtesy of the artist and Edwynn Houk Gallery, New York.

73. *Inghirami, Isabella Stewart Gardner Museum*, 1998. Gelatin silver print; 45.8 × 57.2 cm (18 1/16 × 22 1/2 in.). Courtesy of the artist and Edwynn Houk Gallery, New York.

74. *Tim and Rembrandt, Isabella Stewart Gardner Museum*, 1998. Gelatin silver print; 45.8 × 57.2 cm (18 1/16 × 22 1/2 in.). Courtesy of the artist and Edwynn Houk Gallery, New York.

75. *Nadelman/Hopper, Yale University Art Gallery*, 2008. Inkjet print; 61 × 77.5 cm (24 × 30 ½ in.). Courtesy of Bonni Benrubi Gallery, New York.

76. *Landscape and Figure, Lázaro Galdiano Museum, Madrid, Spain*, 2009. Inkjet print; 61 × 76.2 cm (24 × 30 in.). Courtesy of the artist and Edwynn Houk Gallery, New York.

77. *Frishmuth/Corot, Yale University Art Gallery*, 2009. Inkjet print; 61.2 × 76.5 cm (24 ⅛ × 30 ⅛ in.). Courtesy of Bonni Benrubi Gallery, New York.

78. *Camera Obscura: The Philadelphia Museum of Art East Entrance in Gallery #171 with a De Chirico Painting*, 2005. Inkjet print; 76.2 × 96.2 cm (30 × 37 ⅞ in.). Courtesy of the artist and Edwynn Houk Gallery, New York.

79. *Camera Obscura: Santa Maria della Salute in Palazzo Bedroom, Venice, Italy*, 2006. Inkjet print; 96.3 × 76.2 cm (37 ¹⁵/₁₆ × 30 in.). Courtesy of the artist and Edwynn Houk Gallery, New York.

80. *Camera Obscura: The Piazzetta San Marco Looking Southeast in Office, Venice, Italy*, 2007. Inkjet print; 61 × 76.9 cm (24 × 30 ⁵/₁₆ in.). The Art Institute of Chicago, gift of the artist in memory of David Feingold, 2013.1.

81. *Camera Obscura: Garden with Olive Tree inside Room with Plants, outside Florence, Italy*, 2009. Inkjet print; 60.4 × 76.2 cm (23 ¹³/₁₆ × 30 in.). Courtesy of the artist and Edwynn Houk Gallery, New York.

82. *Camera Obscura: 5:04 AM Sunrise over the Atlantic Ocean, Rockport, Massachusetts, June 17th, 2009*. Inkjet print; 61 × 76.2 cm (24 × 30 in.). Courtesy of the artist and Edwynn Houk Gallery, New York.

83. *Camera Obscura: View of the Brooklyn Bridge in Bedroom*, 2009. Inkjet print; 79 × 101.6 cm (31 ⅛ × 40 in.). The J. Paul Getty Museum, Los Angeles, purchased with funds provided by Richard and Alison Crowell, Daniel Greenberg and Susan Steinhauser, and anonymous donors in honor of James N. Wood, 2011.62.

84. *Camera Obscura: Times Square in Hotel Room*, 2010. Inkjet print; 76.5 × 102.2 cm (30 ⅛ × 40 ¼ in.). High Museum of Art, purchase with funds from Charlotte Dixon and the Friends of Photography, 2012.11.

85. *Camera Obscura: View of Central Park Looking North—Spring*, 2010. Inkjet print; 61 × 76.2 cm (24 × 30 in.). Courtesy of the artist and Edwynn Houk Gallery, New York.

86. *Camera Obscura: View of Central Park Looking North—Summer*, 2008. Inkjet print; 59.6 × 76.2 cm (23 ½ × 30 in.). Courtesy of the artist and Edwynn Houk Gallery, New York.

87. *Camera Obscura: View of Central Park Looking North—Fall*, 2008. Inkjet print; 59.6 × 76.2 cm (23 ½ × 30 in.). Courtesy of the artist and Edwynn Houk Gallery, New York.

88. *Camera Obscura: View of Central Park Looking North—Winter*, 2013. Inkjet print; 61 × 76.2 cm (24 × 30 in.). Courtesy of the artist and Edwynn Houk Gallery, New York.

89. *Camera Obscura: View of the Manhattan Bridge—April 30th, Morning*, 2010. Inkjet print; 57.2 × 76.2 cm (22 ½ × 30 in.). Courtesy of the artist and Edwynn Houk Gallery, New York.

90. *Camera Obscura: View of the Manhattan Bridge—April 30th, Afternoon*, 2010. Inkjet print; 57.2 × 76.2 cm (22 ½ × 30 in.). Courtesy of the artist and Edwynn Houk Gallery, New York.

91. *Camera Obscura: View of the Manhattan Bridge—April 30th, Evening*, 2010. Inkjet print; 57.2 × 76.2 cm (22 ½ × 30 in.). Courtesy of the artist and Edwynn Houk Gallery, New York.

92. *Circular Light on Landscape, Big Bend National Park, Texas*, 2010. Inkjet print; 61.2 × 77.5 cm (24 ⅛ × 30 ½ in.). Courtesy of Bonni Benrubi Gallery, New York.

93. *Tent Camera Image on Ground: View Looking Southeast toward the Chisos Mountains, Big Bend National Park, Texas*, 2010. Inkjet print; 61.2 × 77.5 cm (24 ⅛ × 30 ½ in.). Courtesy of Bonni Benrubi Gallery, New York.

94. *Tent Camera Image on Ground: Rooftop View of the Brooklyn Bridge*, 2010. Inkjet print; 76.4 × 99.5 cm (30 ¹/₁₆ × 39 ³/₁₆ in.). Courtesy of the artist and Edwynn Houk Gallery, New York.

95. *Tent Camera Image on Ground: Rooftop View of Midtown Manhattan Looking Southeast*, 2010. Inkjet print; 77.2 × 102 cm (30 × 40 in.). Courtesy of Bonni Benrubi Gallery, New York.

96. *Tent Camera Image on Ground: View of the Yosemite Valley from Tunnel View, Yosemite National Park, California*, 2012. Inkjet print; 57.2 × 76.2 cm (22 ½ × 30 in.). Courtesy of the artist and Edwynn Houk Gallery, New York.

97. *Tent Camera Image on Ground: View of Upper and Lower Yosemite Falls, Yosemite National Park, California*, 2012. Inkjet print; 57.2 × 76.2 cm (22 ½ × 30 in.). Courtesy of the artist and Edwynn Houk Gallery, New York.

98. *Tent Camera Image on Ground: El Capitan from Cathedral Beach, Yosemite National Park, California*, 2012. Inkjet print; 76.2 × 57.2 cm (30 × 22 ½ in.). Courtesy of the artist and Edwynn Houk Gallery, New York.

99. *Tent Camera Image on Ground: View of Old Faithful Geyser, Yellowstone National Park, Wyoming*, 2011. Inkjet print; 76.5 × 102.2 cm (30 ⅛ × 40 ¼ in.). High Museum of Art, purchase with funds from Joe and Tede Williams and the Friends of Photography, and with funds given in memory of Dr. Robert Bunnen, 2012.10.

100. *Tent Camera Image on Ground: View of the Grand Canyon from Trailview Overlook, Grand Canyon National Park, Arizona*, 2012. Inkjet print; 57.2 × 76.2 cm (22 ½ × 30 in.). Courtesy of the artist and Edwynn Houk Gallery, New York.

101. *Tent Camera Image on Ground: View of Landscape outside Florence, Italy*, 2010. Inkjet print; 57.2 × 76.5 cm (22 ½ × 30 ⅛ in.). Courtesy of Bonni Benrubi Gallery, New York.

102. *Tent Camera Image on Ground: View of the Golden Gate Bridge from Battery Yates*, 2012. Inkjet print; 57.2 × 76.2 cm (22 ½ × 30 in.). Courtesy of the artist and Edwynn Houk Gallery, New York.

103. *Tent Camera Image on Ground: Rio Grande Looking Southeast near Santa Elena Canyon, Big Bend National Park, Texas*, 2011. Inkjet print; 57.2 × 76.2 cm (22 ½ × 30 in.). Courtesy of the artist and Edwynn Houk Gallery, New York.

104. *Tent Camera Image on Ground: View of Jordan Pond and the Bubble Mountains, Acadia National Park, Maine, March 2010*. Inkjet print; 57.2 × 76.2 cm (22 ½ × 30 in.). Courtesy of the artist and Edwynn Houk Gallery, New York.

105. *Tent Camera Image on Ground: View of Sea from Winslow Homer's Studio Backyard, Prouts Neck, Maine*, 2012. Inkjet print; 76.5 × 102.2 cm (30 ⅛ × 40 ¼ in.). High Museum of Art, gift of the artist in honor of Daniel W. McElaney, Jr., 2012.218.

106. *Opening Page: A Farewell to Arms*, 2011. Inkjet print; 76.2 × 57.2 cm (30 × 22 ½ in.). Courtesy of the artist and Edwynn Houk Gallery, New York.

107. *The Great Big Fire Engine Book*, 2011. Inkjet print; 54.5 × 76.2 cm (21 ⁷/₁₆ × 30 in.). Courtesy of the artist and Edwynn Houk Gallery, New York.

108. *Cutout: Piranesi Metropolis*, 2012. Inkjet print; 102 × 76.4 cm (40 ³/₁₆ × 30 ¹/₁₆ in.). Courtesy of the artist and Edwynn Houk Gallery, New York.

109. *Paper Self*, 2012. Inkjet print; 76.6 × 57.4 cm (30 ³/₁₆ × 22 ⅝ in.). High Museum of Art, purchase with funds from Lindsay W. Marshall in memory of Fray F. Marshall, 2012.209.

110. *Microcosmos: Photogram of Water on Film*, 2012. Inkjet print; 101.6 × 124.5 cm (40 × 30 in.). The J. Paul Getty Museum of Art, gift of the artist in memory of his father, Abelardo Morell Armenteros (1922–2007), 2012.82.